PEACE

ng 2003

PHANTASIE AN DIE MACHT /
POWER TO THE IMAGINATION

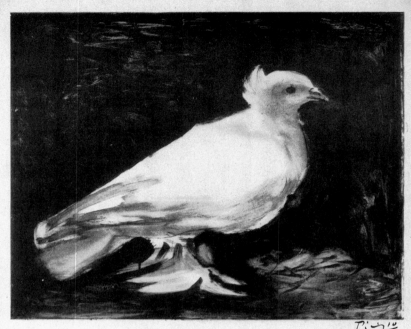

CONGRÈS MONDIAL
DES PARTISANS
DE LA PAIX

SALLE PLEYEL
20·21·22 ET 23 AVRIL 1949
PARIS

MOURLOT_ IMP. PARIS

Jürgen Döring

PHANTASIE
AN DIE MACHT

Politik im Künstlerplakat

POWER TO THE
IMAGINATION

Artists, Posters and Politics

HIRMER VERLAG

Bei einem beträchtlichen Teil der Plakate handelt es sich um eine Schenkung von Claus von der Osten. Das Museum für Kunst und Gewerbe Hamburg ist dem Sammler für die Unterstützung und langjährige Zusammenarbeit zu großem Dank verpflichtet.

A considerable number of the posters were donated by Claus von der Osten. The Museum für Kunst und Gewerbe Hamburg is profoundly grateful to this collector for his support and long-standing cooperation.

Alle abgebildeten Plakate befinden sich in der Plakatsammlung des Museums für Kunst und Gewerbe Hamburg / *All posters are from the poster collection of the Museum für Kunst und Gewerbe Hamburg*

mit Ausnahme von / *with the exception of:* Käthe Kollwitz (S. / *pp.* 20, 21), Oskar Kokoschka (S. / *p.* 26), Ben Shahn (S. / *p.* 33) Joan Miró (S. / *p.* 39), Andy Warhol (S. / *p.* 63), HAP Grieshaber (S. / *p.* 69).

Umschlagvorderseite / *Front cover:* Joan Miró, Helft Spanien / *Help Spain*, Paris 1937 (Detail aus / *Detail of* S. / *p.* 24)

Umschlagrückseite / *Back cover:* Robert Indiana, Hope, New York 2008 (S. / *p.* 166)

Vorsatzpapier / *Endpapers:* Yoko Ono, Imagine Peace, New York / Venedig / *Venice* 2003, Offset / *Offset print*, 28 × 43,5 cm

Frontispiz / *Frontispiece:* Pablo Picasso, Congrès Mondial des Partisans de la Paix / *World Congress of the Friends of Peace*, Paris 1949, Offset / *Offset print*, 60 × 40 cm

Buch

Dieses Buch erscheint anlässlich der Ausstellung / *This book is published on the occasion of the exhibition*

Phantasie an die Macht – Politik im Künstlerplakat / *Power to the Imagination – Artists, Posters and Politics*

Museum für Kunst und Gewerbe Hamburg, 18.3. – 13.6.2011

Galerie Stihl Waiblingen, 7.7. – 25.9.2011

Herausgegeben von / *edited by* Museum für Kunst und Gewerbe Hamburg

Idee und Text / *Concept and text:* Jürgen Döring
Mitarbeit / *With the collabration of:* Claus von der Osten

Projektmanagement / *Project management:* Karen Angne, Eva-Maria Loh (Assistenz / *Assistant*)
Übersetzung / *Translation:* Michael Robinson, London
Lektorat / *Copyediting:* Tanja Bokelmann, München / *Munich*; Christopher Murray, Liverpool; Danko Szabó, München / *Munich* (*Proofreading*)
Gestaltung / *Design:* Peter Grassinger

© 2011 Museum für Kunst und Gewerbe Hamburg, Hirmer Verlag GmbH, München / *Munich*, und der Autor / *and the author*

Bibliografische Information der Deutschen Nationalbibliothek: Die Deutsche Nationalbibliothek verzeichnet diese Publikation in der Deutschen Nationalbibliografie; detaillierte bibliografische Daten sind im Internet über http://dnb.d-nb.de abrufbar. / *Bibliographic information published by the Deutsche Nationalbibliothek: The Deutsche Nationalbibliothek lists this publication in the Deutsche Nationalbibliografie; detailed bibliographic data are available in the Internet at http://dnb.d-nb.de.*

ISBN 978-3-7774-3471-1 (dt.)
ISBN 978-3-7774-3881-8 (engl.)

Printed in Germany

www.hirmerverlag.de

Ausstellung

Museum für Kunst und Gewerbe Hamburg:

Direktorin / *Director:* Sabine Schulze
Kaufmännischer Geschäftsführer / *Managing director:* Udo Goerke
Sammlungsverwaltung / *Collection administrator:* Uta Jeschke
Reprofotografie / *Photo reproduction:* Maria Thrun
Leihverkehr / *Loan exchange:* Margit Tabel-Gerster
Technische Leitung / *Technical director:* Thomas Frey
Ausstellungstechnik / *Exhibition technology:* Alberto Polo Pallares, Damian Kowalczyk, Mike Meier, Gregorij Medvedev, Egon Busch
Ausstellungsgrafik / *Exhibition graphics:* Ahmed Salmann, Andreas Torneberg
Marketing / *Marketing:* Ulrike Blauth
Presse / *Press:* Michaela Hille
Vermittlung / *Procurement:* Nils Jockel, Jens Oestreicher
Veranstaltung / *Organization:* Bettina Schwab, Elcin Schütze

MK&G
MUSEUM FÜR
KUNST UND GEWERBE
HAMBURG

Galerie Stihl Waiblingen:

Leiterin / *Director:* Ingrid-Sibylle Hoffmann
Ausstellungskonzeption / *Exhibition concept:* Ingrid-Sibylle Hoffmann, Zara Reckermann
Presse- und Öffentlichkeitsarbeit / *Press and public relations:* Stephanie Hansen
Verwaltung / *Administration:* Doris Orgonas
Ausstellungstechnik / *Exhibition technology:* Stefan Heuer, Jürgen Griesheimer

Galerie Stihl Waiblingen

Zu sehr Kunst? 6 / *Too Much Like Art? 10*
→ Grosz, Heartfield, Beuys, Grafik Werkstatt Bielefeld, Rauschenberg, Troxler, Blais, Lemel

Revolution und Frieden 14 / *Revolution and Peace 15*
→ Steinlen, Pechstein, Kollwitz, Lissitzky, Cheremnyk, Miró, Shahn, Grieshaber, Kokoschka, Picasso, Erni

Protest 36 / *Protest 37*
→ Grieshaber, Miró, Matta, Self, Vedova, Aléchinsky, Appel, Jorn, Bazaine, Rebeyrolle, Calder, Lennon, Saint-Phalle, Rosenquist, Warhol, Vostell, Gianakos, Maciunas, Johns, Stella, Rauschenberg, Rivers, Flavin, Staeck, Lenk

Freiheit 66 / *Freedom 67*
→ Staeck, Grieshaber, Anuszkiewicz, Delaunay, Miró, Tàpies, Liberman, Arman, Bill, Youngerman, Pistoletto, Calder, Roth, Sonderborg, Hundertwasser, Lichtenstein, Oldenburg, van Bruggen, Saura, Lucebert, Vostell, Haring

Umwelt 96 / *Environment 97*
→ Lichtenstein, Rauschenberg, Trova, Jenkins, Haus-Rucker-Co, Beuys, Warhol, Tàpies, Haring, Hundertwasser, Fukuda, Farah

Gleiche Rechte 118 / *Equal Rights 119*
→ Holzer, Haring, Guerrilla Girls, Borofsky, Kruger, General Idea, Calle, Gerz, Ben, Zush, Wool, Kippenberger

Globalisierung 140 / *Globalization 141*
→ Haring, Rauschenberg, Lichtenstein, Sieverding, Abramović, Droese, Levine, Rosenbach, Lafontaine, Gonzalez-Torres, Rollins, Guerrilla Girls Broadband, Kelley, Serra, Rosler, Abidin, Kamerić, Nara, Indiana

Register / *Index* 167
Copyrights, Bildnachweis / *Picture credits* 168

ZU SEHR KUNST?

1949 entwarf Pablo Picasso, Mitglied der Kommunistischen Partei Frankreichs, das Plakat für den ersten internationalen Friedenskongress, zu dem europäische Kommunisten einluden (→ S. 2). Picasso wählte gemeinsam mit Louis Aragon, dem Vorsitzenden der Partei, das Motiv aus: eine weiße Taube, schlicht auf dem Boden stehend und in schwarzer Tusche lithografiert. Bis dahin war die Taube in der traditionellen Kunst ein Symbol des Heiligen Geistes gewesen. Mit einem Ölzweig im Schnabel war sie das Symbol der Versöhnung zwischen Gott und den Menschen, da sie einst Noah die frohe Botschaft vom Ende der Sintflut überbracht hatte. Nun wurde sie zur »Friedenstaube« – die weiße Taube, fliegend und ohne weitere Attribute, ist zu einem weltweit verständlichen Symbol geworden.

Seit Picasso nehmen Künstler aus aller Welt vermehrt mit Plakaten am politischen Geschehen ihrer Zeit teil; sie kritisieren, sie prangern an oder sie entwerfen das gute Gegenbild. Nur selten haben sie sich von Machthabern in den Dienst nehmen lassen. Eine bemerkenswerte Ausnahme bildeten die ersten Jahre nach der russischen Revolution, als Lenin revolutionären Enthusiasmus verbreitete und Künstler wie El Lissitzky (→ S. 22) und Alexander Rodtschenko die Parolen der Revolution propagierten. Seither haben sich die Künstler der Avantgarde von totalitären Regimes ferngehalten. Vielmehr entwarfen sie für die Entrechteten, sie zeichneten gegen Hunger, Krieg und Unterdrückung, für Menschenrechte und Umweltschutz und sahen sich auf der Seite des Volkes und nicht auf der Seite der Machthaber. Als Joan Miró 1937 sein Plakat gegen die spanischen Faschisten in einer Zeitschrift veröffentlichte, schrieb er handschriftlich darunter: »In dem aktuellen Kampf sehe ich auf der Seite der Faschisten nur Kräfte der Vergangenheit und auf der anderen Seite das Volk, dessen grenzenlose kreative Ressourcen Spanien einen Aufschwung geben werden, der die Welt erstaunen wird.« (→ S. 24)

Die Geschichte des politischen Plakates ist noch überraschend jung: Es dauerte fast ein Jahrhundert von der Einführung des modernen Bildplakates bis zum Erscheinen der ersten politischen Plakate. Diese kamen, abgesehen von wenigen Ausnahmen, erst mit dem Ersten Weltkrieg auf. Nach den kulturellen Plakaten – Theatertruppen und Buchverlage begannen in der ersten Hälfte des 19. Jahrhunderts mit Plakaten zu werben – und nach der Produktwerbung, die nach der Mitte des 19. Jahrhunderts im Plakat häufiger wurde, bildet die Politik den dritten großen Themenbereich des modernen Plakates.

Vorläufer gab es in Form von Zeitschriftenwerbung, deren politischer Standpunkt sich auch in Plakaten äußerte. So beginnt unsere Geschichte mit zwei Arbeiten von Théophile Alexandre Steinlen, einem politisch engagierten Künstler, der vor allem als Illustrator von Zeitschriften, als Karikaturist und Plakatkünstler bekannt wurde (→ S. 16, 17). Er war maßgeblich an der Verbreitung eines Bildrepertoires beteiligt, das später, mit der russischen Revolution, zum Inbegriff einer revolutionären Bilderwelt wurde.

Eugène Delacroix hatte 1830, unter dem Eindruck der Julirevolution in Paris, sein Gemälde »Die Freiheit führt das Volk« (»La Liberté guidant le peuple«) gemalt und damit den Prototyp des Revolutionsbildes geschaffen. Die Verkörperung der Freiheit ist stets weiblich, kraftvoll und weist den Weg in die Zukunft. Zu den Attributen dieser Allegorie gehören die rote Fahne, gesprengte Fesseln und wehende Haare. Sie ist eng verwandt mit den Personifikationen des Friedens und der Republik, die im 19. Jahrhundert das fortschrittliche Gegenbild zur Monarchie war. Diese Allegorien, die mit ihren Vorläufern weit in die europäische

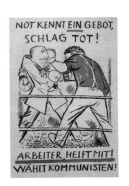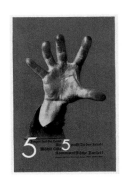

Kunstgeschichte zurückreichen, fanden über Steinlen ihren Weg in die revolutionäre Propaganda nach dem Ersten Weltkrieg. Und wenn Niki de Saint-Phalle eine ihrer Nanas, ihrerseits eine Verkörperung der modernen Frau, die Macht einfordern lässt (→ S. 51), so bewegt sie sich in derselben Tradition.

Plakate, die nicht von Grafikern oder Designern, sondern von bildenden Künstlern entworfen sind, fallen durch ihre individuelle Bildsprache auf, die nicht auf schnelle Lesbarkeit oder allgemeine Verständlichkeit ausgerichtet ist. Dies gilt auch für politische Künstlerplakate, die sich auf den ersten Blick von anderen politischen Plakaten unterscheiden, etwa von der Plakatpropaganda autoritärer Staaten oder auch von den oft langweiligen Wahlplakaten der westlichen Demokratien.

In der ersten Hälfte des 20. Jahrhunderts waren Künstlerplakate eher eine Ausnahme. Erst nachdem sie in Paris in den fünfziger Jahren mit großem Erfolg eingeführt worden waren, entwickelten sie sich in den sechziger Jahren zu einem regelmäßigen Begleiter des internationalen Kunstbetriebes. Zumeist warben die Plakate für eigene Ausstellungen der Künstler oder auch für andere kulturelle Veranstaltungen – und nur im Ausnahmefall ging es um politische Themen. Diese spielten erst im Protestjahr 1968 eine bedeutendere Rolle. Nun fühlte sich auf einmal eine größere Zahl von Künstlern genötigt, mit Plakaten Stellung zu nehmen. Themen waren der Vietnamkrieg, der Pariser Mai '68 und überhaupt ein Aufbegehren gegen die bewaffneten Mächte des Kalten Krieges.

Diese Protestzeit fand 1972 ihr Ende, als in den USA mit dem demokratischen Präsidentschaftskandidaten George McGovern und in Deutschland mit dem SPD-Kanzler Willy Brandt Ziele der Protestbewegungen ihren Weg in die offizielle Politik fanden. Dafür kamen neue Themen und neue Formen der Veröffentlichung auf. In zum Teil umfangreichen Plakatserien, veröffentlicht von der UNESCO oder von internationalen Menschenrechtsorganisationen, äußerten sich Künstler in den siebziger Jahren gegen die Apartheid in Südafrika, sie verurteilten die Folter in Südamerika oder setzten sich für die Selbstbestimmung des von Franco unterdrückten Katalonien ein. Ein großes neues Thema der siebziger und achtziger Jahre war der Umweltschutz. Wenig später kam die Forderung nach gleichen Rechten auf, nach der »politisch korrekten« Behandlung Andersdenkender und Benachteiligter. Das Ende des Kalten Krieges und ein neuer Blick auf den ganzen Erdball, in politischen Zusammenhängen als Globalisierung charakterisiert, schlugen sich auch in den Plakatthemen vieler Künstler nieder. Allen voran organisierte Robert Rauschenberg eine internationale, alle Feindschaften und Grenzen überschreitende Ausstellungstour. Das Goethe-Institut, eine deutsche Institution, die in vielen Ländern der Welt kulturell tätig ist, initiierte eine bemerkenswerte Serie von Großplakaten, die unter dem Motto »I am you« das Miteinander aller Menschen betonte (→ S. 151 ff.).

Der Gesellschaftskritiker George Grosz passte sich im Layout seines Entwurfs »Not kennt ein Gebot« (1922) anderen Wahlplakaten an, vertraute aber in der Zeichnung auf den Biss seines Striches. John Heartfield arbeitete in diesen Jahren als professioneller Grafikdesigner mit modernem Fotodesign und erfand einprägsame Motive wie »Fünf Finger hat die Hand« (1928).

Social critic George Grosz adapted himself to other election posters for the layout of his "Not kennt ein Gebot" ("Need knows one law," 1922), but relied on the bite in his line for the drawing. John Heartfield was working as a professional graphic designer using modern photographic design at this time, and invented striking motifs such as "Fünf Finger hat die Hand" ("The hand has five fingers," 1928).

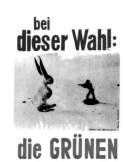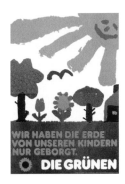

Freiheit – Gleichheit – Brüderlichkeit: Unter dieser Parole der französischen Revolution lassen sich auch heute noch die Inhalte dieser Künstlerplakate zusammenfassen. Gleiche Rechte, ein freiheitliches Leben und ein brüderlicher Umgang miteinander – derart idealistische Ziele muten angesichts unserer heutigen Welt romantisch und naiv an. Doch anders als Wahl- oder Propagandaplakate müssen die politischen Plakate von bildenden Künstlern sich nicht an realistische Ziele halten; sie müssen niemanden verherrlichen und nichts beschönigen. Sie können unabhängig von kommerziellen oder politischen Erwägungen Partei ergreifen, sie können motivisch und im Grunde genommen auch inhaltlich völlig frei mit dem Thema umgehen. Bemerkenswert dabei ist, dass das Engagement der modernen Künstler sich fast nie auf Seiten der Machthabenden findet. Anders als in der Welt der Politik, wo Interessengegensätze aufeinandertreffen und ausgefochten werden, scheint in der Welt der bildenden Kunst ein großer Konsens zu herrschen, der demokratische Rechte und die Freiheiten des Einzelnen zum Ziel hat.

Das Plakat mit der Beuys-Skulptur »Der Unbesiegbare« (1979, → S. 107) wurde von der Partei Die Grünen als Wahlplakat abgelehnt. Stattdessen ging die Partei mit dem rechts abgebildeten Motiv der Grafik Werkstatt Bielefeld in ihre ersten Wahlkämpfe, das sich positiv von den seriösen und langweiligen Plakaten der älteren Parteien absetzte.

The German Green Party rejected the poster with the Beuys sculpture "Der Unbesiegbare" ("The invincible one," 1979, → p. 107). Instead, the party went into its first election campaign with the motif by the Grafik Werkstatt Bielefeld (graphic art workshop) illustrated on the right, which distanced itself positively from the older parties' serious and boring posters.

Warum lässt sich ein arrivierter Künstler darauf ein, zu einem aktuellen und politischen Thema Stellung zu beziehen? Zeichnet sich nicht freie Kunst gerade dadurch aus, dass sie unabhängig von Auftraggebern entsteht? Zwar dürfte die Freiheit der formalen Gestaltung stets gegeben gewesen sein – denn welcher Auftraggeber schreibt heute noch einem Künstler seine Motive vor – doch bleibt es eine Tatsache, dass, angefangen von den Expressionisten in den zwanziger Jahren bis zu den Konzeptkünstlern von heute, die Künstler hier zu Themen Stellung nehmen, die an sie herangetragen wurden. Sie wurden gebeten, mit ihren besonderen Fähigkeiten eine Veranstaltung anzukündigen oder sich gegen konkrete Ungerechtigkeiten auszusprechen. Normalerweise ist dies die Aufgabe von Grafikdesignern, zu deren Profession es gehört, Inhalte in einer gleichermaßen prägnanten wie allgemein verständlichen Weise auszudrücken.

Dagegen spricht aus den politischen Künstlerplakaten der Individualismus der modernen Kunst. Schwerlich erhöht dies die Verständlichkeit der Bildsprache. Das bekam Joseph Beuys zu spüren, der als Gründungsmitglied der Partei Die Grünen ein Wahlplakat entwarf, das von der Mehrheit der Partei abgelehnt wurde: »Nun, was das Plakat betrifft, so mussten wir schnell feststellen, dass die meisten anderen Grünen ganz andere Plakate bevorzugten. Unseres war ihnen zu ›abgehoben‹, zu ›unpolitisch‹, zu sehr ›Kunst‹ und nach ihrer Meinung eher Wähler abschreckend.« (Johannes Stüttgen, Zeitstau. Im Kraftfeld des erweiterten Kunstbegriffs von Joseph Beuys, Stuttgart 1988, S. 133) Die junge Partei entschied sich schließlich für ein von scheinbar fröhlicher Kinderhand bunt gemaltes Sonnenblumen-Plakat, das sehr schnell eine Popularität erlangte, die der intellektuelle Entwurf von Beuys nie hätte erreichen können.

»Zu sehr Kunst« – dieses Etikett könnte über vielen der Plakate in diesem Buch stehen. So stieß die Plakatserie »I am you« des Münchener Goethe-Institutes, die, anders als die meisten der hier ausgewähl-

ten Plakate, tatsächlich plakatiert wurde, auf einiges Befremden. Die zwanzig Großflächenplakate wurden in der deutschen Provinz, aber auch in Ulan Bator oder auf der Potemkinschen Treppe in Odessa gezeigt. Während die Veranstalter ihr Anliegen, »gegen Intoleranz und Fremdenhass« aufzutreten, vermitteln konnten, standen Passanten, die den Umgang mit zeitgenössischer Kunst nicht gewohnt waren, der Bildsprache der meisten Kompositionen mit Befremden gegenüber und äußerten dies auch. Offenbar sind die Erwartungshaltungen an Bilder im öffentlichen Raum anders als an solche, denen man im Museum begegnet. Bei öffentlich ausgehängten Plakaten wird Verständlichkeit erwartet. Ähnlich wie in der kommerziellen Werbung rechnet der Betrachter mit lesbaren Slogans und klaren Motiven, die sich aufeinander in einer Weise beziehen, die sofort zu entschlüsseln ist. Eine solche Eindeutigkeit liefern Künstlerplakate allerdings nur im Ausnahmefall. Viel häufiger irritieren sie, regen an, schaffen Neugier.

Plakate sind ein öffentliches Medium, und auch wenn die vorliegenden Beispiele eher den Sammler und Liebhaber interessieren, so bleibt doch der öffentliche Charakter des Plakates bestehen, sein Anspruch zu werben und zu verkünden. Viele Künstler setzen sich mit dieser besonderen Funktion des Plakates auseinander, nutzen neben dem Bild auch die Schrift oder wählen eine Bildsprache, die auf Fernsicht und Verständlichkeit ausgerichtet ist.

Nicht immer allerdings bearbeiten Künstler ein vorgegebenes Thema auch inhaltlich; mitunter stellen sie einfach ein Werk aus ihrer aktuellen Schaffensphase zur Verfügung, das motivisch wenig mit dem Anlass zu tun hat. Dennoch mag der bekannte Name des Künstlers helfen, ein Anliegen zu finanzieren oder ihm mehr Gewicht zu verleihen. Andererseits gab es Künstler, die aus eigenem Antrieb ihre Entwürfe veröffentlichen, um sich im traditionellen Sinne »einzumischen«, um Partei zu ergreifen, aufzurütteln und zu mahnen. Das tat beispielsweise Oskar Kokoschka mit seinem Plakat für die hungernden Kinder, das er nach dem Zweiten Weltkrieg auf eigene Kosten in der Londoner U-Bahn plakatieren ließ, oder auch Richard Serra mit seinen aggressiven Plakaten gegen die Wiederwahl von George W. Bush, die der Künstler über das Internet verbreitete.

Die Themen, genauer gesagt die Anlässe der Plakate, sind stets bekannt, und man fühlt sich daher auch bei Künstlern zu Interpretationen herausgefordert, die sich sonst mit ihrem Werk einer konkreten Deutung widersetzen. Ein gutes Beispiel hierfür ist das Amnesty-International-Plakat von Max Bill (→ S. 83), dessen schwarze Flächen sich auf einmal als Mauern um die – für das Leben stehenden – Farben verstehen lassen. Andere Künstler wiederum, denen der jeweilige Anlass ihres Plakates offenbar am Herzen liegt, liefern überraschende Entwürfe, die sich in ihrer Gegenständlichkeit und Eindeutigkeit weit von ihrem übrigen Œuvre entfernen – Alexander Calder oder auch Roy Lichtenstein wären Beispiele hierfür (→ S. 85 und 98).

Der besondere Reiz der Plakate, die in diesem Buch vorgestellt werden, liegt vielleicht gerade in ihrem eindeutigen thematischen Bezug. Er stellt die Werke von vielen der großen Künstler der Moderne in einen anderen Kontext und erlaubt auf diese Weise überraschende Vergleiche. Zugleich bietet sich dem Betrachter ein neuer und erfrischender Blick auf die Protest- und Oppositionsbewegungen der vergangenen sechzig Jahre.

In 1949, Pablo Picasso, a French Communist Party member, designed the poster for the first World Peace Congress, held in Paris by the European communist movement (→ p. 2). He and Louis Aragon, poet and leading Party member, agreed that the motif of the poster should be a white dove, standing on the ground and executed as a black-ink lithograph. The dove had traditionally been a symbol of the Holy Spirit, and a dove clasping an olive branch as the symbol of reconciliation between God and humankind, for such a dove had brought Noah the good news that the Flood had abated. Now it became "the dove of peace" – and a white dove, shown flying and with no other attributes, has become a globally recognized symbol.

Since Picasso, artists all over the world have increasingly used the medium of the poster to address the political events of their day – criticizing, satirizing, or depicting a positive alternative. They have rarely worked on behalf of those in power – with the exception of the first few years following the Russian Revolution, when Lenin was working to instill revolutionary enthusiasm and artists like El Lissitzky and Alexander Rodchenko helped to disseminate revolutionary slogans. Since then, avant-garde artists have distanced themselves from totalitarian regimes. Instead, they have worked for the disenfranchised, using their designs to attack the evils of hunger, war, and oppression, and to promote human rights and environmentalism, consistently seeing themselves on the side of the people rather than those in power. In 1937, when Joan Miró published his anti-fascist poster in a magazine, he wrote underneath: "In the current battle, the only powers I see on the fascist side are the forces of the past, whereas on the other side are the people, whose boundless creative resources will bring a new dawn to Spain that will astonish the world."

The political poster has a surprisingly short history. After the emergence of the modern poster, almost a century went by before the first political posters appeared. With a few exceptions, this was not until the First World War. This makes politics the third major theme of modern posters, after cultural events (theater troupes and book publishers began advertising by poster in the first half of the 19th century) and advertisements for products, which became common from the mid-19th century onwards.

The forerunners of political posters were magazine advertisements in the form of posters that expressed the magazine's political outlook. Our story therefore begins with two works by Alexandre Steinlen, a politically aware artist best known for his work as a magazine illustrator, caricaturist, and poster artist. He was instrumental in popularizing a repertoire of images which, after the Russian Revolution, became the epitome of revolutionary imagery.

Eugène Delacroix painted his "Liberty Guiding the People" ("La Liberté guidant le peuple") inspired by the July Revolution in Paris. It was to become the prototype of all revolutionary images. The personification of freedom is always female and strong, pointing the way to the future. This allegorical figure's attributes are the red flag, burst fetters, and streaming hair, and she is closely akin to the personifications of Peace and of the Republic that represented a progressive alternative to monarchy in the 19th century. Through the designs of Steinlen, these allegorical figures, whose forerunners stretch far back into European art history, found their way into post-First World War revolutionary propaganda. With her figure of Nana, an embodiment of the modern woman confidently stating her claim to power, French artists Niki de Saint-Phalle still followed the same tradition (→ p. 51).

Posters designed by artists and not by graphic designers generally stand out through their use of an individual visual language not easily read or widely understood. The same is true of political posters by artists: they are clearly different from other political posters, such as the propaganda posters of authoritarian states or the generally dull election posters of Western democracies.

During the first half of the 20th century, posters by artists were very rare, and only after they were successfully introduced in Paris in the 1950s did they become, during the 1960s, a regular feature of the international art scene. They usually announced the artists' own exhibitions or other cultural events; they very seldom dealt with politics. It was only in 1968 – a year marked by protests – that political posters became really significant. Suddenly, a large number of artists felt compelled to make statements in the form of posters, on themes including the Vietnam War, May '68 in Paris, and the general resentment against the armed powers involved in the Cold War.

This period of protest came to an end in 1972: with the election of the Democratic presidential candidate George McGovern in the USA and the new SPD (Social Democratic Party) Chancellor Willy Brandt in Germany, the aims of the protest movements became more integrated into mainstream politics. New themes and new forms of publishing emerged for posters by artists. During the 1970s, UNESCO and international human rights organizations published several series of posters (sometimes very extensive) in which artists attacked South African apartheid, condemned torture in South America, or declared support for the autonomy of the people of Catalonia, who were oppressed by General Franco. One major new theme that became prevalent in the 1970s and 1980s was the environment. It was followed, a little later, by demands for equal rights and for the "politically correct" treatment of dissidents and those subject to discrimination. The end of the Cold War, and a new perspective on the world, which in political terms was called globalization, also found expression in many posters by artists. Most notably, Robert Rauschenberg organized an international exhibition tour that disregarded all national boundaries and political enmities. The Goethe-Institut (a German institution that undertakes cultural activities in countries all over the world) sponsored a remarkable series of large posters entitled "I Am You" to promote the fellowship of all human beings (→ pp. 151 – 154).

The slogans of the French Revolution – freedom, equality, and fraternity – still accurately summarize the content of these posters by artists. Such ideals seem almost romantic and naive when we look at what the world is like today. But unlike election or propaganda posters, political posters by artists do not need to aim at realistic goals; they do not have to glamorize anyone or gloss over anything. They are free to take sides independently of commercial or political considerations, and can address their theme using any motif and (in theory) any content they choose. Nevertheless, it is important to note that modern artists almost never side with those in power. Unlike in the world of politics, where different interests collide and need to

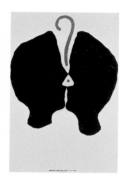
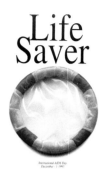

Das Künstlerplakat von Jean-Charles Blais aus der Serie gegen Aids »Images pour la lutte contre le Sida« (1993) erscheint im Vergleich zum Aids-Plakat »Lebensretter« (1993) des israelischen Designers Yossi Lemel mit seiner sinnfälligen Kombination aus Kondom und Rettungsring schwer verständlich.

Jean-Charles Blais' artist's poster from the anti-AIDS series "Images pour la lutte contre le Sida" ("Images for the battle against Aids," 1993) seems difficult to understand in comparison with the "Life Saver" (1993) AIDS poster by the Israeli designer Yossi Lemel with its lucid combination of condom and lifebelt.

be negotiated, among artists there seems to be a consensus to support democratic rights and individual freedoms.

What might lead an already successful artist to take a position on a topical political theme? Is not free art, by definition, independent of any kind of commission? Certainly artists have always retained their creative freedom (no one commissioning an art work today would demand that the artist use a certain motif), but the fact remains that the artists who created these posters – from the Expressionists of the 1920s to the Conceptual artists of the present day – were commenting on subjects that had been proposed to them. They were asked to use their talents to announce an event or to protest against an injustice. Normally this is the job of graphic designers, whose profession it is to express a certain content in a concise and at the same time comprehensible way.

On the other hand, political posters by artists have the individualistic character of modern art – which does not always make their visual language easy to understand. Joseph Beuys experienced this when, as a founder member of Die Grünen (the German Green Party), he designed an election poster that was rejected by the party in a majority vote. "When it came to the poster, it soon became clear that most Greens preferred a very different kind. Our poster was 'too aloof,' 'too un-political,' and 'too arty,' and they felt that it would be more likely to put voters off." (Johannes Stüttgen, "Zeitstau. Im Kraftfeld des erweiterten Kunstbegriffs von Joseph Beuys", Stuttgart 1988, p. 133). In the end, the young party chose a brightly colored sunflower poster which, resembling a child's cheerful doodle, rapidly achieved a popularity that Beuys' intellectual design could never have equaled.

The phrase "too much like art" could describe many of the posters in this book. For instance, the "I Am You" poster series commissioned by the Munich Goethe-Institut – which, unlike most of the posters shown here, were actually displayed in the street – had a rather alienating effect. The 20 large-size posters were shown not only all over Germany, but also in Ulan Bator and on the Odessa Steps. While these posters allowed the sponsors to make their statement "against intolerance and xenophobia," people with no knowledge of modern art often expressed their bewilderment when confronted with the designs. Obviously, expectations are different for images in a public space than for those in a museum. Publicly displayed posters are expected to be easy to understand. Viewers expect legible slogans and clear motifs, as with commercial adverts, in which the relationship between text and image is unambiguous. Artists' posters rarely display this kind of explicit message; they are more likely to provoke, intrigue, arouse curiosity.

Posters are a public medium. Although the posters presented here are more likely to appeal to collectors and enthusiasts, they still have the public function of getting a message across. Many of the artists have responded to the specific functions of the poster medium by using text with their images, or by employing images that can be seen from a distance and are readily comprehended.

Artists don't always create special images for a topic; sometimes they simply offer one of their recent works. The motif may have little to do with the cause, but the name of a well-known artist may still help to raise funds for a campaign or to give it a higher profile. On the other hand, there are artists who publish their designs on their own initiative. This is an "intervention" in the traditional sense – taking sides, agitating, criticizing. Examples include Oskar Kokoschka's poster from the post-Second World War period to raise awareness of starving children, which he had posted up in the London Underground at his own expense, or Richard Serra's aggressive posters campaigning against the reelection of George W. Bush, which Serra distributed via the Internet.

We always know the theme of these posters, or rather the purpose for which they were created. This means that one feels obliged to attribute meaning to the works of artists whose art usually defies a definite interpretation. A good example of this is the Amnesty International poster by Max Bill (→ p. 83), whose black areas are immediately recognizable as walls surrounding colors that represent life. And then there are artists who are clearly committed to the cause and who create surprisingly explicit and unambiguous images very different from their usual works – Alexander Calder and Roy Lichtenstein are cases in point (→ p. 85 and p. 98).

Perhaps the greatest appeal of the posters presented in this book is precisely this: the fact that they deal unambiguously with a certain theme. This places the work of many of the greatest artists of the 20th century in a new context, creating surprising contrasts. At the same time, they present a new and refreshing view of the protest and opposition movements of the past 60 years.

REVOLUTION UND FRIEDEN

»Kunst ist ein Hammer, mit dem man die Welt trifft – und nicht ein Spiegel, der sie reflektiert« – so sah es Wladimir Majakowski, der große Dichter und Propagandakünstler der russischen Revolution. Wie andere Künstler, die sich den Zielen der russischen Revolution verschrieben hatten und forderten, die Staffelei in die Ecke zu stellen, suchte er mit seinen Propagandawerken, vor allem den so genannten ROSTA-Fenstern, eine Bildform zu entwickeln, die verständlich und einprägsam, aber auch leutselig und humorvoll war. Formal orientierte er sich am russischen Bilderbogen, dem Lubok, und verband dessen Volkstümlichkeit mit einer modernen Figurensprache. Hinzu kam eine äußerst innovative Form der Herstellung – angesichts der extremen Mangelwirtschaft während des russischen Bürgerkrieges musste alles improvisiert und von Hand produziert werden.

Die namhaften russischen Künstler, von El Lissitzky und Alexander Rodtschenko bis zu Wassily Kandinsky und Marc Chagall – die beiden letzteren aus Westeuropa heimgekehrt, um das neue Regime zu unterstützen – waren die einzigen Vertreter der Avantgarde im 20. Jahrhundert, die ihre Kunst bewusst in den Dienst der eigenen Regierung stellten. Dies geschah zu einer Zeit, als die russische Revolution noch Hoffnungsträger war und der Hunger von Millionen noch Sinn zu machen schien. Auch in Deutschland unterstützten fortschrittliche Künstler die Kommunistische Partei und die Ziele der Kommunistischen Internationalen, um die Gesellschaft zu verändern. Heinrich Vogeler reiste in die junge Sowjetunion und George Grosz entwarf ein Wahlplakat für die KPD, wie es radikaler kaum hätte ausfallen können. Später wurde Grosz in die Sowjetunion eingeladen. Nachdem er das Land in eigener Anschauung erlebt hatte, entfernte er sich mehr und mehr von der konkreten Parteipolitik.

Als Picasso nach dem Zweiten Weltkrieg Plakate für die internationalen Friedenskongresse und damit letztendlich für kommunistische Auftraggeber entwarf, geschah dies unter ganz anderen Voraussetzungen. Den Zweiten Weltkrieg hatte der Künstler als eine der Leitfiguren der Avantgarde in Paris ausgeharrt und der deutschen Besatzung getrotzt. Den Kommunisten rechnete er es hoch an, dass sie nicht mit den Faschisten paktiert hatten und trat nach Kriegsende in die Partei ein. Auch als er merkte, dass seine Kunst nicht der Doktrin des Sozialistischen Realismus entsprach und auf wenig Gegenliebe stieß, entwarf er weiterhin die Plakate für die internationalen Friedenskongresse. Seine Plakate mit den »Friedenstauben«, wie sie schon bald hießen, wurden international zu einem Bild für eine neue Welt, in der der Krieg verurteilt wurde.

Politische Plakate von bildenden Künstlern bleiben allerdings, sieht man einmal von Picasso – oder in den USA von Ben Shahn und in Deutschland von HAP Grieshaber – ab, bis weit in die sechziger Jahre hinein eine Ausnahme.

REVOLUTION AND PEACE

According to Vladimir Mayakovsky, the great poet and propaganda artist of the Russian Revolution, "Art is not a mirror to hold up to society, but a hammer with which to shape it." Like other artists who subscribed to the aims of the Russian Revolution and wished to set the easel aside, he wanted to develop a pictorial form for his propaganda works that would be crystal clear and hard-hitting, but also affable and humorous. This is demonstrated particularly clearly by the so-called ROSTA windows. The style is based on the Russian popular print or "lubok," uniting this folk tradition with a modern figural language. To this he added a very innovative manufacturing technique – due to severe shortages during the Russian Civil War, everything had to be improvised and produced by hand.

Renowned Russian artists, from El Lissitzky and Alexander Rodchenko to Wassily Kandinsky and Marc Chagall (the last two returned to Russia from Western Europe to support the new regime), were the only 20th-century avant-garde artists who consciously placed their art at the service of their government. This happened at a time when the Russian Revolution was still seen as the great hope for humanity, and the hunger of millions still made sense. There were also progressive artists in Germany who supported the Communist Party and the aims of the Communist International (Comintern) in seeking to transform society. Heinrich Vogeler travelled to the Soviet Union in its early days, and George Grosz designed an election poster for the KPD (German Communist Party) that could hardly have been any more radical. Grosz was later invited to visit the Soviet Union. After he had seen the country for himself, however, he increasingly distanced himself from party politics.

When Picasso designed posters for the World Peace Congress in the years following the Second World War, and so ultimately for communist clients, conditions were very different. The artist had spent the Second World War as a leading figure of the Paris avant-garde scene, braving the German occupation. The communists had gained his respect by refusing to make a pact with the fascists, and he became a member of the party after the war. Despite realizing that his art was not compatible with the doctrines of Socialist Realism and therefore unwelcome, he continued to design posters for the International Peace Congress. His "dove of peace" posters, as they came to be known, became an international symbol for a new world with no place for war.

However, apart from Picasso – and Ben Shahn in the USA and HAP Grieshaber in Germany – political posters by artists were rare until well into the 1960s.

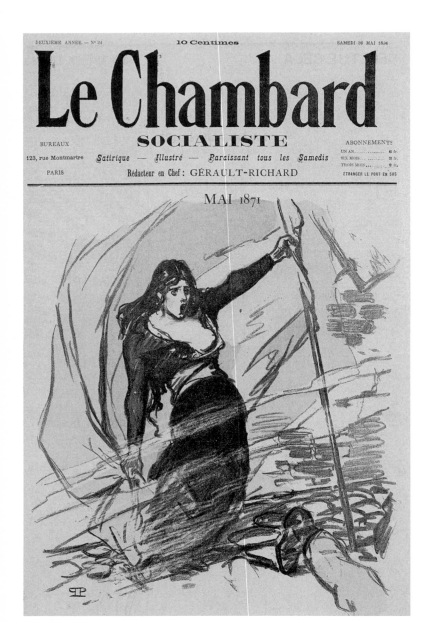

DEUXIÈME ANNÉE. — N° 24

10 Centimes

SAMEDI 26 MAI 1894

Le Chambard
SOCIALISTE

BUREAUX

123, rue Montmartre

PARIS

Satirique — Illustré — Paraissant tous les Samedis

Rédacteur en Chef : GÉRAULT-RICHARD

ABONNEMENTS

UN AN.............. **6 fr.**
SIX MOIS............ **3 fr.**
TROIS MOIS **2 fr.**

ÉTRANGER LE PORT EN SUS

MAI 1871

Théophile Alexandre Steinlen
(1859–1923)

Titelseite der Zeitschrift »Le Chambard
Socialiste« zum 1. Mai / *Title page of
the magazine "Le Chambard Socialiste",
May 1*
Paris 1894
Lithografie, schablonenkoloriert / *Litho-
graph, colored stencil*, 50 × 34 cm

1890 wurde der 1. Mai als Tag der
Arbeiter ausgerufen. Steinlen feiert
ihn auf der Mai-Ausgabe der linken
satirischen Zeitschrift »Le Chambard
Socialiste« mit einer heldenhaften Frauen-
gestalt auf den Barrikaden – zur Erinne-
rung an den Maiaufstand der Pariser
Kommune 1871. Zeitschriftentitel wie
dieser sind als Vorläufer des politischen
Plakates anzusehen.

*In 1890, the May 1 was declared Inter-
national Workers' Day. Steinlen cele-
brated it in the May edition of the left-
wing satirical magazine "Le Chambard
Socialiste" with an image of a heroic
female figure on the barricades, to
commemorate the May rising of the
Paris Commune in 1871. Posters for
magazines like this can be seen as the
forerunners of the political poster.*

Théophile Alexandre Steinlen
(1859–1923)

Le Petit Sou
Paris 1900
Lithografie / *Lithograph*, 203 × 100 cm

Auf diesem Plakat für eine politische
Zeitschrift tritt die Personifikation der
Freiheit mit der phrygischen Mütze
auf und gibt sich damit zugleich als
»La République« zu erkennen, als Ver-
körperung der französischen Republik.
Sie führt das Volk zum Sturm auf die
Kirche Sacré-Cœur, die damals mitten
in das Pariser Arbeiterviertel Montmartre
hineingebaut und als Symbol der staat-
lichen Repression gesehen wurde.

This poster for a political magazine
shows a personification of freedom.
Her Phrygian cap tells us that she is
also La République, the embodiment
of the French Republic. She is leading
the people as they storm the Sacré-
Cœur Basilica in Paris, which was
being built at the time in the center of
the working-class district of Montmartre
and which was seen as a symbol of
official repression.

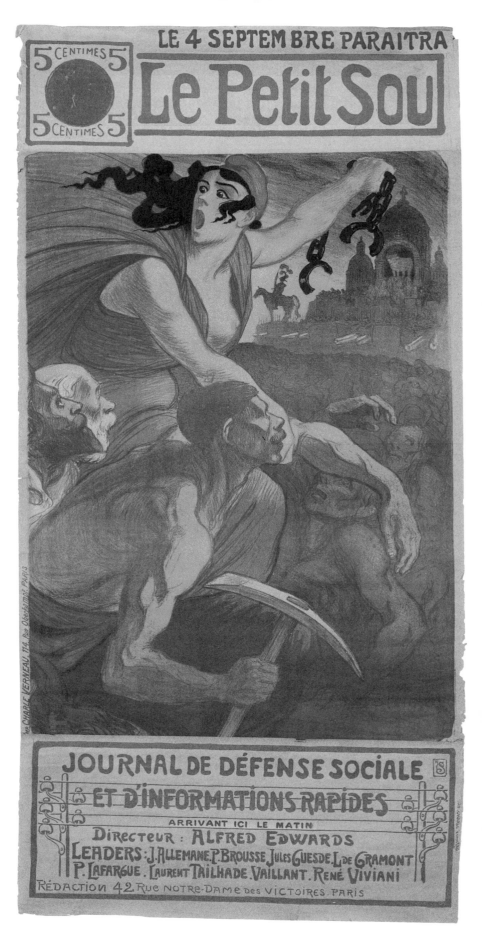

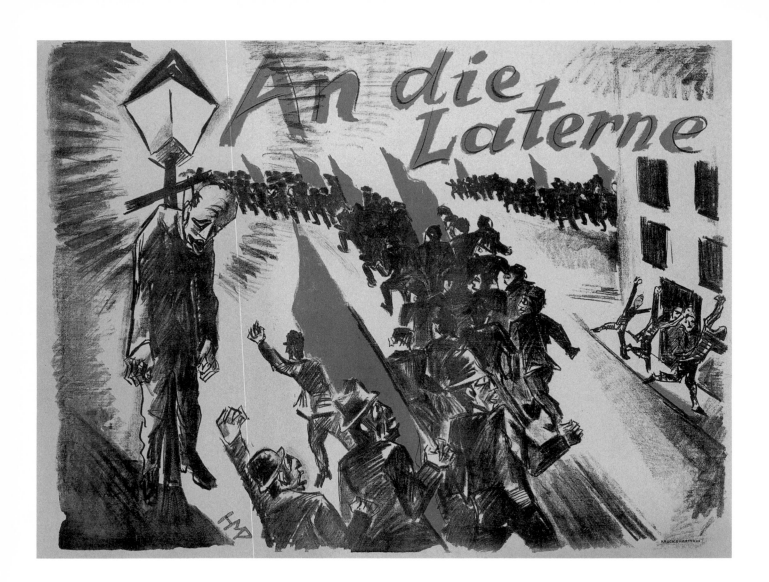

Max Pechstein (1881–1955)

An die Laterne / *To the Lamp Post*
Berlin 1919
Lithografie / *Lithograph*, 72,5 × 95 cm

Das Plakat wirbt für eine anarchistische Zeitschrift, die nach dem Ersten Weltkrieg in wenigen Ausgaben in Berlin erschien. Während der Novemberrevolution nach dem Ersten Weltkrieg und in den Monaten danach herrschte in der zukünftigen Weimarer Republik eine allgemeine Aufbruchstimmung, die auch anarchistische Züge tragen konnte.

An advertisement for an anarchist magazine, this poster was published on a small scale in Berlin after the First World War. During the November Revolution that followed the War, and also during the subsequent months, there was a general spirit of unrest in what was to become the Weimar Republic that sometimes expressed itself in the rise of anarchist movements.

Max Pechstein (1881–1955)

Die Nationalversammlung – der Grundstein der Deutschen Sozialistischen Republik / *The National Assembly – The Foundation Stone of the German Socialist Republic*
Berlin 1919
Lithografie / *Lithograph*, 67,5 × 45 cm

Dieser Aufruf zur ersten Wahl im Deutschen Reich nach dem Ersten Weltkrieg erschien im »Werbedienst der Deutschen Republik«, dem offiziellen Verlag der Übergangsregierung nach der Kapitulation. Der Maurer, der zur Kelle greift und zur Mitarbeit auffordert, nimmt die Haltung des aus seinem Grabe auferstehenden Christus ein.

This poster urging people to vote in the first German election after the First World War appeared in the "Werbedienst der Deutschen Republik," the official mouthpiece of the transitional government that took over after Germany's surrender. The builder, who is picking up his trowel and urging the viewer to join in the task, has adopted the posture of the resurrected Christ.

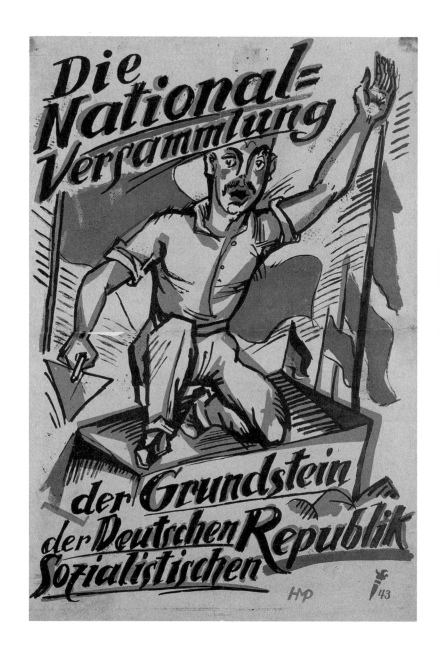

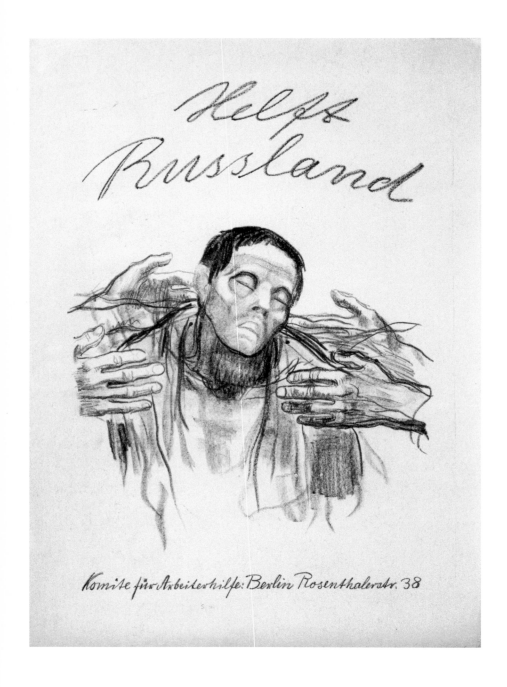

Käthe Kollwitz (1867–1945)

Helft Russland / *Help Russia*
Berlin 1921
Lithografie / *Lithograph*, 73 × 47,5 cm

Käthe Kollwitz' Entwurf diente als
Spendenaufruf für die Internationale
Arbeiterhilfe (IAH), eine Organisation
der Kommunistischen Partei, die in den
zwanziger Jahren Sozialleistungen für
Arbeiter bereitstellte und auch Gelder
für Russland sammelte.

Käthe Kollwitz' design calls for dona-
tions for the Workers' International
Relief (WIR), a Communist Party
organization of the 1920s that provided
social services for workers and also
collected money to send to Russia.

Käthe Kollwitz (1867–1945)

Nie wieder Krieg / *Never Again War*
Berlin 1924
Lithografie / *Lithograph*, 94 × 69,5 cm

Zehn Jahre nach Ausbruch des Ersten
Weltkrieges – in dem Käthe Kollwitz
ihren Sohn verlor – erschien dieses
Plakat zur Ankündigung eines Mittel-
deutschen Jugendtages. In den fünfziger
Jahren wurde es zum Antikriegsplakat
schlechthin.

Ten years after the outbreak of the
First World War – during which Käthe
Kollwitz lost her son – this poster
announced a youth meeting in central
Germany. Since the 1950s it has be-
come one of the most famous antiwar
posters.

Nie wieder Krieg

Mitteldeutscher Jugendtag
Leipzig 2.–4. August 1924

Kollwitz

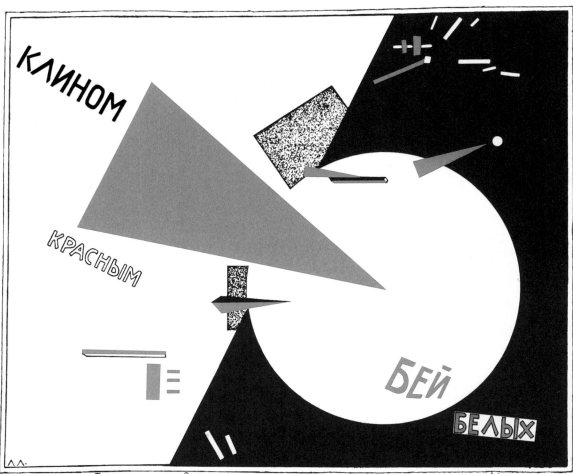

КЛИНОМ КРАСНЫМ БЕЙ БЕЛЫХ

El Lissitzky (1890–1941)

Schlagt die Weißen mit dem roten Keil /
Strike the Whites with the Red Wedge
Moskau / *Moscow* 1920
Offset / *Offset print*, 49 × 69,5 cm

Der avantgardistische Entwurf, der den
Sieg der roten Bolschewisten über die
Menschewisten (die Weißen) fordert,
wurde seinerzeit nicht verbreitet und ist
nur durch einen Nachdruck der DDR
aus den sechziger Jahren erhalten.
Die Vorlage zeichnete der Typograf Jan
Tschichold nach einer Skizze Lissitzkys.

*This avant-garde design calling for
the "red" Bolsheviks to vanquish the
"white" Mensheviks was never distrib-
uted, and has survived only as a copy
from the German Democratic Republic
of the 1960s. It was drawn by the
typographer Jan Tschichold, who based
his design on a sketch by Lissitzky.*

Mikhail Cheremnykh
(1890–1962)

Kampf der Kartoffelfäule – »ROSTA-
Fenster« / *Fight Potato Blight – "ROSTA
window"*
Moskau / *Moscow* 1920
Schablonendruck in 12 Teilen / *Stencil
print in 12 parts*, zusammen / *in total*
204 × 159 cm, abgebildet sind die
Teile / *illustrated here are parts* 1, 2, 4,
5, 9, 10

ROSTA-Fenster hießen die in den
nach der russischen Revolution oft leer
stehenden Schaufenstern ausgehängten
Parteiparolen, die durch die Russische
Telegrafen-Agentur (ROSTA) verbreitet
wurden. Ein Künstlerkollektiv, zu dem
neben Cheremnykh auch Majakowski
gehörte, setzte die Parolen der Partei-
führung in Bildszenen um, die sich
stilistisch am russischen Bilderbogen,
dem Lubok, orientieren.

*The posters with party slogans pro-
duced by the Russian telegraph agency
(ROSTA) and hung in shop windows
(often empty of products in the period
following the Russian Revolution) were
known as "ROSTA windows." An artists'
collective, which included Mayakovsky
as well as Cheremnykh, took slogans
devised by the party leadership and
created images to accompany them in
the style of traditional Russian prints
(lubki).*

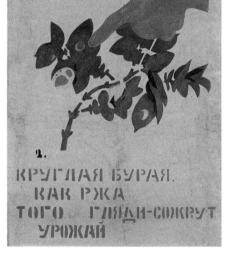

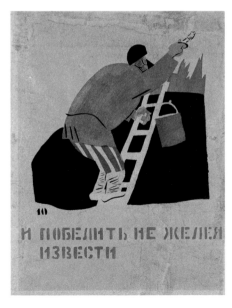

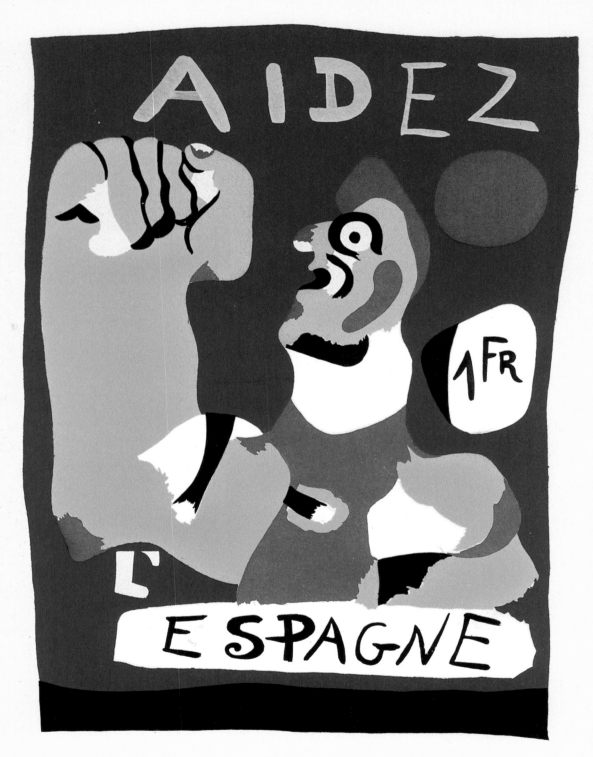

Dans la lutte actuelle, je vois du côté fasciste les forces
périmées, de l'autre côté le peuple dont les immenses ressources
créatrices donneront à l'Espagne un élan qui étonnera
le monde.
 Miró.

Joan Miró (1893–1983)

Helft Spanien / *Help Spain*
Paris 1937
Pochoir-Druck / *Pochoir print,*
31,7 × 24,5 cm

Das kleine Plakat mit dem katalanischen Bauern wurde für einen Franc verkauft, um mit dem Erlös die republikanische Regierung im Bürgerkrieg gegen die Faschisten unter Franco zu unterstützen. Im spanischen Pavillon der Pariser Weltausstellung von 1937 hingen Monumentalgemälde von Picasso (»Guernica«) und Miró (»Katalanischer Bauer in Aufruhr«).

This small poster showing a Catalan farmer was sold for one French franc to raise funds to support the republican government against Franco and the fascists in the Spanish Civil War. The Spanish Pavilion at the Paris World Exhibition of 1937 contained monumental paintings by Picasso ("Guernica") and Miró ("Revolt of Catalan Peasants").

Ben Shahn (1898–1969)

Das ist Nazi-Brutalität / *This is Nazi brutality*
New York 1942
Offset / *Offset print,* 98 × 72 cm

Auf dem Telegrammstreifen wird die Ermordung aller Männer im tschechischen Dorf Lidice bekannt gegeben – eine Strafaktion der deutschen Faschisten, die anschließend auch das Dorf zerstörten und ihre Tat per Telegramm bekannt gaben.

The telegraphic strip announces the murder of all the men in the Czech village of Lidice, a punitive action by the German forces, who then destroyed the village and announced what they had done by telegram.

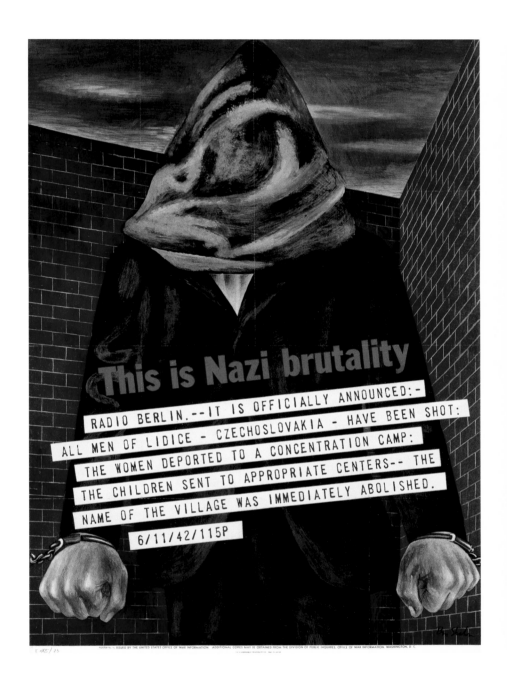

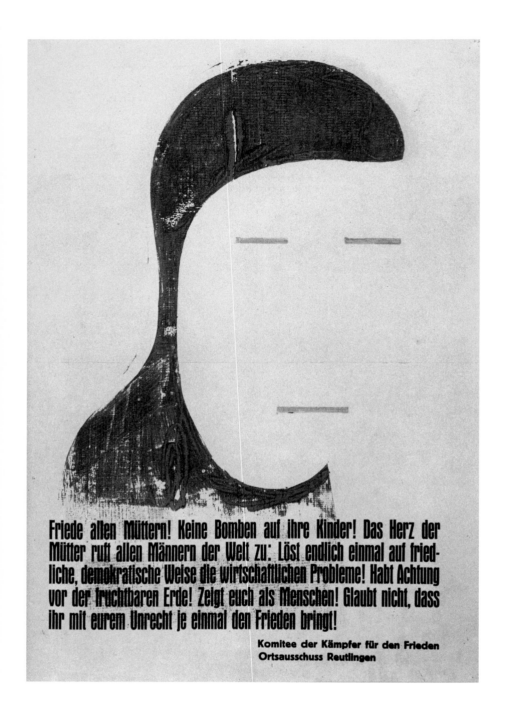

Friede allen Müttern! Keine Bomben auf ihre Kinder! Das Herz der Mütter ruft allen Männern der Welt zu: Löst endlich einmal auf friedliche, demokratische Weise die wirtschaftlichen Probleme! Habt Achtung vor der fruchtbaren Erde! Zeigt euch als Menschen! Glaubt nicht, dass ihr mit eurem Unrecht je einmal den Frieden bringt!

Komitee der Kämpfer für den Frieden
Ortsausschuss Reutlingen

HAP Grieshaber (1909–1981)

Friede allen Müttern! Keine Bomben auf ihre Kinder! / *Peace for All Mothers! Drop No Bombs on Their Children!*
Reutlingen 1950
Holzschnitt / *Woodcut*, 80 × 60 cm

Grieshaber schuf den Holzschnitt in der Nacht vom 25. Juni 1950, als der Koreakrieg ausbrach. Er allein bildete das »Komitee der Kämpfer für den Frieden« und den Ortsausschuss.

Grieshaber created this woodcut during the night of June 25, 1950, the day the Korean War broke out. He was the sole member of the "Committee of Fighters for Peace" and of its local branch.

Oskar Kokoschka (1886–1980)

Zum Gedenken an die Kinder von Wien, die an Hunger gestorben sind /
In Memory of the Children of Vienna Who Died of Hunger
London 1946
Lithografie / *Lithograph*, 76 × 50,5 cm

Kokoschka ließ dieses Plakat, das in einer englischen und in einer – für Südamerika vorgesehenen – spanischen Version existiert, auch als Strichätzung vervielfältigen und auf eigene Kosten in der Londoner U-Bahn plakatieren.

Kokoschka had this poster, which exists in an English and a Spanish version (intended for South America), reproduced as a line etching and put up in the London Underground at his own expense.

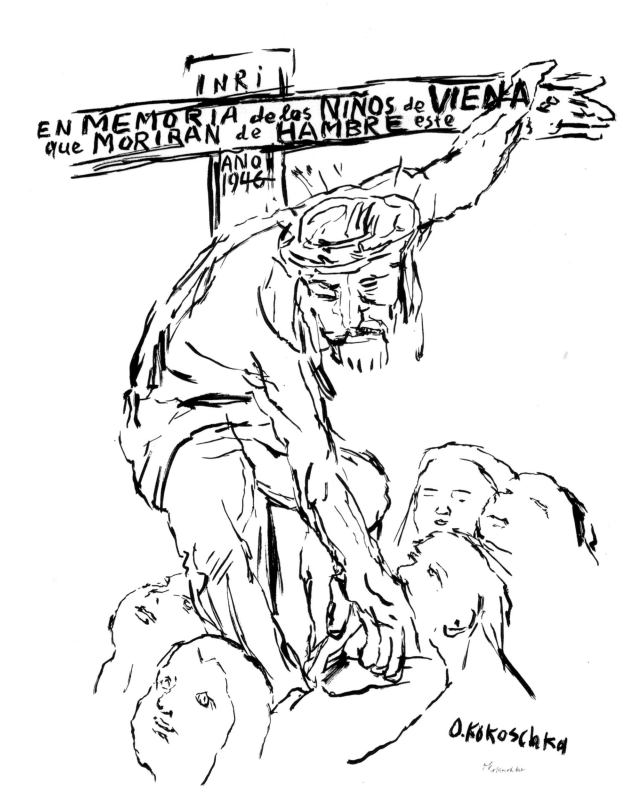

SECOND
WORLD
CONGRESS
OF THE DEFENDERS
OF PEACE
SHEFFIELD
13·19 NOVEMBER 1950

MOURLOT IMP. PARIS

Pablo Picasso (1881–1973)

Zweiter Weltkongress der Verteidiger des Friedens / *Second World Congress of the Defenders of Peace*
Sheffield 1950
Lithografie und Letternsatz / *Lithograph and typography*, 120 × 80 cm

Die internationalen Friedenskongresse wurden weitgehend von der Sowjetunion finanziert und von den westlichen Regierungen als Propagandainstrument angesehen. Picassos Engagement für den Frieden ging in diesen Jahren weit über diese Plakate hinaus. So malte er 1952 für den »Friedenstempel« in Vallauris die zwei großen Kompositionen »Krieg« und »Frieden«.

The internetional peace congresses were largely financed by the Soviet Union, and were perceived by Western governments as a propaganda instrument. Picasso's campaigning for peace during this period went far beyond these posters. For instance, in 1952, he painted the two great compositions "War" and "Peace" for the Temple of Peace in Vallauris, France.

Pablo Picasso (1881–1973)

Kongress der nationalen Friedensbewegung / *National Congress of the Peace Movement*
Mougins 1962
Lithografie / *Lithograph*, 100 × 64 cm

Neben den Weltfriedenskongressen gab es auch nationale Friedensveranstaltungen, wie diese französische in Issy-les-Moulineaux, für die Picasso ein Plakat anfertigte.

The World Peace Congresses were accompanied by national pro-peace events, such as that in Issy-les-Moulineaux in France, for which Picasso created this poster.

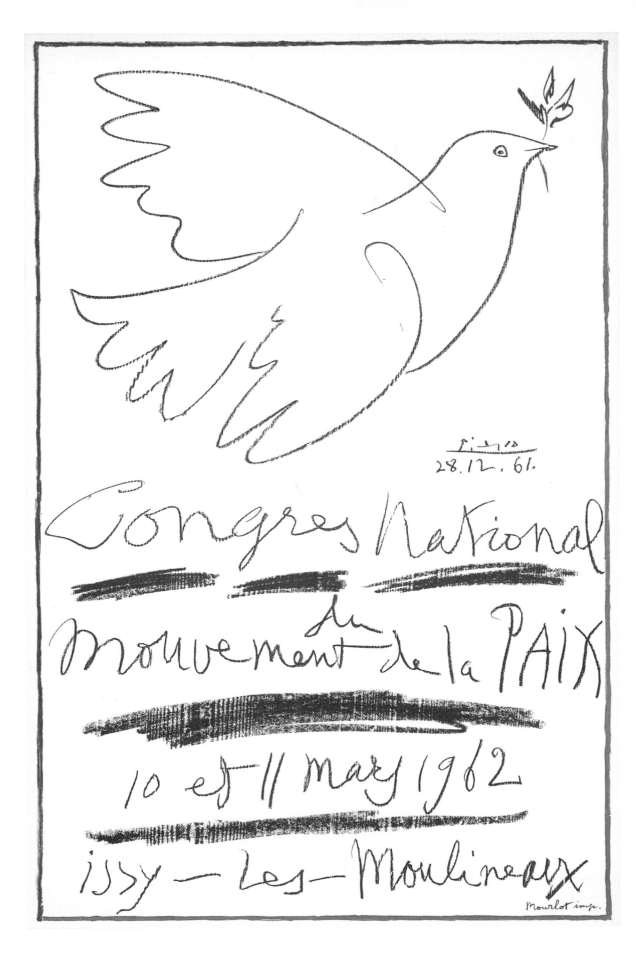

AMNISTIA

ÉDITÉ PAR LE COMITÉ NATIONAL D'AIDE AUX VICTIMES DU FRANQUISME

Pablo Picasso (1881–1973)

Amnestie / *Amnesty*
Aix-en-Provence 1959
Lithografie / *Lithograph*, 75 × 52 cm

Die Friedenstaube wird hier zu einer
Taube der Freiheit. Das Plakat, von
einem internationalen Komitee zur Unter-
stützung der Opfer des Franco-Regimes
herausgegeben, setzt sich für eine
Amnestie für die Gefangenen der
Franco-Diktatur ein.

In this image, the dove of peace be-
comes the dove of freedom. The poster,
issued by an international committee
to support the victims of the Franco
regime, calls for an amnesty for the
prisoners of the Franco dictatorship.

Pablo Picasso (1881–1973)

Frieden – Abrüstung /
Peace – Disarmamant
Paris 1960
Lithografie / *Lithograph*, 120 × 80 cm

Das Plakat kündet einen weiteren Welt-
friedenskongress an, der nach elf Jahren
erneut in Paris stattfand. Die Taube war
durch Picasso mittlerweile zu einem
internationalen Symbol des Friedens
geworden.

This poster announces a second World
Peace Congress, held again in Paris
eleven years after the first. By now,
Picasso's dove had become an inter-
national symbol of peace.

Pablo Picasso (1881–1973)

Frieden / *Peace*
Stockholm 1958
Offset / *Offset print*, 77,5 × 55,5 cm

Die Weltfriedenskongresse wurden vom
World Peace Council in Finnland veran-
staltet. Die Teilnehmer reisten aus über
100 Ländern an und beileibe nicht alle
von ihnen waren Mitglied der kommunis-
tischen Parteien. Unterstützt wurden sie
darüber hinaus von der World Federation
of Trade Unions, von der Women's Inter-
national Democratic Federation und
anderen Organisationen.

The World Peace Congresses were
organized by the World Peace Council,
based in Finland. The events were
attended by delegates from more than
100 countries who were by no means
all members of communist parties.
They were also supported by the World
Federation of Trade Unions, the Women's
International Democratic Federation,
and other organizations.

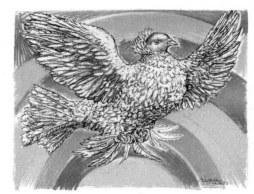

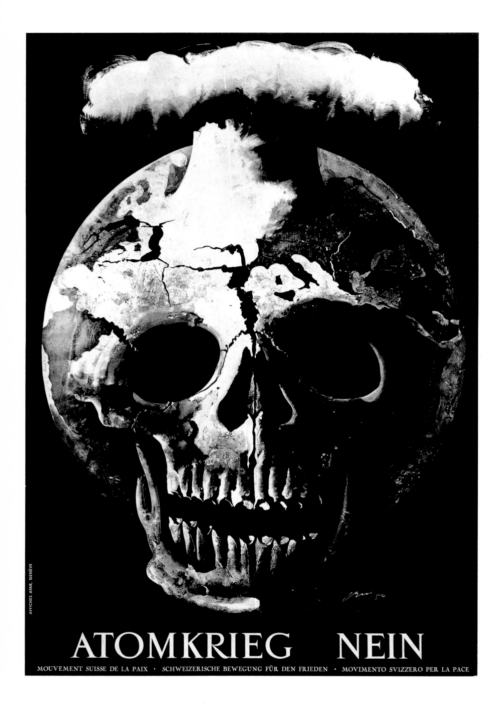

ATOMKRIEG NEIN

MOUVEMENT SUISSE DE LA PAIX · SCHWEIZERISCHE BEWEGUNG FÜR DEN FRIEDEN · MOVIMENTO SVIZZERO PER LA PACE

Hans Erni (*1909)

Atomkrieg nein / *No to Nuclear War*
Luzern / *Lucerne* 1954
Offset / *Offset print*, 128 × 90,5 cm

Das Plakat gegen den Atomkrieg wurde von der Schweizer Konferenz für den Frieden anlässlich der ersten internationalen Atomkonferenz in Genf 1955 veröffentlicht. Die fünf damaligen Atommächte – USA, UdSSR, England, Frankreich und China – sprachen sich optimistisch über die Chancen der friedlichen Nutzung von Kernenergie aus.

This antinuclear war poster was published by the Schweizer Konferenz für den Frieden (The Swiss Conference for Peace) on the occasion of the first international nuclear conference in Geneva in 1955. The five nuclear powers of the age – the USA, the USSR, the United Kingdom, France, and China – made optimistic speeches about the opportunities for the peaceful use of atomic power in the future.

Ben Shahn (1898–1969)

Stoppt die Tests mit Wasserstoffbomben / *Stop H-Bomb Tests*
New York 1962/64
Offset / *Offset print*, 108,5 × 74 cm

Seit die verheerenden Folgen von Wasserstoffbomben bekannt wurden, nahmen die Proteste gegen deren Tests zu. Dieses Plakat wurde von dem National Committee for a Sane Nuclear Policy herausgegeben.

When the devastation that could be caused by a hydrogen bomb became more widely known, protests against the testing of them increased. This poster was issued by the National Committee for a Sane Nuclear Policy.

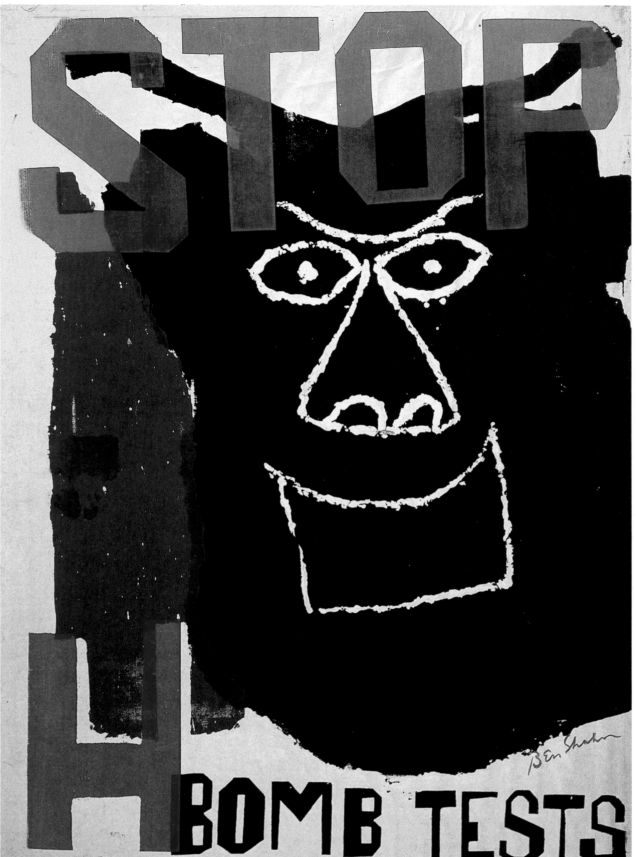

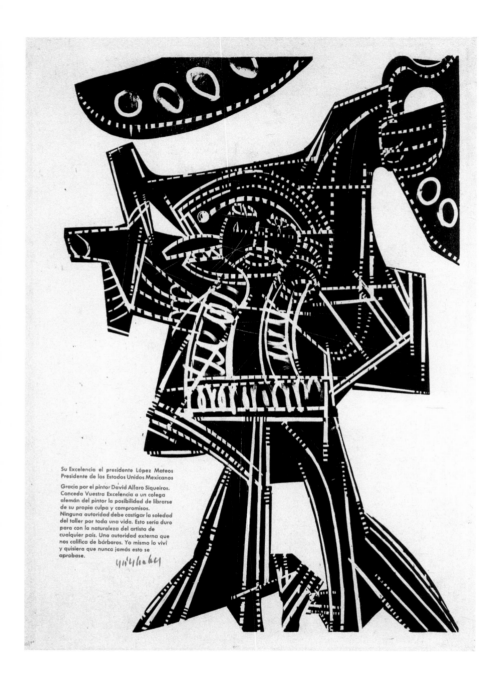

Su Excelencia el presidente López Mateos
Presidente de los Estados Unidos Mexicanos

Gracia por el pintor David Alfaro Siqueiros.
Conceda Vuestra Excelencia a un colega
alemán del pintor la posibilidad de librarse
de su propia culpa y compromisos.
Ninguna autoridad debe castigar la soledad
del taller por toda una vida. Esto seria duro
para con la naturaleza del artista de
cualquier país. Una autoridad externa que
nos califica de bárbaros. Yo mismo lo viví
y quisiera que nunca jamás esto se
aprobase.

HAP Grieshaber (1909–1981)

Gnadengesuch für David Alfaro
Siqueiros / *Clemency appeal for
David Alfaro Siqueiros*
Reutlingen 1964
Holzschnitt / *Woodcut*, 80 × 60 cm

Der mexikanische Maler David Alfaro
Siqueiros war als Kommunist mehrfach
inhaftiert worden. Grieshaber forderte
mit diesem Holzschnitt seine Frei-
lassung.

*The Mexican painter David Alfaro
Siqueiros was arrested several times
for being a communist. In this woodcut,
the German artist Grieshaber demands
his release.*

Joan Miró (1893–1983)

Hommage an Antonio Machado /
Homage to Antonio Machado
Baeza 1966
Lithografie / *Lithograph*, 72 × 52 cm

Der Dichter mit dem Beinamen »Sänger
von Kastilien« starb 1939 auf der Flucht
vor den Franco-Truppen in der Nähe der
spanischen Grenze. Er wurde zu einer
der Symbolfiguren des Widerstandes
gegen Franco. Mirós Hommage an den
Dichter ist eine seiner eindrucksvollsten
Grafiken.

*The poet Antonio Machado, known
as the "Bard of Castile," died in 1939
while fleeing from Franco's troops near
the Spanish border. He became an
iconic figure of the resistance against
General Franco. This homage to the poet
by Miró is among his most impressive
graphical works.*

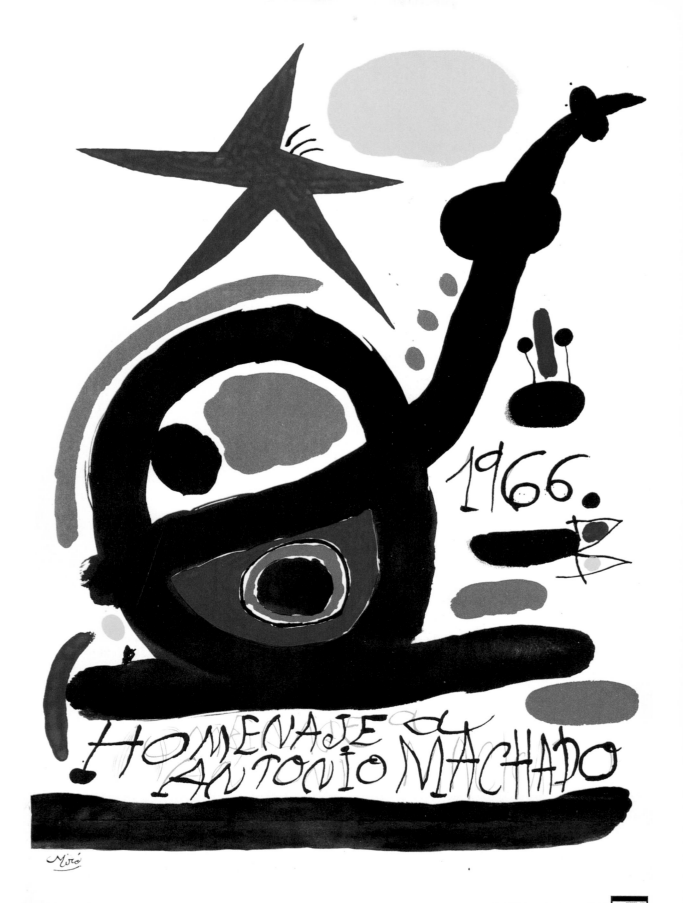

1966.

HOMENAJE A ANTONIO MACHADO

Miró

PROTEST

Die studentischen Protestwellen, die in den sechziger Jahren die westliche Welt überrollten, können als Auflehnung gegen die konservativen Strukturen gesehen werden, die sich während des Kalten Krieges herausgebildet hatten. Bereits 1964 begehrte das Free Speech Movement in der kalifornischen Universität in Berkeley bei San Francisco gegen das Verbot politischer Aktivitäten auf dem Campus auf – und reagierte damit auf Maßnahmen, die auf das berüchtigte Committee for Un-American Activities zurückgehen, das in der Nachkriegszeit unter Senator Joseph McCarthy eine undemokratische und die USA spaltende Kommunisten-Hetze veranstaltet hatte. 1965 setzten die Proteste gegen den Vietnamkrieg ein, die schon bald fantasievolle neue Formen annahmen. Die – von Allan Ginsberg so getaufte – Flower-Power-Bewegung setzte den Waffen der Ordnungskräfte den passiven Widerstand und die Macht der Blumen entgegen. Im »Summer of Love« 1967 wurde in Kommunen und Wohngemeinschaften mit neuen Lebensformen experimentiert, die die bürgerliche Gesellschaft brüskierten.

Die etwa zur selben Zeit in Europa aufkommenden Proteste hatten im Vergleich dazu einen eher dogmatischen und klassenkämpferischen Charakter. In Berlin begannen Studenten 1966 aufzubegehren. Nach dem Besuch des Schah in Berlin im Juni 1967, in dessen Verlauf der Student Benno Ohnesorg von einem Polizisten erschossen wurde, kam es zu einer stärkeren Polarisierung der Fronten. Der charismatische Studentensprecher Rudi Dutschke suchte die sozialistische Revolution durch die Schulung von Arbeitern und Studenten voranzutreiben. Er organisierte Proteste gegen den Vietnamkrieg, gegen die autoritären Strukturen der Universitäten – »Unter den Talaren der Muff von 1000 Jahren« – und rief zum Boykott der rechtsgerichteten und den Hass der Bevölkerung schürenden »Springer-Presse« auf. Bei einem Attentat im April 1968 wurde er lebensgefährlich verletzt und zog sich aus der Politik zurück.

In Frankreich beherrschte seit 1958 mit konservativer Strenge Charles de Gaulle die Fünfte Republik. In Paris begannen die Proteste ebenfalls 1966 und kulminierten im Mai 1968 als Studenten die Pariser Universität Sorbonne besetzten, Barrikaden bauten und zu einem Generalstreik aufriefen, der das Land wochenlang lahm legte. Anders als im übrigen Europa spielten Plakate im Pariser Mai '68 eine besondere Rolle. Eigens gegründete Grafik-Kollektive überzogen die Stadt mit fantasievollen Sprüchen, gedruckt in den Werkstätten und Ateliers der Kunsthochschulen. Auch bildende Künstler entwarfen Plakate zur Unterstützung.

De Gaulle gab nach einem von ihm einberufenen und fehlgeschlagenen Referendum 1969 sein Amt auf. Sein Nachfolger Georges Pompidou setzte zwar seine Politik fort, dennoch bahnte sich ein allmählicher Wechsel von einem autoritären Staatsverständnis zu mehr Demokratie an. In Westdeutschland setzte 1972 mit der Wahl von Willy Brandt ebenfalls ein Wandel ein, der letztlich das Ende des Kalten Krieges herbeiführte. Und auch in den USA fanden schließlich 1972 Ziele der Demonstranten ihren Weg in die nationale Politik, wenngleich der demokratische Senator George McGovern die Wahl haushoch verlor.

PROTEST

The wave of student protest that swept the West in the 1960s can be seen as a revolt against the conservative social and political structures that had developed during the Cold War. In 1964, the Free Speech Movement was formed at the University of California in Berkeley near San Francisco to resist the ban on political activities on campus – a measure that could be traced back to the notorious Committee for Un-American Activities headed by Senator Joseph McCarthy, which during the postwar period conducted an undemocratic witch hunt against communists that divided the USA. In 1965, protests against the Vietnam War began and rapidly took on a variety of imaginative forms. What the Beat poet Allan Ginsberg dubbed the "Flower Power" movement opposed the forces of law and order with passive resistance and flowers. During the Summer of Love in 1967, communes and other forms of experimental lifestyles provoked conventional society.

In comparison, the protests that were occurring around the same time in Europe were more dogmatic in character, and had more to do with class warfare. In Berlin, students began staging protests in 1966. After the Shah of Iran's visit to Berlin in June 1967, during which the student Benno Ohnesorg was shot and killed by a policeman, positions became more entrenched. The charismatic student spokesman Rudi Dutschke tried to promote a socialist revolution by educating workers and students. He organized protests against the Vietnam War and against authoritarian university structures ("under the gowns is the musty odor of a thousand years"), and called for a boycott of the newspapers of the right-leaning Springer Company for its incitement of anti-leftist feeling. Attacked in April 1968, he sustained life-threatening injuries and subsequently withdrew from politics.

In France, Charles de Gaulle, a sternly conservative authority figure, had been president of the Fifth Republic since 1958. Protests began in Paris in 1966 and culminated in May 1968, when students occupied the Sorbonne University, building barricades and calling for a general strike that brought the country to a standstill for weeks. The events of May '68 in Paris were unique in Europe in that posters played a significant role. Printing collectives sprang up to cover the city with imaginative statements, printed in the workshops and studios of the art academies, though fine artists also designed posters in support of the movement.

In 1969, after calling a referendum that backfired, De Gaulle resigned. His successor, Georges Pompidou, largely followed the same political bent, but embarked on a gradual transition from an authoritarian state to a more democratic one. In West Germany, the election of Willy Brandt ushered in an era of change that ultimately led to the end of the Cold War. In the USA in 1972, the protesters' concerns finally found their way into mainstream politics, even though Democratic Senator George McGovern lost the election by a landslide.

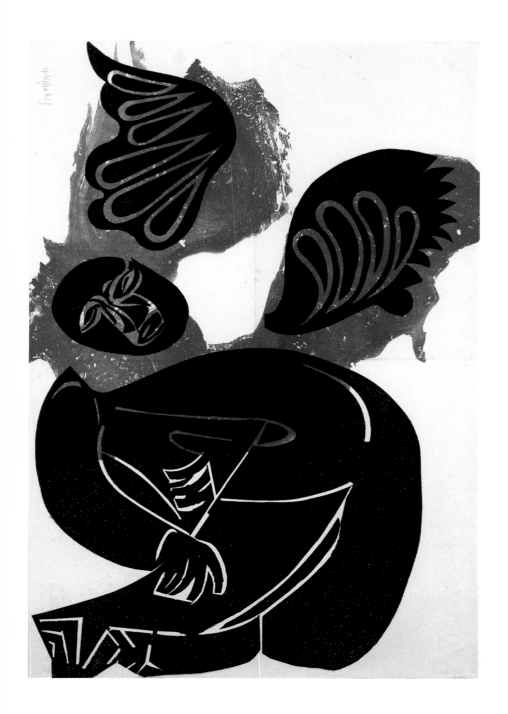

HAP Grieshaber (1909–1981)

Für Martin Luther King / *For the Death of Martin Luther King*
Reutlingen 1968
Holzschnitt / *Woodcut*, 82 × 58,5 cm

Der schwarze Bürgerrechtler und Friedensnobelpreisträger Martin Luther King wurde am 4. August 1968 in Memphis, Tennessee, ermordet. King propagierte zivilen Ungehorsam, um die Rassentrennung, die »Racial Segregation«, zu überwinden. Grieshabers Holzschnitt war seine spontane Reaktion auf den Mord.

The black civil liberties campaigner and Nobel Peace Prize laureate Martin Luther King was murdered in Memphis, Tennessee, on August 4, 1968. King advocated civil disobedience as a response to racial segregation. This woodcut was created by Grieshaber as a spontaneous reaction to his murder.

Joan Miró (1893–1983)

1. Mai 1968 / *May 1, 1968*
Barcelona 1968
Lithografie / *Lithograph*, 64 × 49 cm

Das Plakat von Miró ist ein Aufruf in katalanischer Sprache – damals in der Öffentlichkeit verboten – zur Teilnahme an der Feier zum 1. Mai 1968 in Barcelona. Das Blatt wurde in 15 000 Exemplaren in Barcelona plakatiert und verteilt und gehört heute zu den seltensten Grafiken des Künstlers.

This poster by Miró is written in Catalan – a language whose use in public was forbidden at the time – calling on people to take part in the festival on May 1, 1968 in Barcelona. 15,000 copies of this poster were posted up and distributed in Barcelona. Today it is one of the rarest prints by the artist.

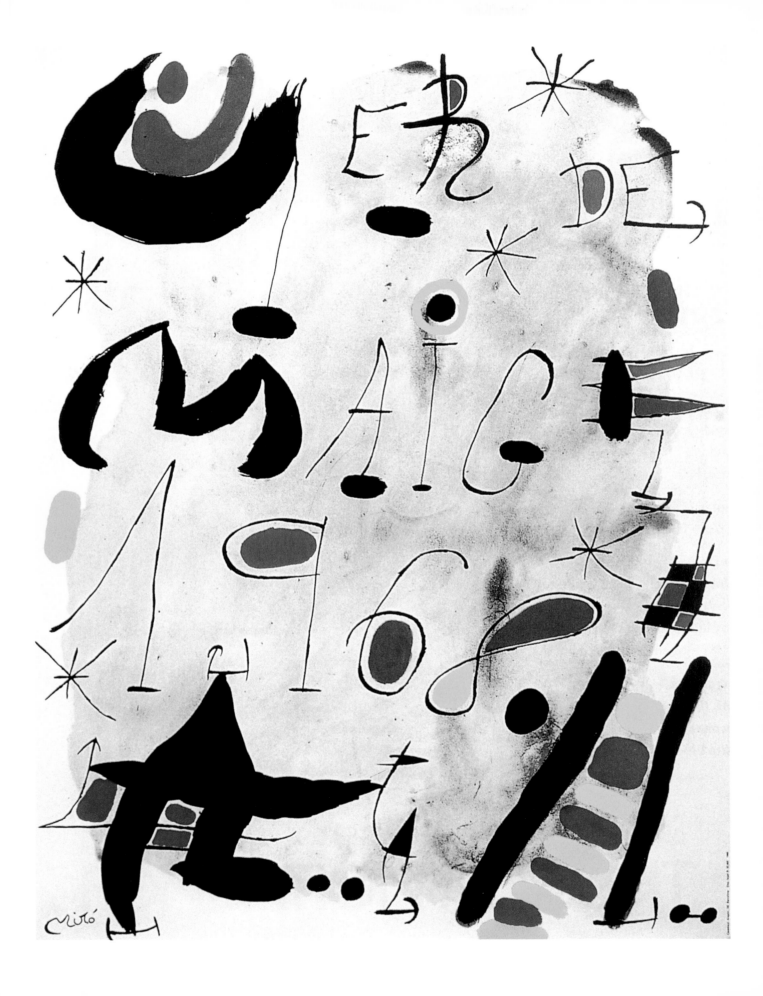

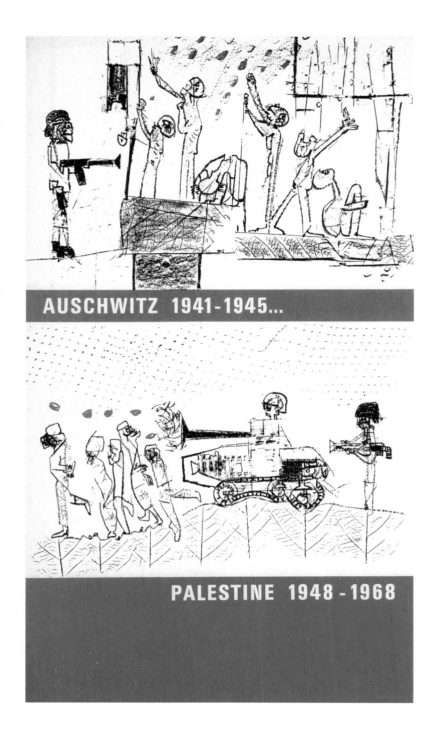

AUSCHWITZ 1941-1945...

PALESTINE 1948-1968

Roberto Matta Echaurren
(1911–2002)

Auschwitz 1941–1945 ... Palästina /
Palestine 1948–1968
Paris 1968
Lithografie / *Lithograph*, 83,5 × 49 cm

Das Plakat entstand als Reaktion auf
den israelisch-arabischen Sieben-Tage-
Krieg 1967 und die darauf folgende
israelische Herrschaft über palästinen-
sische Wohngebiete. Matta hielt sich
1968 in Kuba auf und engagierte sich
danach bei den Pariser Studenten-
protesten.

*This poster is a reaction to the Arab-
Israeli Six-Day War of 1967 and
the subsequent Israeli occupation of
Palestinian territory. Matta visited Cuba
in 1968, and was also involved in the
student protests in Paris.*

Colin Self (*1941)

Lassen Sie mich Ihnen einen
elektrischen Stuhl verkaufen / *Allow Me
to Sell You an Electric Chair*
London 1968
Offset / *Offset print*, 97,5 × 36,5 cm

Das »Poster Poem« verbindet ein Foto
von 1940, das eine Hinrichtung auf
dem »First Portable Electric Chair«
zeigt, mit einem satirischen Verkaufstext.
Die andere Seite des Blattes zeigt das-
selbe Motiv in Schwarzweiß-Umkehrung.

*This "poster poem" combines a photo-
graph from 1940 showing an execution
using the "First Portable Electric Chair"
with a satirical sales pitch. On the
reverse is a negative of the same image.*

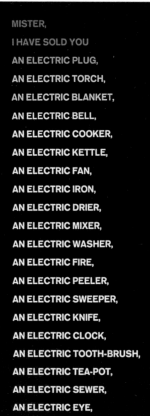

MISTER,

I HAVE SOLD YOU

AN ELECTRIC PLUG,

AN ELECTRIC TORCH,

AN ELECTRIC BLANKET,

AN ELECTRIC BELL,

AN ELECTRIC COOKER,

AN ELECTRIC KETTLE,

AN ELECTRIC FAN,

AN ELECTRIC IRON,

AN ELECTRIC DRIER,

AN ELECTRIC MIXER,

AN ELECTRIC WASHER,

AN ELECTRIC FIRE,

AN ELECTRIC PEELER,

AN ELECTRIC SWEEPER,

AN ELECTRIC KNIFE,

AN ELECTRIC CLOCK,

AN ELECTRIC TOOTH-BRUSH,

AN ELECTRIC TEA-POT,

AN ELECTRIC SEWER,

AN ELECTRIC EYE,

AN ELECTRIC LIGHT;

ALLOW ME TO SELL YOU

AN ELECTRIC CHAIR.

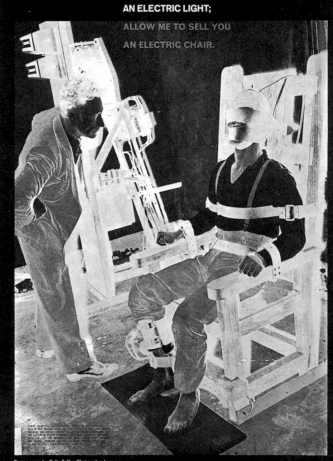

Poster poem by Colin Self + Christopher Logue
published by Ad Infinitum Limited, London © 1968 105

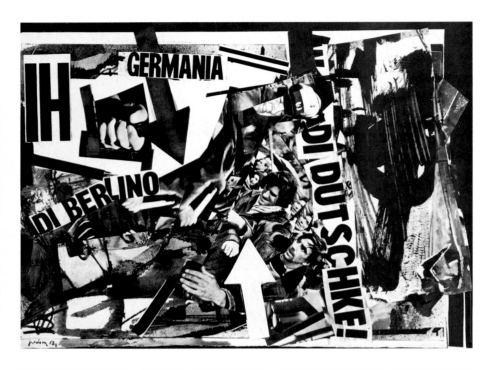

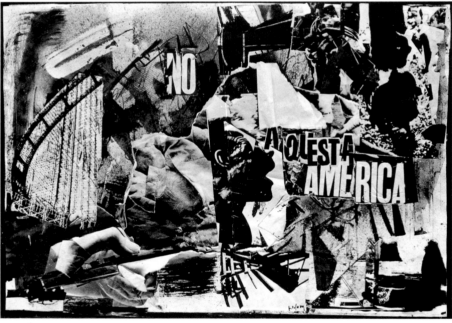

Emilio Vedova (1919–2006)

Berlin, Dutschke! / *Berlin, Dutschke!*
Nein zu diesem Amerika / *No To This America*
Saigon
Venedig / *Venice* 1968
Offset / *Offset print*, 81,5 × 60 cm

Die drei Plakate gehören zu einer sechs-
teiligen Serie, in der Vedova die Unruhe-
herde des Jahres nebeneinanderstellt.
In Westberlin führt der charismatische
Rudi Dutschke die studentischen Pro-
teste an. Am 2. Juni 1967 war hier der
Student Benno Ohnesorg von einem
Polizisten erschossen worden. Dutschke
wurde am 11. April 1968 bei einem
Attentat lebensgefährlich verletzt.
In einem anderen der sechs Plakate
versammelt Vedova Bilder aus Mittel-
und Südamerika zu einem Schreckens-
szenario. Zwei weitere Plakate verurteilen
den Vietnamkrieg. Neben diesem Blatt
über Saigon gibt es ein weiteres zu
Nordvietnam. Diese wie auch die ande-
ren Collagen der Serie fallen in dem
sonst gegenstandslosen Œuvre des
venezianischen Malers aus dem Rahmen.
Allerdings bleibt der Künstler bei den
Schwarzweißkontrasten, die er auch in
seinen Gemälden bevorzugt.

*These three posters belong to a series
of six in which Vedova juxtaposes the
world's various trouble spots. In West
Berlin, the charismatic Rudi Dutschke
is leading the student protests. It is also
where the student Benno Ohnesorg
as shot to death on June 2, 1967. On
April 11, 1968, Dutschke was critically
injured during an attempt on his life.
In another of the six posters, Vedova
has composed a doomsday scenario
using images from Central and South
America. Two other posters condemn
the Vietnam War. Besides this poster
about Saigon there is also one about
North Vietnam. These collages are
strikingly different from the Venetian
painter's otherwise abstract oeuvre.
The artist has, however, retained his
preference for black and white contrasts,
which also permeate his paintings.*

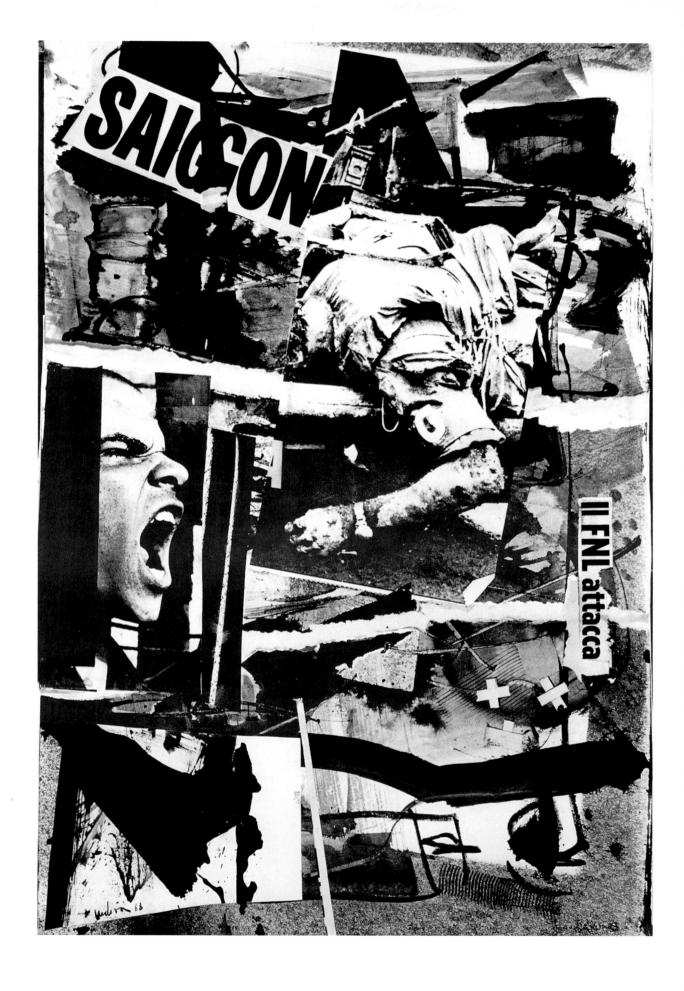

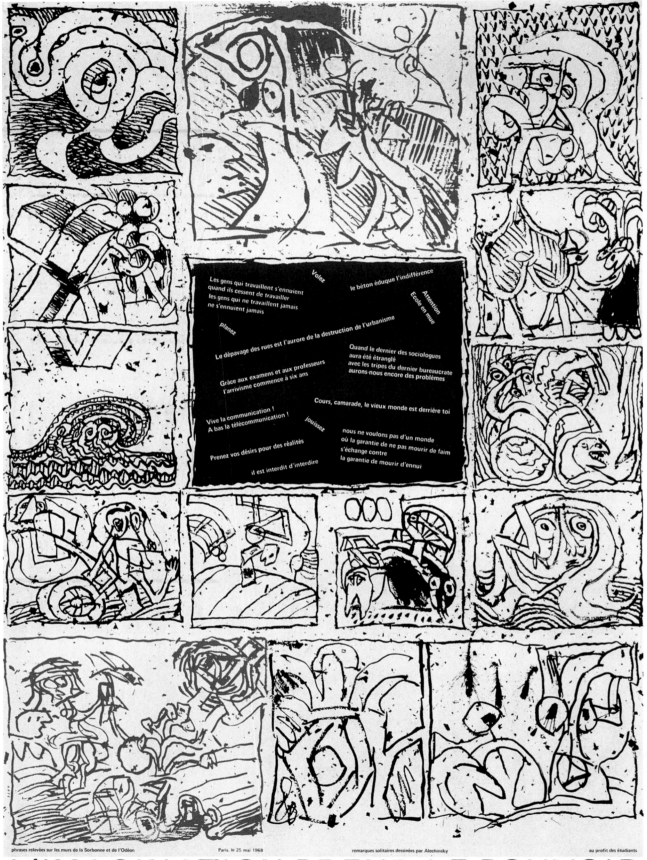

Volez

Les gens qui travaillent s'ennuient
quand ils cessent de travailler
les gens qui ne travaillent jamais
ne s'ennuient jamais

le béton éduque l'indifférence

Attention
École en mue

planez

Le dépavage des rues est l'aurore de la destruction de l'urbanisme

Quand le dernier des sociologues
aura été étranglé
avec les tripes du dernier bureaucrate
aurons-nous encore des problèmes

Grâce aux examens et aux professeurs
l'arrivisme commence à six ans

Cours, camarade, le vieux monde est derrière toi

Vive la communication !
A bas la télécommunication !

jouissez

nous ne voulons pas d'un monde
où la garantie de ne pas mourir de faim
s'échange contre
la garantie de mourir d'ennui

Prenez vos désirs pour des réalités

il est interdit d'interdire

phrases relevées sur les murs de la Sorbonne et de l'Odéon. Paris, le 25 mai 1968 remarques solitaires dessinées par Alechinsky au profit des étudiants

L'IMAGINATION PREND LE POUVOIR

Pierre Aléchinsky (*1927)

Die Fantasie ergreift die Macht /
Power to the Imagination
Paris 1968
Lithografie / *Lithograph*, 82,5 × 59 cm

Im Zentrum des Blattes stehen die
studentischen Parolen des Pariser
Mai '68. Die ein zentrales Bildfeld
umkreisenden einzelnen Szenen,
die wie auf einer Comic-Seite ange-
ordnet sind, finden sich auch auf den
großen Gemälden des Künstlers.

In the center of this poster are the
slogans of the student protests of
May '68. As with the artist's large-
scale paintings, individual scenes are
arranged like the panels in a comic
book around a central pictorial field.

Karel Appel (1921–2006)

Mit ihren Taten haben sie uns die Quelle
ihrer Schönheit gezeigt / *Their Actions*
Have Shown Us The Source of Their
Beauty
Paris 1968
Lithografie / *Lithograph*, 78,5 × 60 cm

Das Plakat entwarf Appel zum Pariser
Mai '68. Die Wahl des Zitats, das die
Schönheit der revolutionären Handlung
preist, zeugt von gewissem Trotz und
Ironie, war doch der holländische
Künstler, der seit 1950 in Paris lebte,
immer wieder für die Hässlichkeit seiner
Gestalten kritisiert worden.

Appel was inspired to create this poster
by the events of May '68. The quotation
he chose – one that praises the beauty
of revolutionary action – shows a
certain defiance and irony, for this
Dutch artist, who had lived in Paris
since 1950, was often criticized for
the ugliness of his creations.

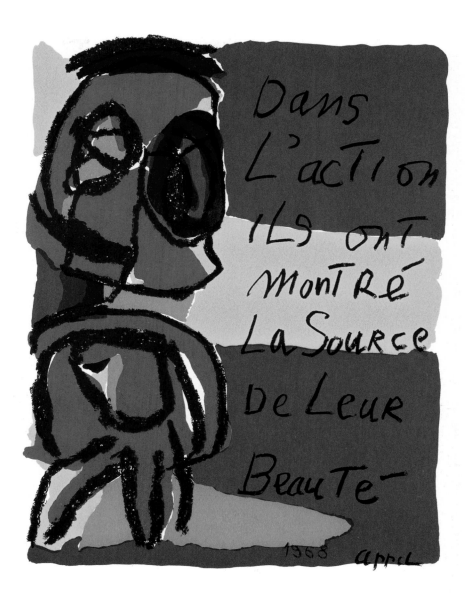

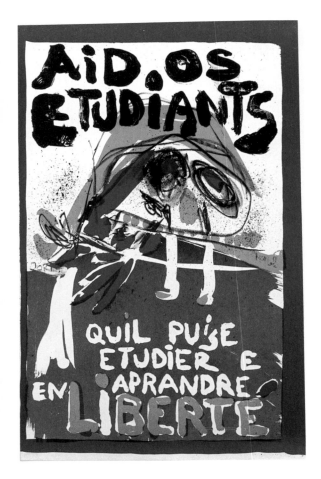

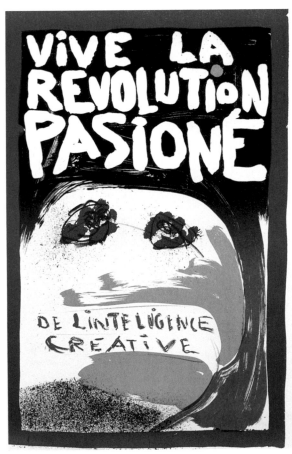

Asger Jorn (1914–1973)

Helft den Studenten, dass sie in Freiheit
studieren und lernen können / *Help the
Students to Study and Learn in Freedom*
Es lebe die leidenschaftliche Revolution
der kreativen Intelligenz / *Long Live
the Passionate Revolution of Creative
Intelligence*
Paris 1968
Lithografie / *Lithograph*, 51 × 38,5 cm
(102 × 77 cm), zwei von vier Kompositio-
nen, gedruckt auf einen Bogen / *two out
of four compositions, printed on one
sheet*

Jorn schuf insgesamt vier Kompositionen
mit Parolen der Pariser Studenten. Er
ließ die Motive zusammen auf einen
großen Bogen drucken, der in der Regel
zerschnitten wurde.

*In total, Jorn created four compositions
with Paris student slogans. He had the
four designs printed on a single page,
which would generally then be cut into
four separate posters.*

Jean René Bazaine (1904–2001)

ORTF à tous – Fernsehen für das Volk /
Television for All
Paris 1968
Lithografie / *Lithograph*, 79,5 × 59,5 cm

Die Zeichnung zeigt den zentralen Kopf
der Figurengruppe »La Marseillaise«,
die François Rude 1833–1836 für den
großen Pariser Triumphbogen schuf.
Es existiert ebenso eine zweifarbige Ver-
sion der Lithografie mit einem Text, der
wie das Blatt von Calder (→ S. 49) die
Übergabe des französischen Staatsfern-
sehens an das Volk fordert.

*This design shows the central head of
the "Marseillaise" figural tableau, cre-
ated by François Rude from 1833 to
1836 for the Arc de Triomphe in Paris.
This lithograph also exists in a two-color
version with a text. Like Calder's design
(→ p. 40), it demands that the French
state television service ORTF (Office de
Radiodiffusion-Télévision Française) be
handed over to the people.*

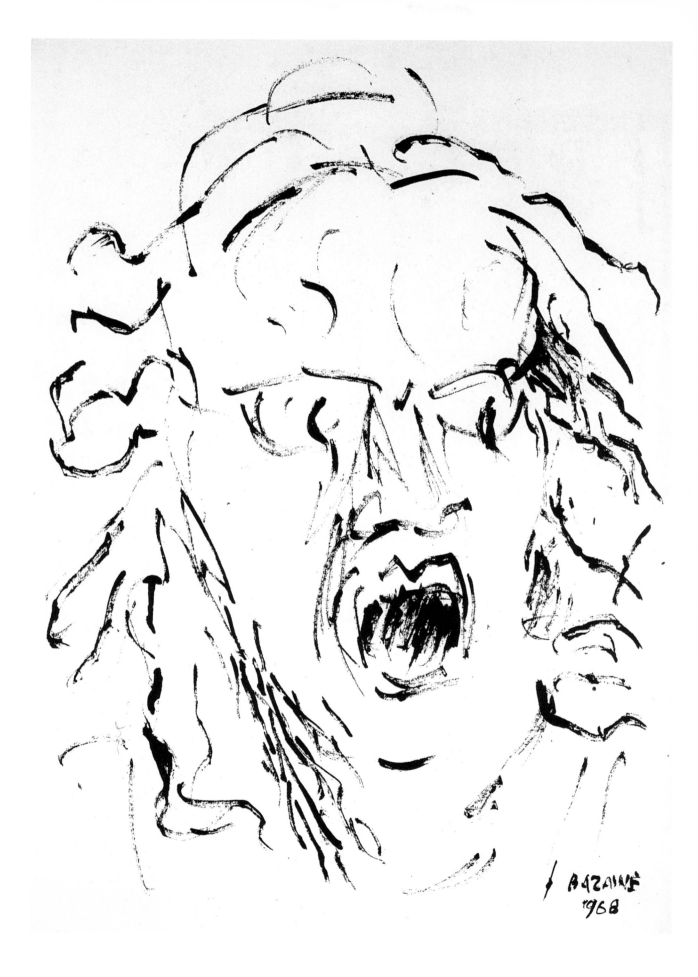

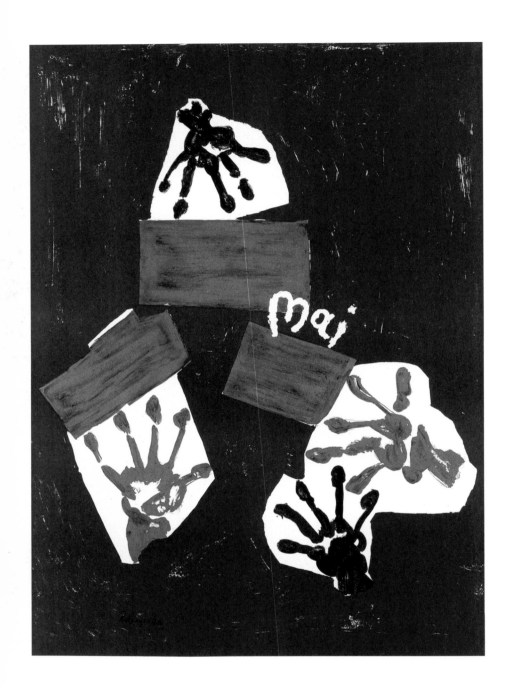

Paul Rebeyrolle (1926–2005)

Mai / *May*
Paris 1968
Lithografie / *Lithograph*, 80 × 60,5 cm

Rebeyrolle, einer der bekannten Vertreter der École de Paris, spielte mit seinen Bildtiteln oft auf politische Themen an, während seine Bildsprache, anders als hier in seinem Plakat zum Pariser Mai '68, in der Regel gegenstandslos blieb.

Rebeyrolle, one of the best-known artists of the École de Paris, often gave his pictures titles that refer to political themes, while his visual style is generally non-representational. This May '68 poster is an exception.

Alexander Calder (1898–1976)

ORTF für alle / *ORTF for All*
Paris 1968
Lithografie / *Lithograph*, 75 × 44,5 cm

Calder übernimmt eine der Parolen der Studentenrevolte und fordert, das französische Staatsfernsehen dem Volk zu übergeben. Seit der Künstler nach 1930 drei Jahre in Paris verbracht hatte und seither modernen Kunstkreisen nahestand, hielt er sich immer wieder in Frankreich auf.

Adopting one of the slogans of the student revolts, Calder calls for French state television service to be handed over to the people. After going to Paris in 1930 and spending three years there (marking his entry into modern art circles) the American artist made regular visits to France.

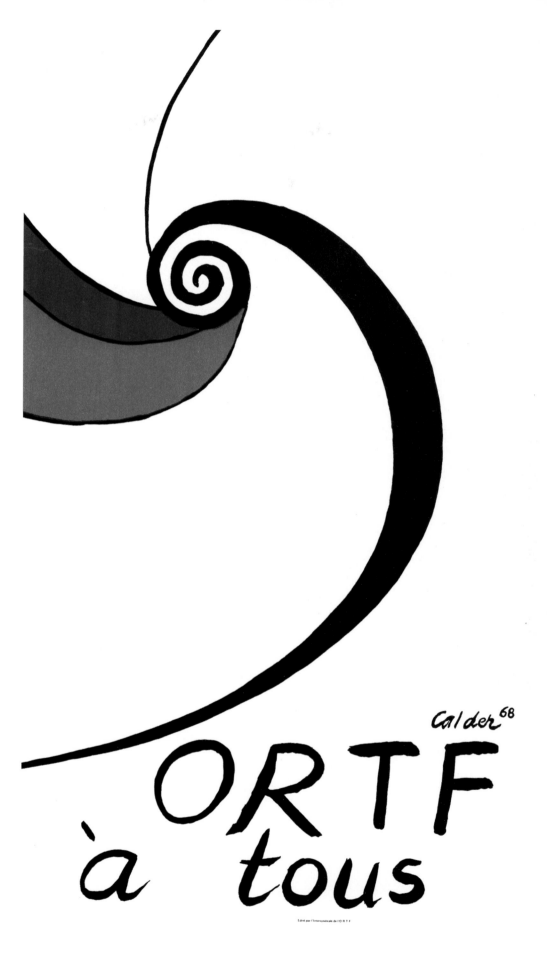

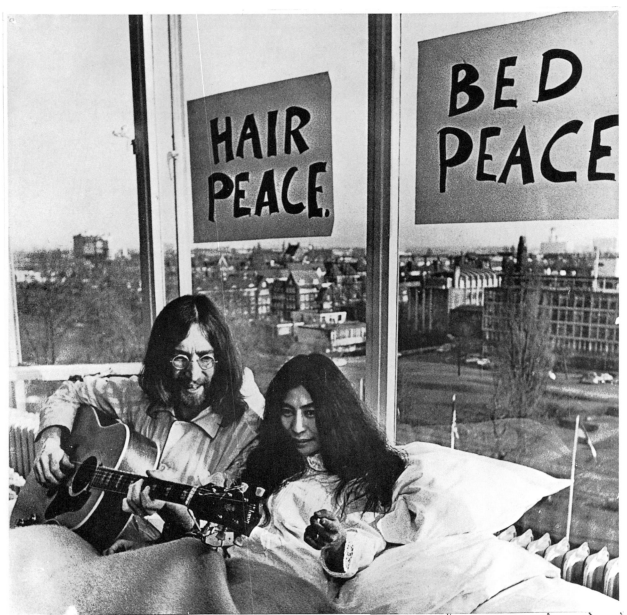

Unbekannt / *Unknown artist*

nach / *inspired by* John Lennon
und / *and* Nico Koster

Bleib im Bett – lass dein Haar wachsen /
Stay in Bed – Grow your Hair!
Amsterdam 1969
Siebdruck / *Silkscreen print*, 110 × 76 cm

Als symbolische Handlung für den
Frieden blieben John Lennon und Yoko
Ono eine Woche in Amsterdam im
Bett und gaben Interviews. Im gleichen
Jahr entstand auch das Friedens-Lied
»Give Peace a Chance«.

John Lennon and Yoko Ono spent a
week in bed in Amsterdam – giving
interviews – to express their support
for peace. Lennon's antiwar song
"Give Peace a Chance" was released
in the same year.

Niki de Saint-Phalle (1930–2002)

Die Nanas an die Macht /
Power to the Nanas
Amsterdam 1967
Siebdruck / *Silkscreen print*, 95,5 × 65 cm

In dem Ausstellungsplakat des Stedelijk
Museum in Amsterdam klingt, umgemünzt
auf das Frauenbild Niki de Saint-Phalles,
der Ton der Studentenrevolten an.

This exhibition poster for the Stedelijk
Museum in Amsterdam shows the
mood of the student riots in the form
of Niki de Saint-Phalle's celebrated
female figure.

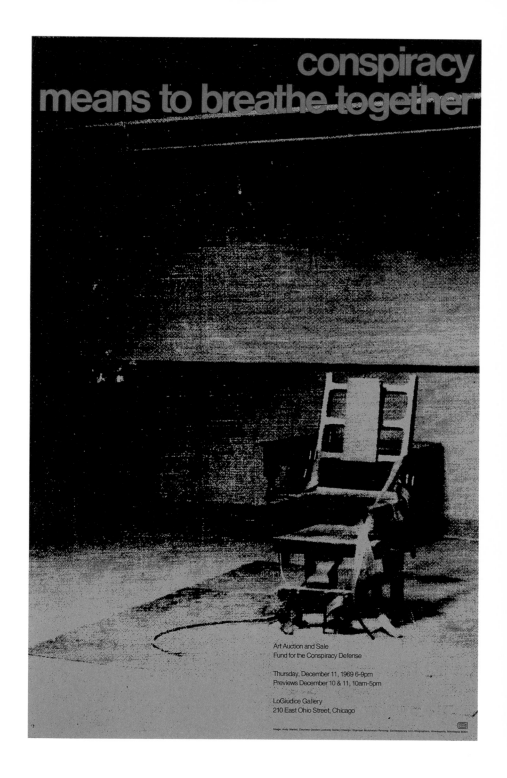

James Rosenquist (*1933)

Schwankend (Klassensysteme) /
See Saw (Class Systems)
Chicago 1968
Lithografie / *Lithograph*, 61 × 87,6 cm

Auf diesem Plakat der Richard L. Feigen
Gallery befindet sich der Ankündigungs-
text auf der Rückseite. Rosenquist por-
trätiert den Bürgermeister von Chicago,
Richard J. Daley, »schwankend«, wie
der Titel sagt, zwischen den Klassen-
Bezeichnungen »upper – middle – lower«.
Daley ging während der Democratic
National Convention 1968 massiv gegen
die Antikriegs-Demonstranten vor und
ließ die »Chicago Seven« (s. unten) ver-
haften.

*Published by the Richard L. Feigen
Gallery, this print has its text on the
reverse side. Rosenquist shows the
mayor of Chicago, Richard J. Daley,
"seesawing," as the title indicates,
between the "upper, middle, and lower"
classes. Daley forcefully opposed
the antiwar demonstrations during
the Democratic National Convention
in 1968, ordering the arrest of the
"Chicago Seven" (see below).*

Andy Warhol (1928–1987)

Konspirieren heißt zusammen atmen /
Conspiracy Means to Breathe Together
New York 1969
Offset / *Offset print*, 107 × 72 cm

Das Blatt mit einem der Electric Chairs
von 1963 half bei der Finanzierung der
Verteidigung der »Chicago Seven«.
Diese waren nach einer Demonstration
anlässlich der Democratic National Con-
vention in Chicago 1968 festgenommen
worden. Abbie Hoffmann, Jerry Rubin
und fünf weiteren Gefangenen wurde
Staatsverschwörung (Conspiracy) vorge-
worfen, ein Straftatbestand, der 1945
zur Verurteilung der Nazi-Verbrecher
eingeführt worden war.

*This poster, depicting an electric chair
from 1963, helped to finance the
defense of the "Chicago Seven," the
seven people arrested at the Demo-
cratic National Convention in Chicago
in 1968 for incitement to riot. Abbie
Hoffman, Jerry Rubin, and five others
were accused of "conspiracy," a statutory
offence that was defined in 1945 in
order to condemn Nazi criminals.*

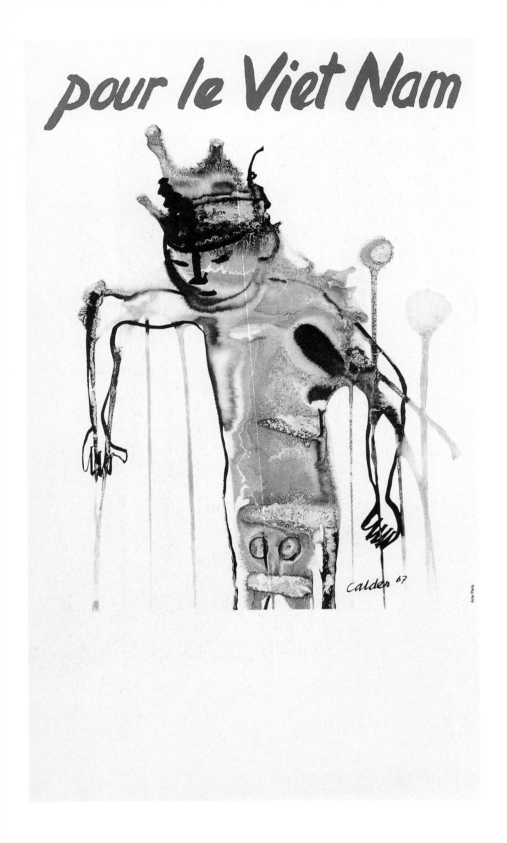

pour le Viet Nam

Calder 67

Arts Paris

Alexander Calder (1898–1976)

Für Vietnam / *For Vietnam*
Paris 1967
Offset / *Offset print*, 75 × 44,5 cm

Die anrührende Zeichnung vergleicht
ein Kriegsopfer aus Vietnam mit dem
Gekreuzigten – eine erstaunliche Bild-
sprache des für seine großen Stahl-
skulpturen, die Mobiles und Stabiles,
bekannten Künstlers.

*This moving drawing compares a victim
of the Vietnam War with the crucified
Christ, a remarkable use of imagery by
an artist best known for his large steel
sculptures, his "mobiles" and "stabiles."*

Wolf Vostell (1932–1998)

Umfunktionierungen / *Conversions*
Köln / *Cologne* 1969
Siebdruck / *Silkscreen print*,
56,5 × 67,5 cm

Das Ausstellungsplakat zeigt einen
Ausschnitt aus dem berühmten Foto
»Saigon Execution« von Edward T. Adams.
Vostell konfrontiert es mit harmlosen
Urlaubsszenen und spricht bei einer
solchen Bildverwendung von »Umfunk-
tionierungen«. Er hatte im Jahr zuvor be-
gonnen, sich in Aktionen und Werken mit
dem Vietnamkrieg auseinanderzusetzen.

*Here, Vostell has used the famous
photograph "Saigon Execution" by
Edward T. Adams. He combined it with
harmless holiday scenes, describing
this use of pictures as "conversion."
He had begun creating artworks and
happenings on the Vietnam War the
previous year.*

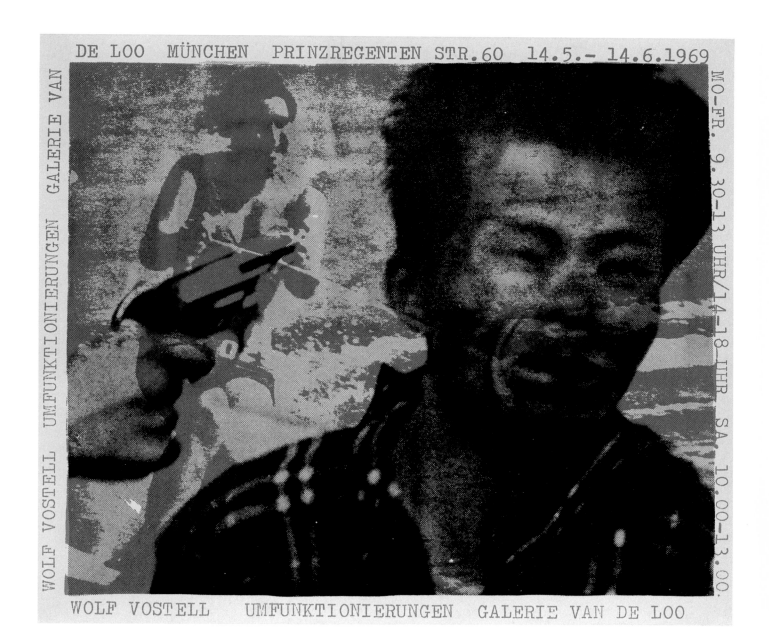

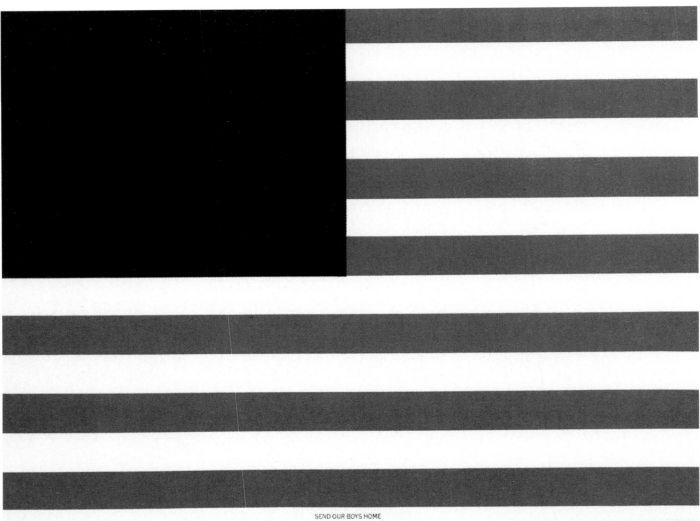

SEND OUR BOYS HOME

Cristos Gianakos (*1934)

Schickt unsere Jungs nach Haus /
Send Our Boys Home
USA 1966
Offset /*Offset print*, 31,5 × 42,5 cm

Im März 1965 war der Vietnamkrieg
offiziell begonnen worden; im folgenden
Jahr befanden sich bereits 400 000
US-Soldaten im Einsatz. Der amerikani-
sche Bildhauer entwarf diese US-Flagge
mit dem Trauerflor als eines der ersten
Plakate gegen den Vietnamkrieg.

*The Vietnam War officially began in
March 1965. By the following year,
400,000 US troops had been deployed.
This US flag with black crape by the
American sculptor Cristos Gianakos
was one of the first anti-Vietnam War
posters.*

U.S.A. SURPASSES ALL THE GENOCIDE RECORDS!

KUBLAI KHAN MASSACRES 10% IN NEAR EAST

SPAIN MASSACRES 10% OF AMERICAN INDIANS

JOSEPH STALIN MASSACRES 5% OF RUSSIANS

NAZIS MASSACRE 5% OF OCCUPIED EUROPEANS AND 75% OF EUROPEAN JEWS

U.S.A. MASSACRES 9.5% OF SOUTH VIETNAMESE & 75% OF AMERICAN INDIANS

FOR CALCULATIONS & REFERENCES WRITE TO: P.O. BOX 180, NEW YORK, N.Y. 10013

George Maciunas (1931–1978)

Die USA übertreffen alle Völkermord-
Rekorde! / *U.S.A. Surpasses All the
Genocide Records!*
New York 1969
Nachdruck des deutschen Künstlers
Albrecht D. / *Reproduction by the German
Artist Albrecht D., Reflection Press*,
Stuttgart
Offset / *Offset print*, 40 × 61 cm

Maciunas protestiert gegen den Viet-
namkrieg mit dem Hinweis auf die Opfer
amerikanischer Kriege. »Albrecht D.«,
der seine Identität bis hin zum Namen
hinter anderen Künstlern versteckt, unter-
hielt besonders zu George Maciunas
enge Kontakte und sorgte auf seine
Art wesentlich für die Bekanntheit des
amerikanischen Fluxuskünstlers.

*Maciunas' protest against the Vietnam
War focuses on the victims of American
wars. "Albrecht D.," who hides his iden-
tity, including his name, behind other
artists, was particularly close to George
Maciunas, who contributed considerably
to the reputation of this American
Fluxus artist.*

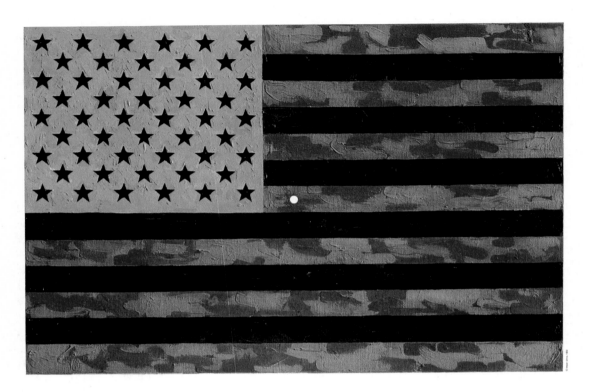

MORATORIUM

Jasper Johns (*1930)

Moratorium
New York 1969
Offset / *Offset print*, 57 × 71 cm

Die amerikanische Flagge in den Komplementärfarben beinhaltet ein optisches Spiel: Konzentriert man sich auf den weißen Punkt und schließt dann die Augen, erscheint die Flagge als Nachbild vor dem inneren Auge in den korrekten Farben. Durch den Titel und durch den an Tarnfarben erinnernden Farbauftrag macht Jasper Johns daraus einen Protest gegen den Vietnamkrieg.

This American flag in complementary colors is a kind of optical illusion. If you concentrate on the white dot and then close your eyes, a flag in the correct colors will appear as an afterimage behind your eyelids. The title and the green paint that looks like camouflage turn the American flag into Jasper Johns' protest against the Vietnam War.

Frank Stella (*1936)

Attica Defense Fund
New York 1975
Lithografie / *Lithograph*, 75 × 75 cm

Nach einem Aufstand 1971 im Staatsgefängnis von New York, bei dem 43 Menschen von der Polizei erschossen wurden, wurden zahlreiche Insassen angeklagt. Bürgerrechtler finanzierten Anwälte für den Prozess, der fast dreißig Jahre dauerte. Dieses Plakat diente dem Fundraising.

After a riot in the New York State Penitentiary in 1971, during which 43 people (prisoners and hostages) died when state troopers and guards retook the prison, a number of inmates faced charges. Civil rights activists paid for defense lawyers for the legal proceedings, which lasted almost 30 years. This poster was part of a fund-raising campaign.

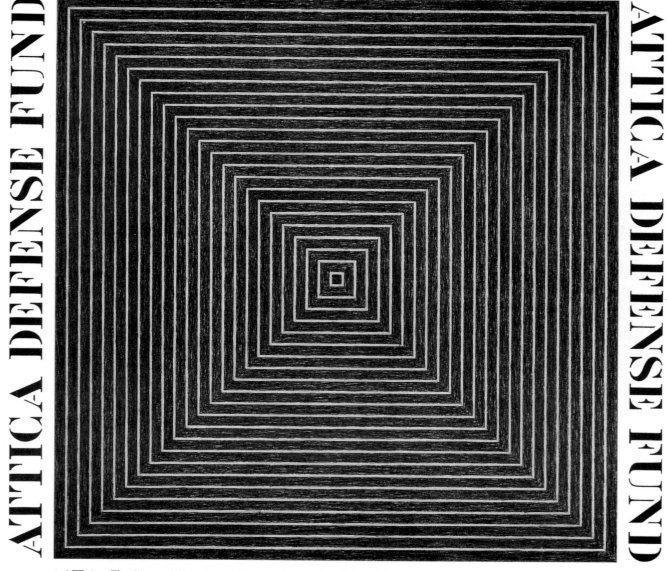

Robert Rauschenberg
(1925–2008)

Plakat zur Wiederwahl von Senator
Javits / *Poster for Senator Javits'*
Re-Election Campaign
New York 1968
Offset / *Offset print*, 58 × 56 cm

Der republikanische Senator Jacob K.
Javits aus New York war einer der ersten
Gegner des Vietnamkrieges im US-Senat.
Rauschenbergs Poster – frei von Texten –
dürften dem Fundraising gedient haben.

Republican senator Jacob K. Javits
from New York was one of the first
opponents of the Vietnam War in the
US Senate. Rauschenberg's poster,
which has no text, may have been used
for fund-raising.

Larry Rivers (1923–2002)

Amerika braucht McGovern – er kann
es wieder richten / *America Needs*
McGovern – He Can Put It Together
New York 1972
Offset / *Offset print*, 76 × 59 cm

Rivers vergleicht in seinem Plakat für die
Wahlkampagne den Zustand der USA
nach vier Jahren unter Nixon mit einem
verrutschten Puzzle, das McGovern
wieder zusammenfügen soll.

In his poster created for an election
campaign, Rivers compares the USA's
situation after four years under Nixon
with a jumbled-up puzzle, which only
McGovern can fit together again.

America Needs

McGOVERN

HE CAN
PUT IT TOGETHER

Photo by Malcolm Varon Printed by Colorcraft Offset, Inc. New York, N.Y.

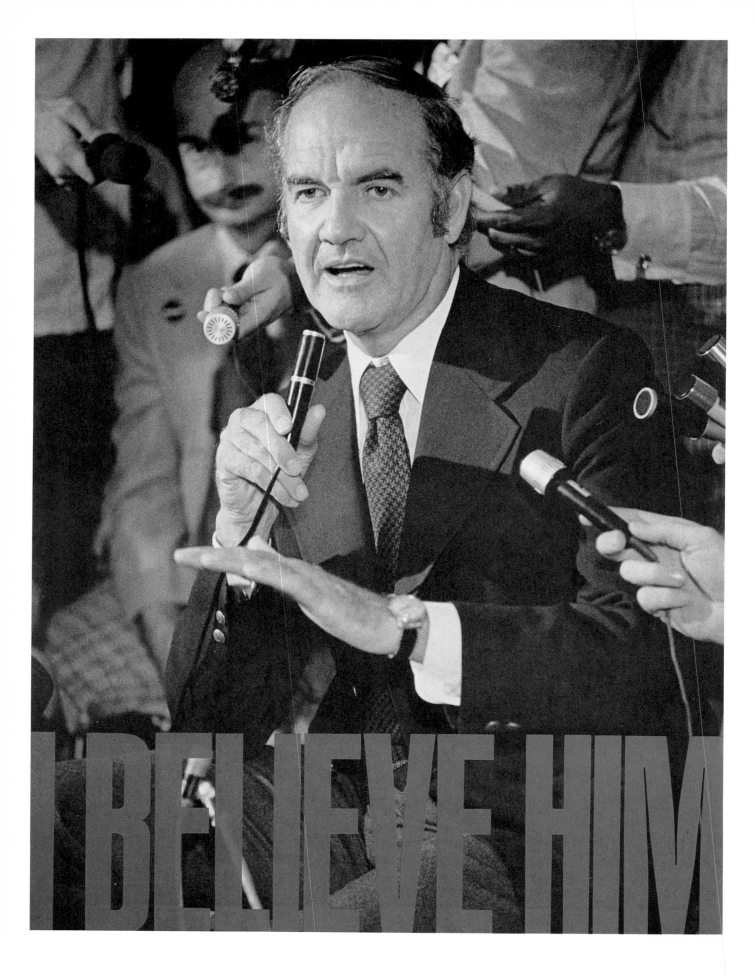

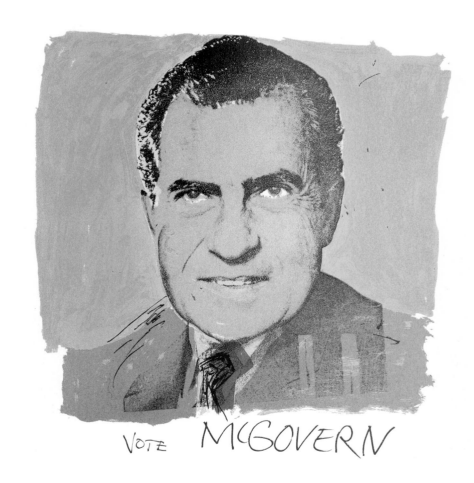

VOTE McGOVERN

Dan Flavin (1933–1996)

Ich glaube ihm / *I Believe Him*
New York 1972
Offset / *Offset print*, 81,5 × 68 cm

George McGovern, ein Gegner des
Vietnamkrieges, trat 1972 in der Präsi-
dentschaftswahl gegen Richard Nixon
an, der sich zur Wiederwahl stellte. Zahl-
reiche Künstler und Bürgerrechtler unter-
stützten die Kampagne von McGovern.
Das Plakat ist ein sehr ungewöhnliches
Werk des für seine Lichtskulpturen be-
kannten Künstlers.

George McGovern, an opponent of the
Vietnam War, ran against Richard Nixon
in the 1972 presidential election, with
Nixon running for reelection. A number
of artists and civil rights activists sup-
ported McGovern's campaign. This
poster represents an unusual artwork
by an artist better known for his light
sculptures.

Andy Warhol (1928–1987)

Wählt McGovern / *Vote McGovern*
New York 1972
Siebdruck / *Silkscreen print*, 107 × 107 cm

Dieser Wahlaufruf für George McGovern
wurde nie als Plakat gedruckt und
existiert nur als Sammlergrafik in einer
Auflage von 250 Exemplaren. Vielleicht
erschien den Herausgebern der Mc-
Govern-Plakatedition das boshaft einge-
färbte Nixon-Porträt zu widersprüchlich.

This call to vote for George McGovern
was never printed as a poster. It exists
only as a collector's print in an edition
of 250. Perhaps the publishers of the
McGovern poster edition thought that
the portrait of Nixon, with its unsettling
colors, was too confusing.

Klaus Staeck (*1938)

Zur Konfirmation / *For a Confirmation*
Heidelberg 1970
Siebdruck / *Silkscreen print*,
84,5 × 59,5 cm

Dieser Siebdruck ist eine der ersten politischen Grafiken im Plakatformat von Staeck, der sich von nun an auf satirische Plakate spezialisieren sollte. Ausgangspunkt ist eine der populärsten Zeichnungen von Albrecht Dürer, die »Betenden Hände«, deren Aussage Staeck durch die Schraubzwingen konterkariert. Kirchengemeinden oder Taufpaten schenkten ihren Konfirmanden früher häufig eine Reproduktion der Dürer-Zeichnung.

This silkscreen print is one of the first political prints in poster form by Staeck, who went on to specialize in satirical posters. It is based on one of Albrecht Dürer's best-known drawings – "Praying Hands" – which Staeck has caricatured by adding a screw clamp. Godparents and congregations often used to give young people reproductions of this Dürer drawing on the occasion of their confirmation.

Klaus Staeck (*1938)

Sozialnotfall / *Social Emergency*
Heidelberg 1971
Siebdruck / *Silkscreen print*, 86 × 61 cm

Staeck verwendet die Dürer-Zeichnung von der Mutter des Künstlers, um auf die soziale Not älterer Menschen hinzuweisen. Sie erschien im »Dürer-Jahr« 1971, als der Künstler anlässlich seines 500. Geburtstages erneut zur nationalen Identitätsfigur stilisiert wurde.

Staeck uses Dürer's drawing of his mother to draw attention to the issues affecting older people, asking: "Would you rent out a room to this woman?" The image appeared in 1971 – Dürer's 500th anniversary year – when the artist was again stylized as a national icon.

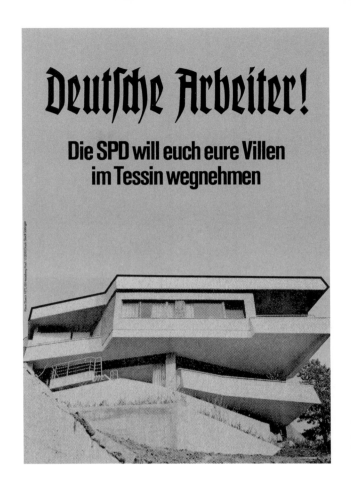

Klaus Staeck (*1938)

Deutsche Arbeiter! / *German Workers!*
Heidelberg 1972
Siebdruck / *Silkscreen print*, 83,5 × 59 cm

Der satirische Kommentar auf Angst
schürende Parolen rechter Politiker er-
schien im Jahr der Wahl Willy Brandts
zum Bundeskanzler. Das Plakat wurde
nicht direkt als Wahlplakat verwendet,
war aber das erste des Künstlers, das
unmittelbar auf die Tagespolitik Bezug
nahm.

*"The SPD will take away your villas in
the Ticino": this satirical commentary
on the scaremongering slogans of
right-wing politicians appeared in the
year that Willy Brandt was elected as
chancellor of the Federal Republic of
Germany. Not used directly as an elec-
tion poster, it was the first by the artist
to refer to the politics of the day.*

Kaspar-Thomas Lenk (*1933)

Ich wähle SPD / *I'm Voting SPD*
Bonn 1972
Siebdruck / *Silkscreen print*, 80 × 59,5 cm

Ähnlich wie McGovern in den USA
gelang es Willy Brandt in der Bundes-
republik, eine breite Unterstützung von
Intellektuellen und Künstlern zu erreichen.
Neben Schauspielern und Schriftstellern
– wie dem späteren Nobelpreisträger
Günter Grass – unterstützten auch
bildende Künstler die »Sozialdemokra-
tische Wählerinitiative«.

*In Germany, Willy Brandt enjoyed broad
support among intellectuals and artists,
as George McGovern did in the USA.
In addition to actors and authors –
including Günter Grass, who later
won the Nobel Prize – supporters of the
Sozialdemokratische Wählerinitiative
(Social Democrat Voter Initiative)
included visual artists.*

FREIHEIT

Die Jahre um 1968 hatten das politische Denken bleibend verändert. Überkommene Strukturen, staatliche Macht und generell Obrigkeit wurden mit Skepsis betrachtet; Ideale von Freiheit und Selbstverwirklichung ersetzten Traditionen und Konventionen. An solchen Wertvorstellungen wurde auch die Politik mächtigster Staaten gemessen. Hatte es in den fünfziger Jahren nur ein schwaches Aufbegehren gegen den Koreakrieg gegeben und setzten die Proteste gegen den Vietnamkrieg in den sechziger Jahren erst vergleichsweise spät ein, so wurden die »imperialistischen« Übergriffe der USA in Chile und Nicaragua sofort angeprangert. Die »außerparlamentarische Opposition« – die Anfänge der NGO's, der Non Governmental Organisations – hatte sich in allen westlichen Gesellschaften als fester Bestandteil der politischen und sozialen Landschaft etabliert.

Politische Themen fanden sich seit der 68er-Zeit häufiger im Künstlerplakat, doch spiegelten sie nicht die Vielfalt der Themen der siebziger Jahre, sondern konzentrierten sich auf vergleichsweise wenige Anliegen. Jenseits des Künstlerplakates hatten sich, als Teil von Protestbewegungen, eigene Grafikszenen gebildet, die die Aktivitäten und Forderungen gerade im Medium Plakat an die Öffentlichkeit trugen. Vorbild mögen die Plakate des Pariser Mai '68 gewesen sein, die gleichermaßen mit Fantasie und Bildgewalt auftraten.

Überschaut man die politischen Plakate von bekannteren Künstlern, so fällt auf, wie entscheidend das Engagement Einzelner dazu beitrug, manche Themen international publik zu machen. So wurden Joan Miró und Antoni Tàpies nicht müde, die Unterdrückung ihrer katalanischen Heimat anzuprangern. Bereitwillig schufen sie Plakate für verschiedenste Anliegen, um die Forderung nach dem katalanischen Autonomiestatus zu unterstützen. Ihre diesbezüglichen Arbeiten gehören zu den eindringlichsten Grafiken der beiden Künstler. Gerade Tàpies gelang es, mit der Reduktion des Themas auf die Bestandteile der katalanischen Flagge – vier rote Streifen auf gelbem Grund – zu kraftvollen Aussagen zu kommen.

Eine weitere Entwicklung des Künstlerplakates ist in den siebziger Jahren entscheidend für die Abbildung politischer Themen, nämlich das Aufkommen von Plakatserien. Den Anfang machte 1971 eine sechsteilige Serie zum Umweltschutz, auf die im nächsten Kapitel eingegangen wird. Als die UNESCO das Jahr 1977 zum Jahr des politischen Gefangenen ausrief, forderte die Gefangenenhilfsorganisation Amnesty International Künstler aus verschiedenen Ländern auf, sich mit einem Entwurf an einer umfangreichen Serie von Künstlerplakaten zu beteiligen. Die Plakatdrucke wurden noch im selben Jahr rund um die Welt ausgestellt. Ähnlich kam sechs Jahre später eine Serie gegen die Apartheid in Südafrika zustande, diesmal organisiert von einem Komitee der UNO. Diese Künstlerplakate demonstrieren den stilistischen Reichtum der zeitgenössischen Kunst und fordern zugleich – handelt es sich doch stets um dieselben Themen – zu einem vergleichenden Betrachten der individuellen Stile heraus, zur Beurteilung ihrer Bildsprache und zur Kraft ihrer Aussage.

FREEDOM

The events of 1968 had a lasting impact on political thought. Traditional structures, state power and authority in general were met with suspicion, and ideals of freedom and self-determination replaced tradition and convention. The political conduct of powerful states began to be measured by these values. There was only slight resistance to the Korean War in the 1950s, and protests against the Vietnam War during the 1960s began at a comparatively late stage, but the USA's "imperialist" attacks on Chile and Nicaragua were quickly condemned. A non-parliamentary opposition, made up of what would later become NGOs, or Non-Governmental Organizations, had become established in all Western societies as a fixture of the political and social landscape.

Since 1968, political posters by artists had become more common, but rather than reflecting the wide variety of issues that existed during the 1970s they focused on a comparatively small range of topics. Aside from posters by artists, the protest movement had spawned its own printing scene, which reported its activities and demands to the public in poster form. These may have been inspired by the Paris posters of May '68, which featured images that were imaginative and powerful in equal measure.

Political posters by well-known artists show how influential some individuals were in bringing certain themes to international public attention. For instance, Joan Miró and Antoni Tàpies tirelessly drew attention to the oppression of their home region of Catalonia. They enthusiastically created posters for a number of initiatives for Catalan autonomy, and their prints on this subject are some of the most impressive by the two artists. Tàpies in particular managed to create powerful messages by reducing his designs to the components of the Catalan flag – four red stripes on a yellow background.

Another development in artists' posters in the 1960s crucially affected the way political themes were depicted, namely the emergence of poster series. This began in 1971 with a six-part series on environmental conservation, which will be discussed in the next chapter. When UNESCO designated 1977 as the Year of the Political Prisoner, the prisoners' aid organization Amnesty International called on artists from a number of different countries to create designs for an extensive series of art posters. In the same year, these poster prints were exhibited all over the world. Six years later, a series was created attacking apartheid in South Africa, this time under the auspices of a UN committee. Such art posters demonstrate the stylistic variety in the art of the time, inviting us to compare individual styles and to assess their visual language and impact.

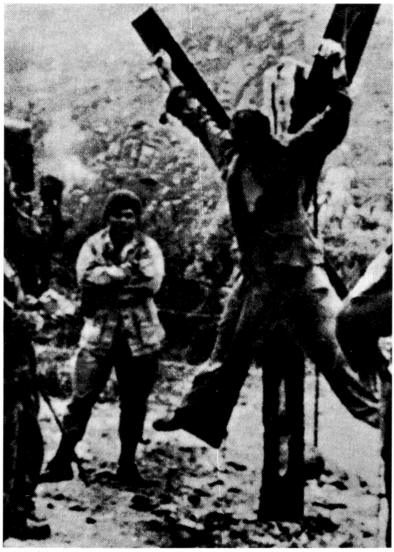

Olympische Spiele München 1972

Staeck Bill Heidelberg Box 471

Klaus Staeck (*1938)

Olympische Spiele München /
Munich Olympic Games
Heidelberg 1972
Siebdruck / *Silkscreen print*, 99,5 × 64 cm

Staeck übernahm den Schriftzug der offiziellen Münchener Olympiaplakate und setzte eine Folterszene aus Südamerika darüber. Aus dem olympischen Symbol der fünf Ringe, das auf die Freundschaft der Völker verweisen soll, machte er einen Schlagring.

Here, Staeck imitates the typography of the official Munich Olympics posters, adding a South or Central American torture scene. He replaced the Olympic symbol – the five rings – with a set of brass knuckles.

HAP Grieshaber (1909–1981)

Chile
Reutlingen 1972
Holzschnitt / *Woodcut*, 77 × 56 cm

Das Plakat wurde für verschiedene Chile-Veranstaltungen in Süddeutschland verwendet, die zur Solidarität mit dem sozialistischen Präsidenten Salvador Allende aufriefen. Dessen Regierung wurde von den USA boykottiert und später durch einen Militärputsch gestürzt.

This poster was used for various events in southern Germany relating to Chile and promoting solidarity with the socialist president Salvador Allende. This regime was boycotted by the USA and later fell in a military putsch.

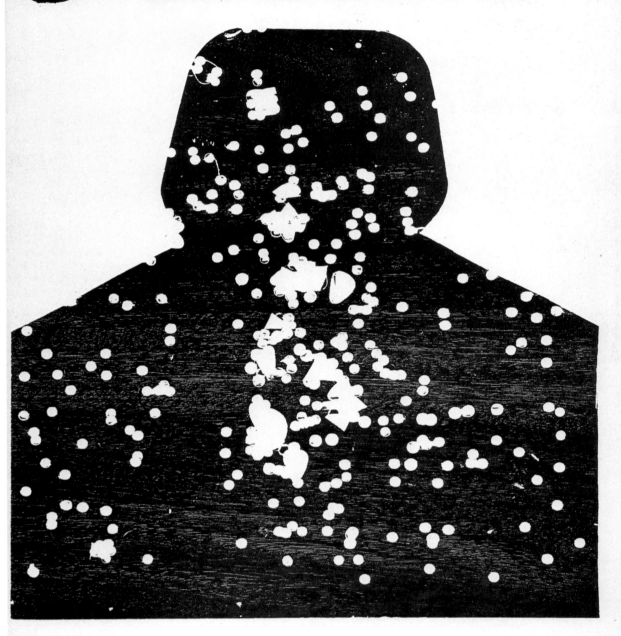

1920 LEAGUE OF WOMEN VOTERS 1970

Richard Anuszkiewicz (*1930)

Liga der Wählerinne / *League of Women Voters*
USA 1969
Siebdruck / *Silkscreen print*,
59,5 × 100,5 cm

Anuskiewicz, einer der Begründer der Op-Art, weicht in diesem Plakat zum Frauenwahlrecht in den USA nicht von seinem gegenstandslosen Weg ab. Fünfzig Quadrate in zunehmender Intensität feiern das fünfzigjährige Bestehen des Wahlrechts für Frauen.

Anuszkiewicz, a pioneer of Op Art, used his customary abstract style to create this poster on women's enfranchisement in the USA. Fifty squares, increasing in intensity from left to right, celebrate fifty years of votes for women.

Sonia Delaunay (1885–1979)

Internationales Jahr der Frau /
International Year of the Woman
Paris 1975
Lithografie / *Lithograph*, 77 × 51 cm

Die Grande Dame der französischen Malerei schuf – im Alter von 90 Jahren – mit diesem Auftrag für die UNESCO noch einmal eine ihrer farbintensiven Kompositionen aus Kreissegmenten.

The "grande dame" of French painting created this colorful arrangement of circle sections – commissioned by UNESCO – at the age of 90.

UNESCO

ANNÉE INTERNATIONALE
DE LA FEMME 1975

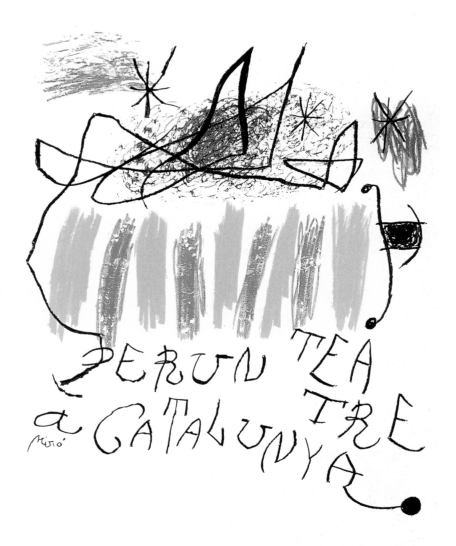

Joan Miró (1893–1983)

Für ein katalanisches Theater /
For a Catalan Theater
Barcelona 1973
Lithografie / *Lithograph*, 75 × 56 cm

Franco beendete 1939 den Autonomie-
status Kataloniens und ging gegen alle
Bestrebungen katalanischer Selbst-
bestimmung vor. Auch die katalanische
Kultur, bis hin zum öffentlichen Ge-
brauch der Sprache, wurde unterdrückt.

In 1939, Franco ended Catalonia's
autonomous status and opposed
all self-determination for the region.
Catalan culture, including the public
use of the Catalan language, was also
suppressed.

Joan Miró (1893–1983)

UNESCO – Menschenrechte /
Human Rights
Palma de Mallorca / New York 1974
Lithografie / *Lithograph*, 74 × 54,5 cm

Das Plakat entstand für eine Menschen-
rechtskampagne der UNESCO und
wurde von dieser in verschiedenen
Sprachen verbreitet.

This poster was designed for a
UNESCO campaign for human rights,
and was distributed in several languages.

unesco miró

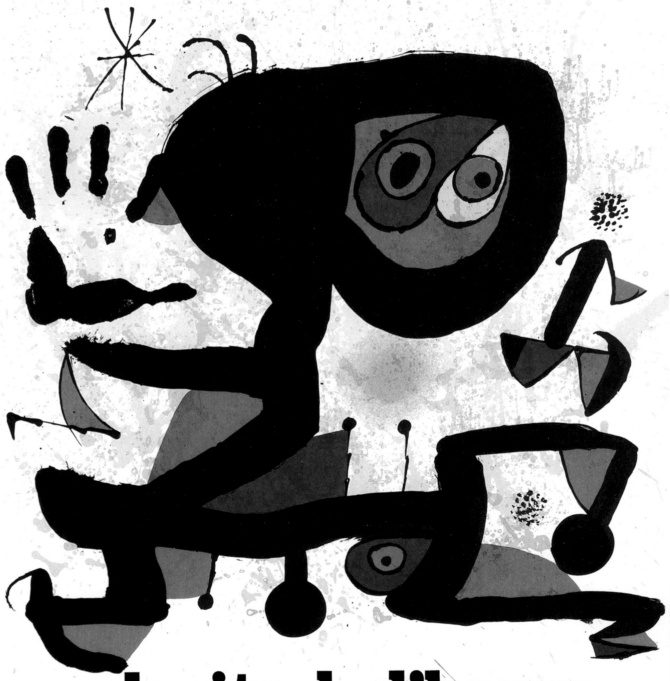

droits de l'homme

ARTE PARIS

DIARI EN CATALÀ

Joan Miró (1893–1983)

Avui
Barcelona 1976
Lithografie / *Lithograph*, 68,5 × 52 cm

Miró unterstützt hier die Tageszeitung
»Avui«, die nach dem Ende des Franco-
regimes in katalanischer Sprache er-
scheinen konnte.

Miró shows his support for "Avui,"
the Catalan daily newspaper, which was
again able to be printed in Catalan
following the death of Franco in 1975.

Joan Miró (1893–1983)

Katalanischer Kulturkongress / *Catalan*
Congress of Culture
Barcelona 1977
Lithografie / *Lithograph*, 75 × 57 cm

Zeitgleich mit einem vorhergehenden
Entwurf, der eine eigene Verfassung
forderte, entstand diese Ankündigung
für einen katalanischen Kulturkongress.

Miró created this poster announcing
a Catalonian cultural congress at the
same time as his preceding design,
which demanded a constitution for
Catalonia.

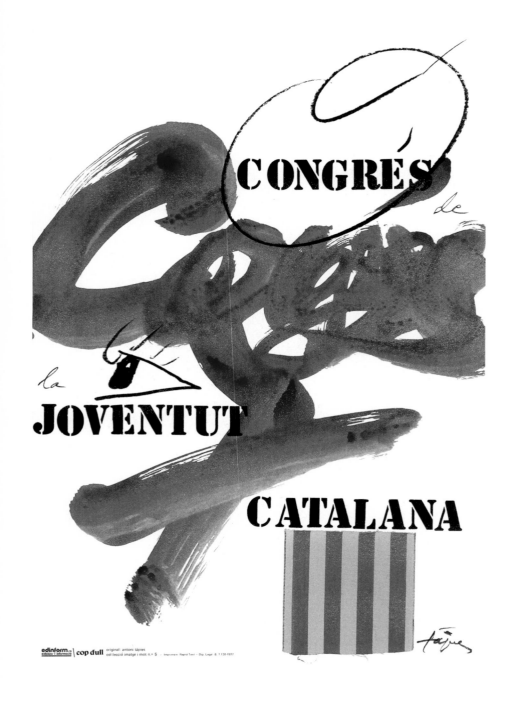

CONGRÉS de la JOVENTUT CATALANA

Antoni Tàpies (*1923)

Katalanischer Jugendkongress /
Catalan Youth Congress
Barcelona 1977
Offset / *Offset print*, 62 × 42 cm

1977, zwei Jahre nach dem Tod Francos, erlangte Katalonien erneut, wenn auch zunächst nur provisorisch, sein Autonomiestatut. Wohl aus diesem Grund entstanden in diesem Jahr besonders viele Plakate, die für die Eigenständigkeit des Landes und seiner Kultur eintraten.

In 1977, two years after the death of Franco, Catalonia regained its autonomous status, albeit on a provisional basis. Presumably for this reason a particularly large number of posters appeared promoting the region's independence and culture.

Antoni Tàpies (*1923)

Katalanischer Kulturkongress /
Catalan Congress of Culture
Barcelona 1977
Lithografie / *Lithograph*, 75,5 × 58 cm

Der Ankündigung eines Kulturkongresses fügte Tàpies die Forderung nach der Freiheit Kataloniens hinzu. Der Entwurf entstand zum selben Anlass wie derjenige von Miró (→ S. 75).

Tàpies combines the announcement of an upcoming cultural congress with a demand for the freedom of Catalonia. Miró's design (→ p. 75) was created to mark the same event.

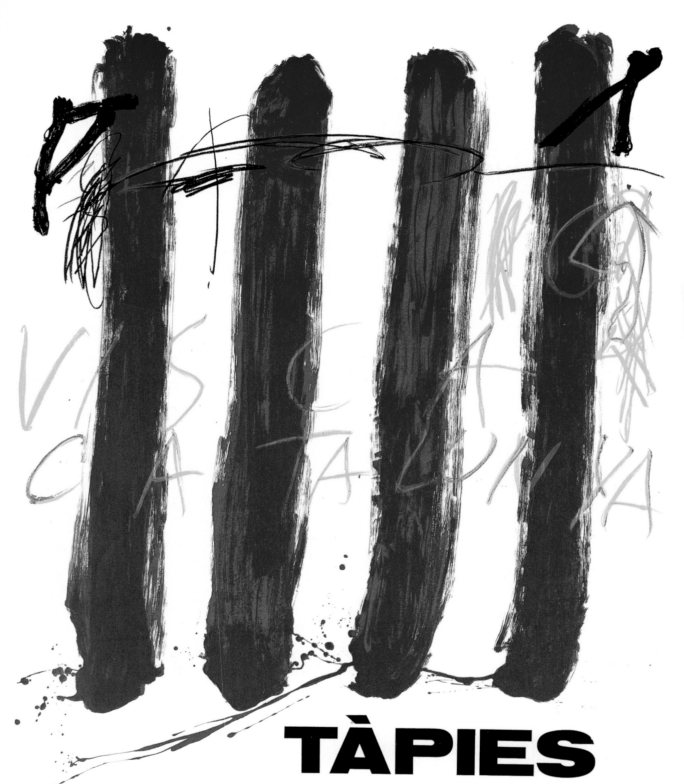

TÀPIES

GALERIE MAEGHT

Antoni Tàpies (*1923)

Galerie Maeght
Barcelona / Paris 1972
Lithografie / *Lithograph*, 160 × 119 cm

Tàpies wählte für sein großes Pariser
Ausstellungsplakat die Farben seiner
Heimat Katalonien: die »quatre barres«
auf dem gelben katalanischen Tuch.
Der Sage nach soll Karl der Kahle
den Grafen Wilfried von Barcelona am
Krankenbett besucht, seine Finger in
das Blut des Verwundeten getaucht
und damit vier rote Streifen über dessen
noch wappenlosen goldenen Schild
gezogen haben.

For his large Paris exhibition poster,
Tàpies used the colors of his Catalan
home: the "quatre barres" (four bars)
on the yellow Catalan cloth. According
to legend, Charles the Bald visited the
wounded Count Wilfred of Barcelona,
dipping his fingers in his blood and
making four red stripes on what had
hitherto been a plain golden shield.

Antoni Tàpies (*1923)

Friedensmarsch / *The March*
of Liberty
Barcelona 1976
Offset / *Offset print*, 63 × 43 cm

Das Plakat entwarf Tàpies für einen
Protestmarsch zur Wiedererlangung des
Autonomiestatus Kataloniens nach dem
Tod des Diktators Franco. Die Generali-
tät, die katalanische Regierung, wurde
im folgenden Jahr wieder zugelassen.

Tàpies designed this poster for a
protest march calling for the restoration
of Catalonia's autonomous status after
the death of the dictator Franco. The
Generality – the Catalan government –
was restored the following year.

MARXA DE
LA LLIBERTAT

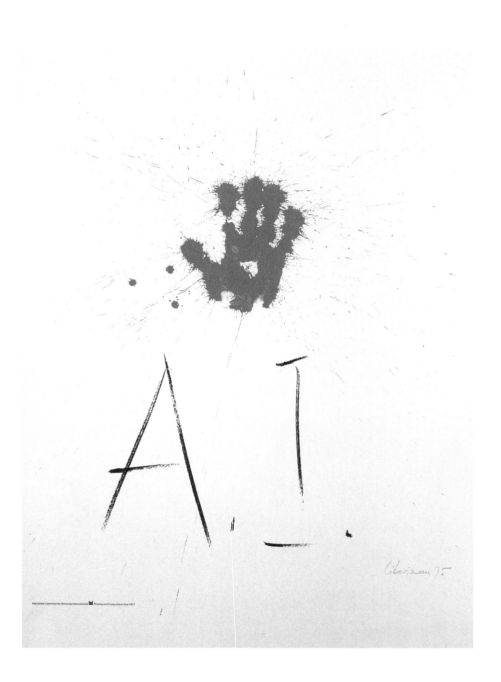

Alexander Liberman (1912–1999)

A.I.
New York 1977
Offset / *Offset print*, 84,5 × 64 cm

Liberman, seit den fünfziger Jahren einer der führenden gegenstandslosen Künstler der USA, wählte mit dem roten Handabdruck ein emotional aufgeladenes Symbol für sein Amnesty-Plakat. Die Anfangsbuchstaben »A.I.« dienten der Gefangenenhilfsorganisation bis 2008 als Logo. Seither wird international einheitlich der Name ausgeschrieben und daneben eine von Stacheldraht umwickelte Kerze abgebildet.

For his Amnesty poster, Liberman (from the 1950s onwards one of the USA's leading non-representational artists) chose an emotionally charged symbol: a red handprint. Until 2008 the initials A.I. were the logo of this organization dedicated to helping prisoners. In that year the logo changed into the fully written name accompanied by an image of a candle enclosed in barbed wire.

Arman (Armand Pierre Fernandez; 1928–2005)

Amnestie / *Amnesty*
Paris 1977
Lithografie / *Lithograph*, 75 × 50,5 cm

Das Blatt gehört zur Serie der Künstlerplakate für Amnesty International. Der Schriftzug Amnesty entstand aus den Abdrucken von verschiedenen Teilen einer zerstörten Violine. Arman setzte in seinen Materialbildern mehrfach Violinen ein, zerstörte ihre Körper und platzierte die Einzelteile nebeneinander.

This poster comes from the Amnesty International series of artists' posters. Here the word "Amnesty" has been created using various parts of a destroyed violin. Arman often used violins in his material pictures, breaking the soundbox apart and placing the pieces side by side, or using them to apply the paint.

Arman for Amnesty International ⊡ Prisoners of Conscience Year 1977

amnesty international

Max Bill for Amnesty International ▮ Prisoners of Conscience Year 1977

Max Bill (1908–1994)

Amnesty International
Zürich / *Zurich* 1977
Offset / *Offset print*, 83 × 61 cm

Anders als bei dem ebenfalls ungegen-
ständlichen Entwurf von Jack Younger-
man (→ S. 84) meint man bei Max Bill
das Motiv interpretieren zu können:
Das Schwarz versinnbildlicht Gefängnis-
mauern, aus denen das bunte Leben
herausbricht.

Unlike the equally non-representational
design by Jack Youngerman (→ p. 84),
this image by Max Bill suggests a clear
interpretation. The black areas symbolize
prison walls, with brightly-colored life
breaking out.

Joan Miró (1893–1983)

Amnesty International
Palma de Mallorca 1977
Lithografie / *Lithograph*, 90 × 60,5 cm

Mirós Beitrag zu der Amnesty-Plakat-
serie gehört zu seinen besten Plakaten.
Die 15 Blätter der Serie wurden 1977
im zwei Jahre zuvor eröffneten Museum
Fundació Joan Miró in Barcelona ge-
zeigt.

Miró's contribution to the Amnesty
poster series is one of his best poster
designs. In 1977, this series of 15
posters was displayed at the Fundació
Joan Miró in Barcelona, which had
opened two years previously.

JOAN MIRO FOR AMNESTY INTERNATIONAL ▣ PRISONERS OF CONSCIENCE YEAR 1977

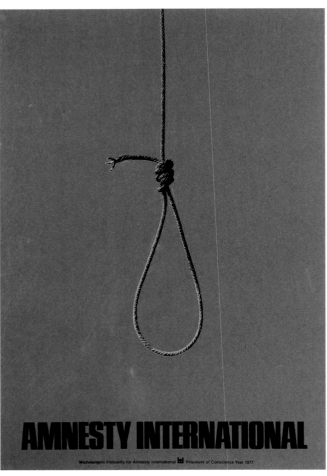

Jack Youngerman (*1926)

Amnesty International
New York 1977
Siebdruck / Silkscreen print, 81,5 × 64 cm

Das Plakat wurde mit den anderen der
Serie im »Prisoners of Concsience Year«
in Barcelona ausgestellt. Die Gefange-
nenhilfsorganisation erhielt im Dezember
des Jahres den Friedensnobelpreis.

*This poster was exhibited in Barcelona
along with the others in the "Prisoners
of Conscience Year" series. Amnesty
International was awarded the Nobel
Peace Prize in December of the
same year.*

Michelangelo Pistoletto (*1933)

Amnesty International
Italien / Italy 1977
Siebdruck auf verspiegelter Aluminium-
folie / Silkscreen print on mirrored
aluminum foil, 83 × 59 cm

Pistoletto, der in seinem Werk häufig
mit Spiegeln arbeitet und dadurch den
Betrachter ins Bild mit einbezieht, ver-
wandte diese Bildidee mit geändertem
Text auch mehrfach für eigene Ausstel-
lungen. In Barcelona wurde dieses Plakat
1977 neben anderen ausgewählt, um die
Ausstellung der Amnesty-Plakate in der
Fundació Joan Miró anzukündigen.

*Pistoletto, who often incorporates
mirrors into his work to make the viewer
part of the picture, used this image –
with altered text – several times for his
own exhibitions. This was one of the
posters selected to publicize the exhibi-
tion of Amnesty posters at the Fundació
Joan Miró in Barcelona in 1977.*

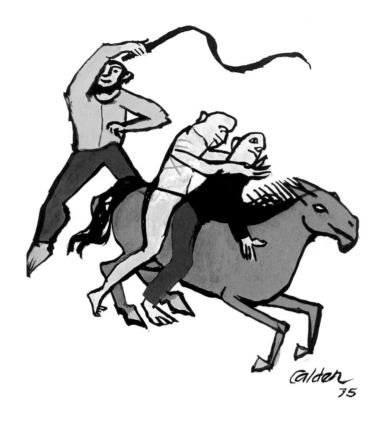

Alexander Calder (1898–1976)

Amnesty International
Connecticut 1975 / London 1977
Offset / *Offset print*, 77,5 × 76,5 cm

Der Bildhauer Calder, bekannt für seine
großen Mobiles und Stabiles aus Eisen,
tritt hier mit einer für ihn ungewöhnlichen
figürlichen Zeichnung auf. Sie entstand
zwei Jahre vor der Amnesty-Plakatserie
von 1977, in deren Rahmen sie als Plakat
gedruckt wurde.

This figural drawing is an unusual art-
work by Calder, a sculptor best known
for his large steel "mobiles" and
"stabiles." It was created two years prior
to the Amnesty poster series of 1977,
for which it was reproduced as a poster.

HAP Grieshaber (1909–1981)

Amnesty International
Reutlingen 1977
Holzschnitt / *Woodcut*, 70 × 59 cm

Die UNESCO rief 1977 zum Jahr des
politischen Gefangenen aus. Die Ge-
fangenen-Hilfsorganisation Amnesty
International veröffentlichte aus diesem
Anlass eine umfangreiche, international
verbreitete Serie von Künstlerplakaten.
Grieshaber führte seinen Beitrag als
Holzschnitt aus.

UNESCO designated 1977 as the
Year of the Political Prisoner. To mark
this, the aid organization for prisoners,
Amnesty International, published an
extensive international art poster series.
Grieshaber contributed this woodcut.

rot

Dieter Roth (1930–1998)

1
Stuttgart 1994
Siebdruck / *Silkscreen print*, 84 × 59,4 cm

Herausgegeben von der Kulturgemeinschaft des Deutschen Gewerkschaftsbundes in Stuttgart, die häufig Künstler mit Plakaten zum 1. Mai beauftragte.

Published by the Kulturgemeinschaft des Deutschen Gewerkschaftsbundes (Cultural Confederation of German Trade Unions) in Stuttgart, which often commissioned posters from artists to mark May 1.

HAP Grieshaber (1909–1981)

Demokraten wählen! / *Democrats Vote!*
Reutlingen 1980
Siebdruck / *Silkscreen print*, 100 × 63 cm

Grieshaber wählte ein Wortspiel, um vor Neofaschisten und rechtsradikalen Parteien zu warnen und zugleich darauf aufmerksam zu machen, dass es eine Pflicht des Demokraten sei, an der Wahl teilzunehmen.

Grieshaber's play on words (Democrats vote! / Vote for democrats!) is both a warning against neo-fascists and radical right-wing parties and a reminder to those who support democracy that they have a duty to vote.

K.R.H. Sonderborg (1923–2008)

Arbeit für Alle / *Work for All*
Stuttgart 1989
Offset / *Offset print*, 98 × 67,8 cm

Zum 1. Mai 1989 vom Deutschen Gewerkschaftsbund herausgegeben.

Issued by the Deutscher Gewerkschaftsbund (Confederation of German Trade Unions) in 1989 to mark May 1. The poster demands: "Work for all – but not too much!"

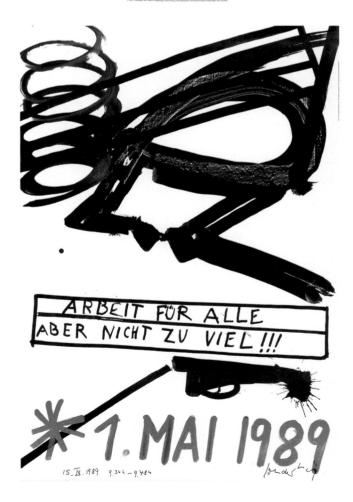

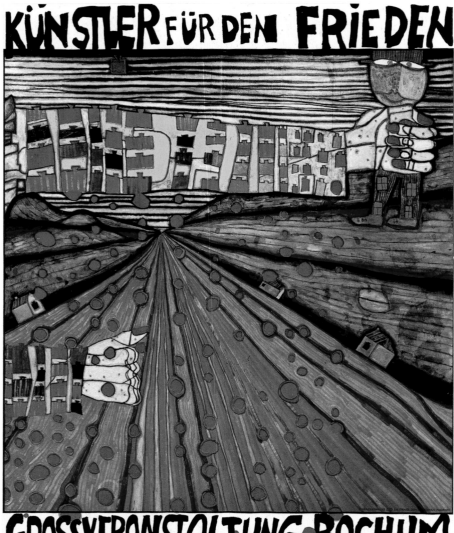

Friedensreich Hundertwasser
(1928–2000)

Künstler für den Frieden / *Artists for Peace* (833A)
ohne Ort / *no place* 1982
Offset / *Offset print*, 84 × 59 cm

Dieses Blatt gehört zu einer Serie von 15 Plakaten, die zu einer Großdemonstration in Bochum 1982 aufriefen. Die Veranstaltung richtete sich gegen den so genannten Nato-Doppelbeschluss, der die Stationierung amerikanischer Mittelstreckenraketen in Europa vorsah.

This poster is from a series of 15 posters calling for a major demonstration in Bochum in 1982. The event was organized by opponents of the so-called Nato Double-Track Decision to permit the stationing of mid-range rockets in Europe.

Roy Lichtenstein (1923–1997)

I Love Liberty
New York 1982
Offset / *Offset print*, 99,5 × 60 cm

Das Plakat kündigte eine kalifornische Aktion zur Einhaltung der in der Verfassung verbürgten Rechte an. Das Bildzitat mit dem Kopf der Freiheitsstatue beruht mit seiner starken Unteransicht auf einer Ansichtspostkarte.

This poster announces a Californian campaign to safeguard the rights enshrined in the American Constitution. This profile of the Statue of Liberty, seen from below, is based on a postcard view.

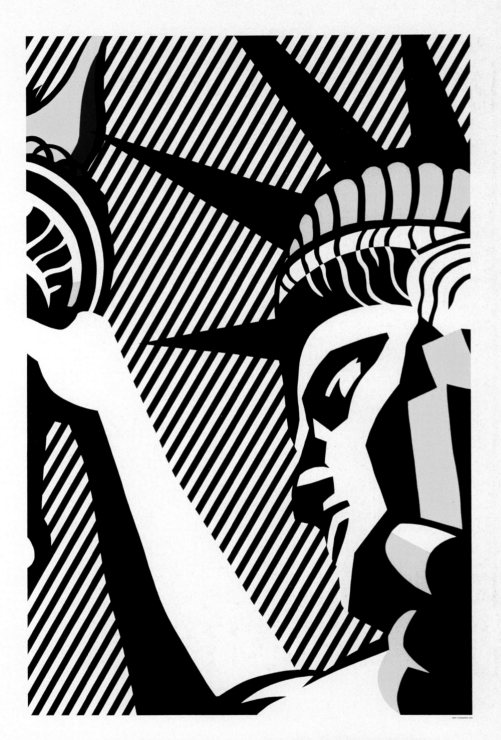

I LOVE LIBERTY

22 FEB 1982

ARTISTS CALL AGAINST U.S. INTERVENTION IN CENTRAL AMERICA

IF WE CAN SIMPLY WITNESS THE DESTRUCTION OF ANOTHER CULTURE, WE ARE SACRIFICING OUR OWN RIGHT TO MAKE CULTURE. ANYONE WHO HAS EVER PROTESTED REPRESSION ANYWHERE SHOULD CONSIDER THE RESPONSIBILITY TO DEFEND THE CULTURE AND RIGHTS OF THE CENTRAL AMERICAN PEOPLE.

THE ARTS ARE USED BY OUR GOVERNMENT AS EVIDENCE OF CREATIVE FREEDOM, AND THE LACK OF CENSORSHIP IN A DEMOCRACY. AT THE SAME TIME, THE REAGAN ADMINISTRATION DENIES THE PEOPLE OF CENTRAL AMERICA THE RIGHT TO SELF-DETERMINATION AND TO INDEPENDENCE.

IT IS OF THE UTMOST IMPORTANCE THAT THE PEOPLE OF NORTH AMERICA EXPRESS NOW OUR DEEP CONCERN FOR PEACE AND FREEDOM IN CENTRAL AMERICA, WHERE THE SITUATION BECOMES MORE CRITICAL EACH DAY.

THE U.S. GOVERNMENT CONTINUES TO AMPLIFY ITS MILITARY PRESENCE IN THE REGION, AND IN THE CASE OF NICARAGUA, TO IMPOSE UNJUST ECONOMIC SANCTIONS THAT MAKE LIFE EVEN HARDER FOR ITS INHABITANTS. HONDURAS HAS BEEN TRANSFORMED INTO A GIGANTIC MILITARY BASE, THE ONGOING GENOCIDE OF GUATEMALAN INDIANS IS IGNORED, AND AN UNDECLARED OVERT WAR IS BEING WAGED AGAINST NICARAGUA. EXTENSIVE MILITARY ASSISTANCE IS GIVEN TO A GOVERNMENT IN EL SALVADOR THAT VIOLATES INTERNATIONALLY RECOGNIZED HUMAN RIGHTS BY SUBJECTING PRISONERS TO INHUMANE PUNISHMENT, BY CLOSING THE NATIONAL UNIVERSITY AND BY TOLERATING POLITICAL ASSASSINATIONS BY RIGHT-WING DEATH SQUADS.

ACCORDING TO A REPORT SUBMITTED BY AMNESTY INTERNATIONAL TO THE COMMITTEE ON FOREIGN AFFAIRS OF THE U.S. CONGRESS ON JULY 26, 1983, TEACHERS AND ACADEMICS IN PARTICULAR HAVE BEEN TARGETED FOR REPRESSION BECAUSE, AS POTENTIAL COMMUNITY LEADERS, THEY FOCUS OPPOSITION TO THE AUTHORITIES. ARTISTS, WRITERS, POETS, MUSICIANS, JOURNALISTS, WORKERS, UNION MEMBERS AND MEDICAL PERSONNEL ARE ALSO AMONG THE 35,000 VICTIMS OF MURDER AND TORTURE BY THE U.S.-BACKED FORCES IN EL SALVADOR IN THE LAST THREE YEARS. OVER 1000 PEOPLE, MANY OF THEM INNOCENT CIVILIANS, HAVE BEEN KILLED BY THE U.S.-BACKED COUNTER-REVOLUTIONARIES IN NICARAGUA IN THE LAST YEAR.

THE U.S. GOVERNMENT RECOGNIZES HUMAN RIGHTS LAWS AS BINDING ON THE INTERNATIONAL COMMUNITY AND AT THE SAME TIME GIVES MILITARY AND ECONOMIC SUPPORT TO A GOVERNMENT IN EL SALVADOR THAT OPENLY VIOLATES THESE LAWS. THE U.S. GOVERNMENT RECOGNIZES THE RIGHT TO NATIONAL SELF-DETERMINATION, AND AT THE SAME TIME, SUPPORTS DAILY INCURSIONS INTO NICARAGUA.

WE CALL UPON THE REAGAN ADMINISTRATION TO HALT MILITARY AND ECONOMIC SUPPORT TO THE GOVERNMENTS OF EL SALVADOR AND GUATEMALA, TO STOP THE MILITARY BUILDUP IN HONDURAS AND TO CEASE SUPPORT OF THE CONTRAS IN NICARAGUA.

INTERVENTION BY THE U.S. GOVERNMENT INEVITABLY REINFORCES COLONIALIST AND OLIGARCHICAL ELEMENTS HOSTILE TO THE PEOPLE, AS THE INVASION OF GRENADA DEMONSTRATES. THEREFORE, WE CALL UPON THE REAGAN ADMINISTRATION AND THE U.S. CONGRESS TO RESPECT THE RIGHT OF THE CENTRAL AMERICAN PEOPLES TO SELF-DETERMINATION AND TO STOP INTERFERING IN THEIR INTERNAL AFFAIRS. WE MUST SPEAK OUT AGAINST THESE BURNING INJUSTICES NOW AND WE WILL CONTINUE TO DO SO AS LONG AS IT IS NECESSARY.

ARTISTS CALL AGAINST U.S. INTERVENTION IN CENTRAL AMERICA IS A NATIONWIDE MOBILIZATION OF ARTISTS ORGANIZING OUT OF NEW YORK CITY. A HUGE SERIES OF EXHIBITIONS AND EVENTS WILL BE CENTERED AROUND JANUARY 22ND—THE 52ND ANNIVERSARY OF THE 1932 MASSACRE IN EL SALVADOR WHICH MARKED THE BEGINNING OF THE SYSTEMATIC DESTRUCTION OF THE SALVADORAN CULTURE. IN CONJUNCTION WITH THE INALSE (THE INSTITUTE FOR THE ARTS AND LETTERS OF EL SALVADOR IN EXILE) AND IN COOPERATION WITH THE ASTC (THE SANDINISTA ASSOCIATION OF CULTURAL WORKERS)— ARTISTS CALL WILL JOINTLY EXHIBIT ART FROM CENTRAL AMERICA, ART ABOUT CENTRAL AMERICA AND ART IN SUPPORT OF CENTRAL AMERICA, AS A POLITICAL AND ESTHETIC STRATEGY TO CALL ATTENTION TO CENTRAL AMERICAN ISSUES. ARTISTS CALL REPRESENTS THE OUTRAGE OF THOUSANDS OF ARTISTS AND INTELLECTUALS CONCERNED WITH THE REPRESSION OF THE CRUCIAL CULTURAL RIGHTS OF ALL PEOPLE.

ARTISTS CALL GENERAL STATEMENT, JANUARY 1984

Poster Design: Claes Oldenburg
Production: Sara Seagull & the Poster Committee of ARTISTS CALL

Claes Oldenburg (*1929) und/and
Coosje van Bruggen (1942–2009)

Aufruf der Künstler gegen die US-Inter-
vention in Mittelamerika / *Artists Call
against U.S. Intervention in Central
America*
New York 1984
Offset / *Offset print*, 94,2 × 61 cm

Die USA unter Ronald Reagan unter-
nahmen in den achtziger Jahren mehr-
fach den Versuch, die Sandinistische
Regierung in Nicaragua zu stürzen.
Der Internationale Gerichtshof in Den
Haag verurteilte das Vorgehen der USA.
Das Bildmotiv zitiert Joe Rosenthals
berühmtes Foto vom Hissen der Flagge
nach der Erstürmung der japanischen
Insel Iwo Jima im Zweiten Weltkrieg.
Hunderte von Künstlern sind alpha-
betisch aufgelistet.

*During the 1980s under Ronald
Reagan, the USA repeatedly tried to
overthrow Nicaragua's Sandinista
regime. The International Court in The
Hague condemned the USA's actions.
This image references Joe Rosenthal's
famous photograph of the raising of the
flag after the storming of the Japanese
island of Iwo Jima during the Second
World War. The poster lists hundreds
of artists in alphabetical order.*

Antonio Saura (1930–1998)

Tod der Apartheid / *Death to Apartheid*
Paris 1983
Lithografie / *Lithograph*, 85 × 60 cm

In der aufrechten weißen Form mag man
eine geballte Faust erkennen, in ihrer
Ausführung typisch für die expressive
Bildsprache des spanischen Künstlers.
Sie schlägt einen kämpferischen Ton an,
wie ihn der African National Congress
als wichtigste Anti-Apartheid-Organisa-
tion seit den siebziger Jahren vortrug.

*This erect white shape could be seen
as a clenched fist, its execution typical
of this Spanish artist's expressive
imagery. It is militant in tone, matching
the attitude taken by the ANC (African
National Congress), the most important
African anti-apartheid organization at
the time.*

MUERTE AL APARTHEID

En coopération avec le Comité Spécial des Nations Unies contre l'apartheid · In co-operation with the United Nations Special Committee against Apartheid

Antoni Tàpies (*1923)

Apartheid ist ein Verbrechen /
Apartheid is a Crime
Barcelona 1983
Offset / *Offset print*, 85 × 60 cm

1983 organisierte das United Nations
Special Committee against Apartheid
eine 15-teilige Serie von Künstler-
plakaten, die sich gegen Apartheid
aussprach. Zehn Jahre zuvor hatte die
UNO in einer Resolution Apartheid als
Verbrechen gegen die Menschheit
gebrandmarkt.

*In 1983, the United Nations Special
Committee Against Apartheid instigated
a 15-part series of artists' posters with
anti-apartheid messages. Ten years
previously, the UN had passed a
resolution branding apartheid a crime
against humanity.*

Arman (Armand Pierre Fernandez; 1928–2005)

Künstler der Welt gegen Apartheid /
Artists of the World Against Apartheid
Paris 1983
Lithografie / *Lithograph*, 85 × 60 cm

Der symbolträchtige Entwurf des
französischen Künstlers wendet sich
im Rahmen der 15-teiligen Serie der
UNO – »Artistes du monde contre
l'apartheid« – gegen das System der
Rassentrennung in Südafrika.

*This highly symbolic design by the
French artist Arman is part of the
UN's 15-part series "Artistes du Monde
Contre L'Apartheid," a protest against
South Africa's system of racial
segregation.*

Lucebert (Lubertus Jacobus Swanswijk; 1924–1994)

Apartheid – wie die Weißen groß werden /
Apartheid – How Whites Grow Big
Amsterdam 1983
Lithografie / *Lithography*, 85 × 60 cm

Wie die anderen Mitglieder der Pariser
Künstlergruppe Cobra verwendet der
niederländische Maler und Dichter eine
krude figürliche Bildsprache mit durch-
aus satirischen Anklängen, die auch
in diesem Anti-Apartheid-Plakat der
UNO-Serie zum Ausdruck kommt.

*Like other members of the COBRA
artist group in Paris, this Dutch painter
and poet used crude figural imagery
with highly satirical overtones. These
qualities can also be seen in this anti-
apartheid poster for the UN series.*

artistes du monde contre l'apartheid

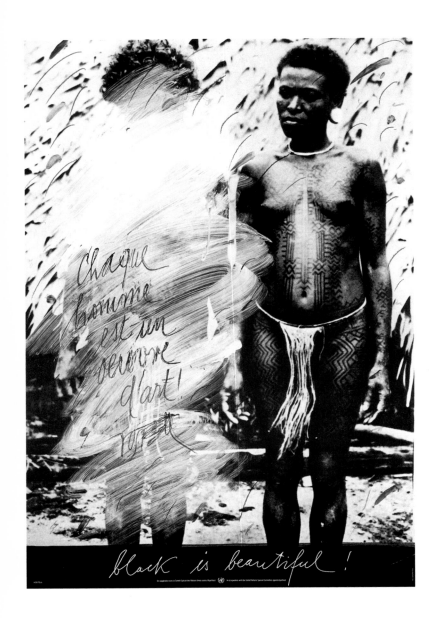

Wolf Vostell (1932–1998)

Jeder Mensch ist ein Kunstwerk /
Every Human Being Is a Work of Art
Köln / *Cologne* 1983
Siebdruck / *Silkscreen print*, 85 × 60 cm

Der deutsche Künstler Vostell zitiert in
seinem Beitrag für die UNO-Serie eine
der typischen Bildpostkarten aus der
Kolonialzeit, bei denen ein scheinbar
wissenschaftlich-ethnologisches Inter-
esse nicht zu übersehende voyeuris-
tische Nebentöne rechtfertigt. Vostell
betont mit seiner ins Bild geschriebenen
programmatischen Aussage die Gleich-
heit aller Menschen.

In his contribution to the UN series,
Vostell, a German artist, references
a typical picture postcard from the
colonial period in which the scientific
or ethnological gaze is used as a cloak
for an unmistakable voyeurism. Vostell
emphasizes the equality of all human
beings by means of a programmatic
quotation.

Keith Haring (1958–1990)

Befreit Südafrika / *Free South Africa*
New York 1985
Offset / *Offset print*, 122 × 122 cm

Das Plakat, zu dem es eine größere Zahl
von Entwürfen gibt, entstand auf eigenes
Betreiben des Künstlers. Haring ließ
den großformatigen Druck in seinem
»Pop Shop« in New York für eine Schutz-
gebühr von einem Dollar abgeben.

Haring created this poster, for which
a large number of designs exist, on his
own initiative. Haring sold this large-
format print in his "Pop Shop" in New
York for a token charge of one dollar.

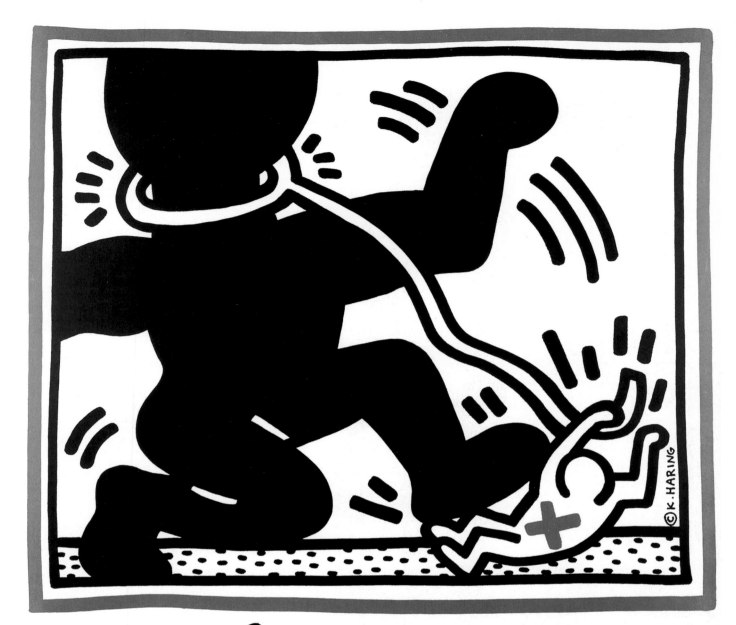

FREE SOUTH AFRICA

Die ersten größeren Umweltbewegungen entstanden um 1970. 1971 wurde Greenpeace in Vancouver gegründet. Im Jahr zuvor hatte in den USA der erste »Earth Day« stattgefunden, ein Tag, an dem einmal im Jahr mit Aktionen im ganzen Land – von Schulklassen, die Müll sammelten, bis hin zu großen Kundgebungen – die Umwelt in den Mittelpunkt gerückt wurde. Die ersten dieser jährlichen Aktionstage wurden von Künstlerplakaten begleitet, die jedoch nicht zum Plakatieren gedacht waren, sondern sich an Sammler richteten, so dass ihr Verkauf half, Gelder aufzutreiben. 1971 veröffentlichte die UNESCO eine sechsteilige Serie von Künstlerplakaten unter dem Motto »Save our Planet«, die der italienische Olivetti-Konzern finanzierte.

Die interessantesten Künstlerplakate zum Thema Umwelt stammen von zwei Künstlern, die beide gleichermaßen Kunst und Leben vereinten, und die dennoch nicht unterschiedlicher hätten auftreten können: Joseph Beuys und Friedensreich Hundertwasser. Letzterer zog schon früh die Abgeschiedenheit der Natur dem Großstadtleben vor. Er wählte Wohnorte abseits der Kunstzentren – und ging zugleich mit einer farbenfrohen Kunst auf ein großes Publikum zu, das die dekorativen Qualitäten seiner Werke honorierte, seine Poster sammelte und seine verspielte Architektur bewunderte.

Joseph Beuys ist ein anderer Fall, komplexer und schwerer zugänglich. Er sah sein gesellschaftspolitisches Engagement als Teil seiner Kunst und sprach dabei von sozialer Plastik. Für deren Gestaltung wies Beuys dem Künstler und seiner Kreativität eine Führungsrolle zu. Die kreative Mitarbeit an einer neuen Gesellschaft konnte aus jedem einen Künstler machen. Eine solche Sicht ist nicht weit von Andy Warhols Standpunkt entfernt, der in jedem Menschen das Potenzial zu einem Star sah und ihm Berühmtheit für 15 Minuten versprach. Nicht von ungefähr waren die beiden befreundet. Bei Beuys mündete das zunächst kunsttheoretische, später gesellschaftspolitische Engagement 1979 in den Eintritt in die Partei der Grünen, zu deren Gründungsmitgliedern er gehörte.

Joseph Beuys war nicht nur als Künstler ein Sonderfall, darauf bedacht, den Kunstbegriff neu zu definieren und »zu erweitern«, sondern auch seine Plakate stellen unter den Künstlerplakaten eine Ausnahme dar. Selten trat er im traditionellen Verständnis des Wortes als Entwerfer auf, sondern er verließ sich auf Mitarbeiter, Organisatoren und Freunde, die mit Fotos des Künstlers und seiner Werke arbeiteten und sich farblich mit überwiegend braunen und grauen Tönen an die Ästhetik des Meisters hielten. Das Werkverzeichnis der Beuys-Plakate umfasst rund dreihundert Nummern, viele davon mit explizit politischen Inhalten.

Beuys erfand neue Sinnbilder für viele politische Themen. Sein symbolgeladenes Verständnis von Materialien, die er für seine Kunst wählte – allen voran Filz und Fett – bezeugt den Zusammenhang von Natur und Gesellschaft. Das berühmte in Italien entstandene lebensgroße Foto des Künstlers, der energisch auf den Betrachter zuschreitet, machte ihn zum Inbegriff des Revolutionärs. Exemplarisch äußert sich dieses Verständnis auch in dem Bild der Rose, in dem Beuys revolutionäres Gedankengut mit naturverbundener Symbolik dargestellt sah: Ein dorniger Stil führt zu einer überraschend schöne Blüte.

The first large-scale environmental movements began around 1970. Greenpeace was founded in Vancouver in 1971. The previous year, the first Earth Day was held in the USA; this was a new annual event, a day dedicated to initiatives focusing on the environment, ranging from schoolchildren picking up rubbish to major rallies. The earliest of these annual days of action were accompanied by art posters intended for sale to collectors rather than for street display, with sales helping to raise money. In 1971, UNESCO published a six-part artists' poster series under the title "Save Our Planet," financed by the Italian Olivetti company.

Two artists in particular created the most interesting environmental posters: Joseph Beuys and Friedensreich Hundertwasser. The lives of both men were closely intertwined with their art, and yet the two were very different. From an early stage, Hundertwasser preferred nature and solitude to metropolitan life, and generally lived a long way from the centers of the art world; nevertheless, his colorful art reached a large public, and is collected by those who appreciate the decorative qualities in his work and his fanciful architecture.

Joseph Beuys – a more complex and inaccessible artist – was very different. He saw socio-political engagement as part of his art, and talked about "social sculpture." Beuys believed that the artist, and artistic creativity, played a crucial role in shaping society, and that anyone who participated in creating a new society was acting as an artist. This is not far from Andy Warhol's observation that anyone could potentially be a star and enjoy fame for 15 minutes; it is no surprise that the two artists were friends. The socio-political engagement that later arose from this theory of art led Beuys to become a member of Die Grünen (Germany's Green Party) in 1979 – in fact, he was one of its founder members.

Joseph Beuys was an unusual artist who tried to redefine art and to "expand" its scope, and his posters are not typical of artist-designed posters. He is rarely the designer in the traditional sense; instead, employees, organizers, and friends created posters using photographs of the artist and his works, predominantly in shades of brown and gray appropriate to Beuys' aesthetic. The catalogue raisonné of his posters contains around 300 works, many of which are explicitly political in content.

Beuys created original visual metaphors for many political themes. His symbolically charged understanding of the materials he chose for his art – above all, felt and fat – confirms the connection between nature and society. The famous life-size photo of the artist taken in Italy, capturing him striding vigorously towards the viewer, shows him as the epitome of the revolutionary. This understanding is also expressed in the image of the rose, in which Beuys saw revolutionary thought presented in terms of nature-linked symbolism: a thorny style leads to a surprisingly beautiful blossom.

Save Our Planet Save Our Water

Roy Lichtenstein

Roy Lichtenstein (1923–1997)

Rettet unseren Planeten – rettet unser
Wasser / *Save Our Planet – Save Our
Water*
New York 1971
Siebdruck / *Silkscreen print*, 58 × 81 cm

Das Blatt gehört zu einer sechsteiligen
Plakatserie, in der amerikanische
Künstler sich für den Umweltschutz
aussprechen. Die Serie wurde von der
italienischen Firma Olivetti finanziert und
erschien im Rahmen einer UNESCO-
Kampagne zum Umweltschutz.

*This image belongs to a six-part poster
series of environmental messages
created by American artists. This series
was financed by the Italian Olivetti
company, as part of a UNESCO cam-
paign to encourage protection of the
environment.*

Robert Rauschenberg
(1925–2008)

Earth Day 22 April
New York 1970
Offset / *Offset print*, 85,5 × 64 cm

Der nationale Umwelttag der USA
wurde 1970 das erste Mal ausgerufen
und mit Demonstrationen und Aktionen
im ganzen Land begangen. Rauschen-
bergs Plakat dafür verbindet geschickt
Ansichten zerstörter und desolater
Landstriche mit dem vom Aussterben
bedrohten Weißkopfadler, dem Wappen-
tier der USA.

*Earth Day, the USA's national environ-
ment day, took place for the first time
in 1970, and was marked by demonstra-
tions and campaigns all over America.
Rauschenberg's poster adeptly com-
bines visions of destroyed, desolate
landscapes with images of the bald
eagle, a threatened species and the
USA's national symbol.*

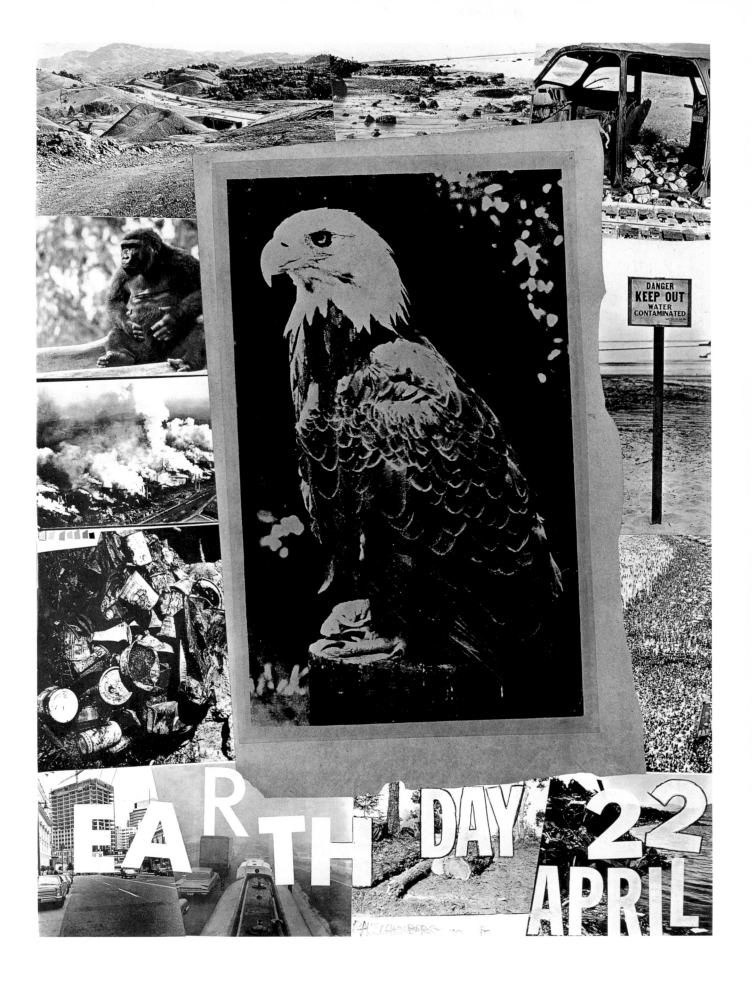

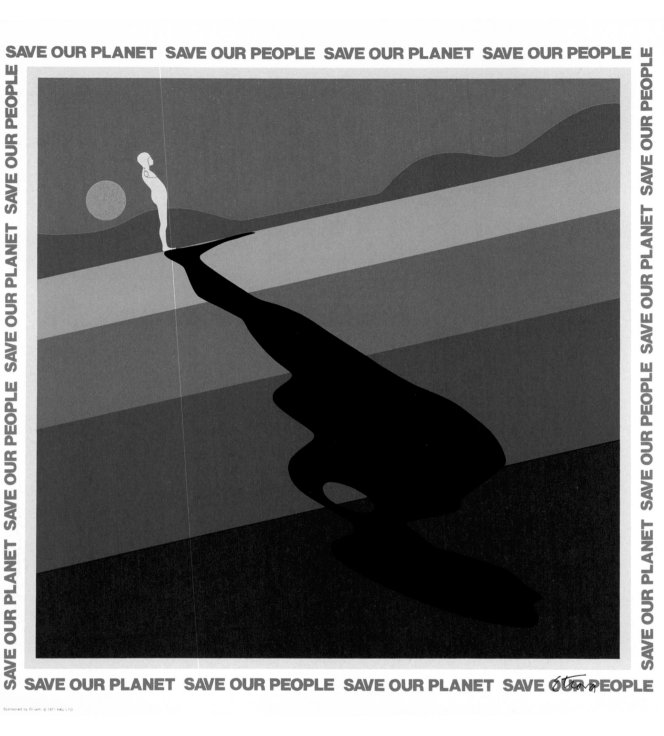

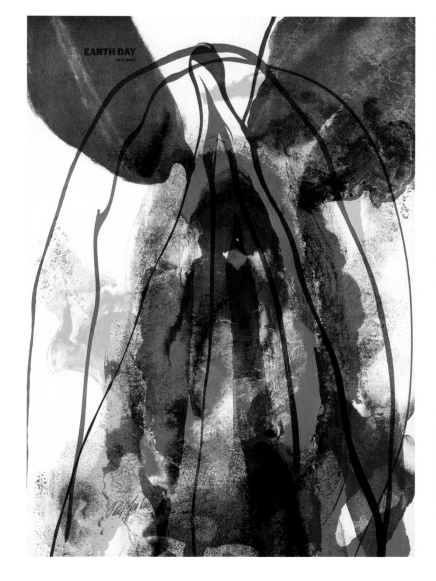

Ernest Trova (1927–2009)

Rettet unseren Planeten – rettet unsere
Menschen / *Save Our Planet – Save Our
People*
New York 1971
Siebdruck / *Silkscreen print*, 89 × 90 cm

Trovas stehender, armloser Mann gehört
zu seiner Werkserie der »Falling Men«,
die die Unzulänglichkeit des Menschen
zum Thema hat. Das Blatt gehört zur
selben Plakatserie der UNESCO wie
dasjenige von Lichtenstein (→ S. 98).

*Trova's standing figure of a man with
no arms is from his "Falling Man" series,
which centers around the imperfections
of humanity. The poster comes from the
same series as Lichtenstein's poster
(→ p. 97).*

Paul Jenkins (*1923)

Earth Day
New York 1971
Lithografie / *Lithograph*, 75,5 × 44,5 cm

Dieses Plakat für den zweiten nationalen
Umwelttag der USA setzt die von
Rauschenberg begonnene Serie der
Künstlerplakate zu diesem Anlass fort
(→ S. 99) . Die auf schwerem Papier
gedruckten Plakate waren nicht zum
Plakatieren gedacht, sondern ihr Verkauf
diente dem Fundraising.

*This poster for the USA's second
national environmental event continues
the series of artists' posters begun by
Rauschenberg on this theme (→ p. 97).
These posters were printed on heavy
paper, and were intended to be sold
to raise funds rather than for street
displays.*

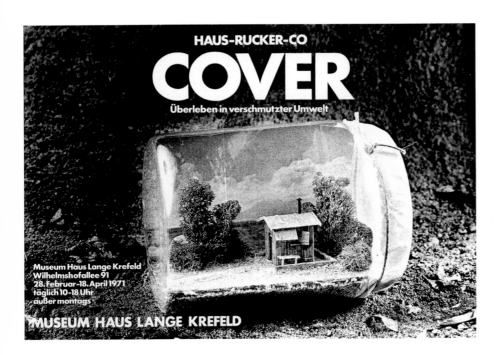

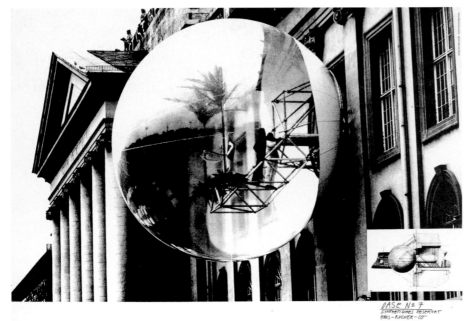

OASE Nº 7
SYNTHETISCHES RESERVAT
HAUS-RUCKER-CO
DOCUMENTA 5

Haus-Rucker-Co (»Architekten-Künstlergemeinschaft« / *A group of architects and artists*; 1967–1997)

Schutzhüllen – Überleben in verschmutzter Umwelt / *Cover – Survival in a Polluted Environment*
Wien / *Vienna* 1971
Siebdruck / *Silkscreen print*, 59,7 × 85 cm

Die Künstlergruppe wurde 1967 von den Architekten Laurids Ortner, Günther Zamp Kelp und dem Maler Klaus Pinter in Wien gegründet. Das Ausstellungsplakat für das Museum Haus Lange in Krefeld zeigt ein Beispiel der utopischen umweltbezogenen Projekte der Gruppe.

This group was founded in 1967 in Vienna by the architects Laurids Ortner and Günther Zamp Kelp, and the painter Klaus Pinter. The exhibition poster for the Museum Haus Lange in Krefeld is an example of the group's utopian environmental projects.

Haus-Rucker-Co (»Architekten-Künstlergemeinschaft« / *a group of architects and artists*; 1967–1997)

Oase No. 7 – Synthetisches Reservat / *Oasis No. 7 – Synthetic Reservation*
Documenta 5, Kassel 1972
Offset / *Offset print*, 69,4 × 97,8 cm
(Foto / *Photograph*: Brigitte Hellgoth)

»Oase 7« war das bekannteste Projekt der Gruppe. Wie eine Blase hing eine begehbare Kugel aus durchsichtigem Kunststoff an der Fassade des Fridericianums in Kassel. In der Plastikblase war zwischen kleinen Palmen eine Hängematte gespannt, und es baute sich ein eigenes Klima auf, welches das Thema der Oase unmittelbar nachempfinden ließ.

"Oase 7," this group's best-known project, involved hanging a sphere of transparent plastic that people could climb into on the façade of the Fridericianum museum in Kassel, like a huge bubble. Inside this plastic bubble, a hammock was stretched between two small palms, and the space developed its own climate, allowing people to experience the "oasis" of the title for themselves.

102

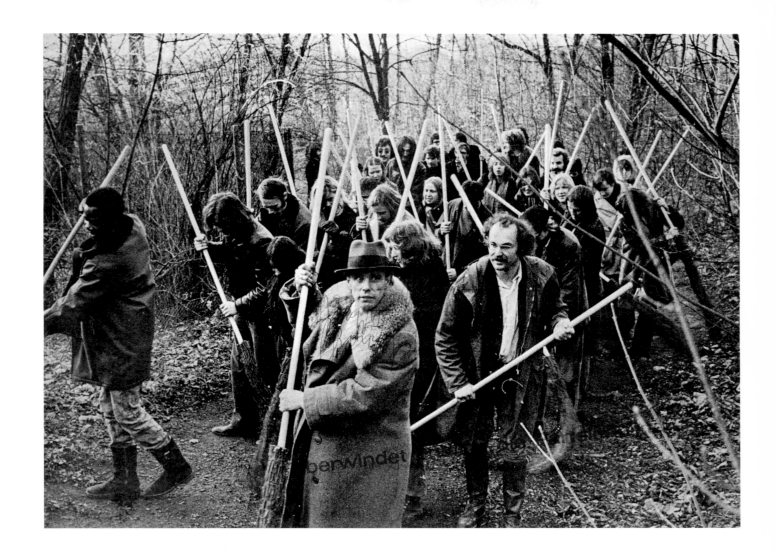

Joseph Beuys (1921–1986)

Überwindet endlich die Parteien-
diktatur / *Let Us Finally Overcome
the Dictatorship of Parties*
Düsseldorf 1971
Offset / *Offset print*, 29,5 × 41 cm

Der kleine Druck dokumentiert eine
Aktion von Beuys, der mit Studenten
und Anhängern einen Wald »ausfegt«
– eine symbolische Handlung zur
Reinigung von Natur und Gesellschaft.

*This small print shows Beuys "sweep-
ing" a wood with the aid of students
and associates – a symbolic "purifying"
of nature and society.*

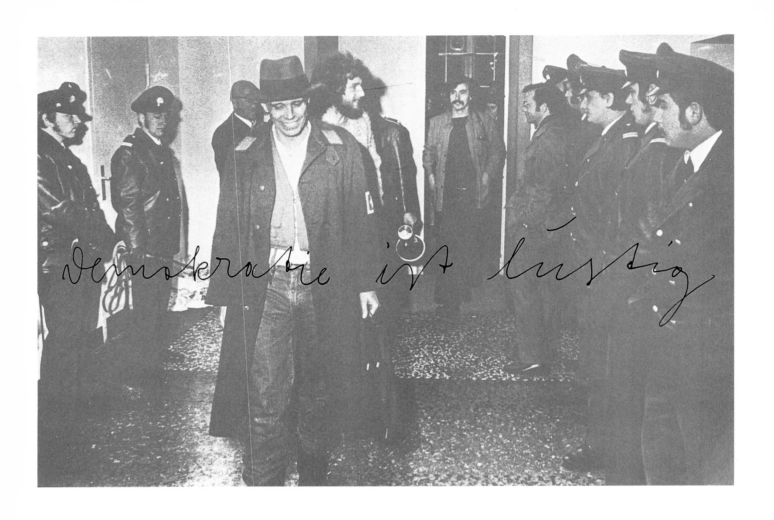

Joseph Beuys (1921–1986)

Demokratie ist lustig / *Democracy Is Fun*
Düsseldorf 1973
Siebdruck / *Silkscreen print*, 75 × 114 cm

Beuys hatte als Professor der Düssel-
dorfer Kunstakademie gegen Studien-
beschränkungen aufbegehrt und auch
abgelehnte Studenten in seiner Klasse
aufgenommen. Die Besetzung des
Hochschulbüros war schließlich für den
nordrhein-westfälischen Wissenschafts-
minister der Anlass, Beuys fristlos zu
entlassen. Hier verlässt der Künstler
kopfschüttelnd und durch ein Polizei-
spalier schreitend das Hochschul-
gebäude.

*As a professor at the Düsseldorf
Kunstakademie, Beuys had rebelled
against study restrictions and included
rejected students in his classes. Finally,
Beuys and his followers occupied the
academy's office, causing North Rhine-
Westphalia's minister for sciences to
dismiss Beuys without notice. Here,
the artist is shown shaking his head as
he leaves the academy building through
a police cordon.*

Joseph Beuys (1921–1986)

Joseph Beuys in der Galerie Modern
Art Agency / *Joseph Beuys in the Modern
Art Agency*
Neapel / *Naples* 1971
Lichtpause / *Diazocopy*, 191 × 100,5 cm

Der Künstler als Revolutionär und Aktivist schreitet unbeirrt voran. Das Foto von Giancarlo Pancaldi wurde im folgenden Jahr für die Edition »La revoluzzione siamo noi« (»Wir sind die Revolution«) erneut aufgelegt. Beuys hatte in Italien viele Anhänger und verband sein soziales Engagement für den armen Süden des Landes mit umweltpolitischen Themen.

The artist strides resolutely forward, the epitome of the revolutionary and activist. Taken by Giancarlo Pancaldi, this photograph was reprinted the following year for the edition entitled "La revoluzzione siamo noi" (We Are the Revolution). Beuys had many admirers in Italy. He combined a social concern for the impoverished southern region with environmental concerns.

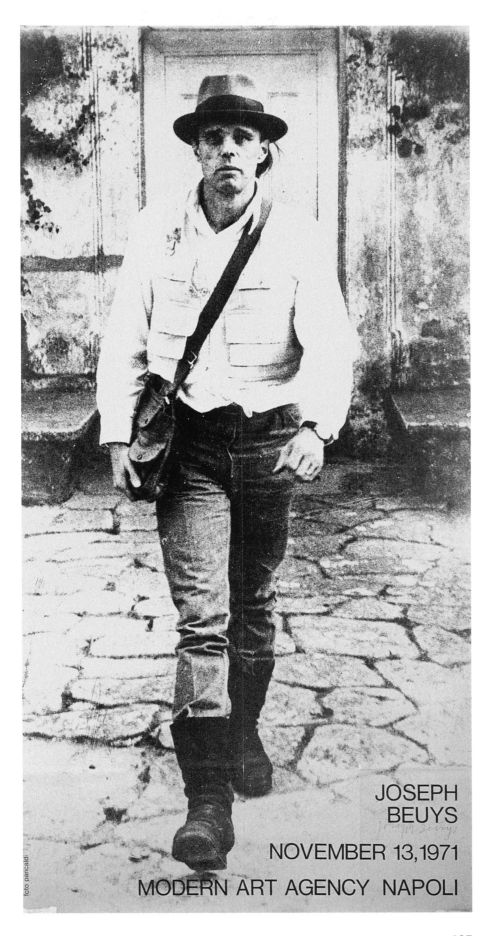

foto pancaldi

JOSEPH
BEUYS
NOVEMBER 13, 1971
MODERN ART AGENCY NAPOLI

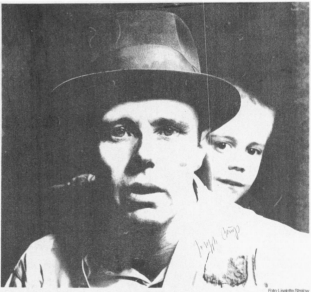

Andy Warhol (1928–1987)

Andy Warhol für die Grünen /
Andy Warhol for the Greens
New York 1979
Siebdruck / *Silkscreen print*, 101 × 77 cm

Warhol entwarf dieses Wahlplakat, das
von der Partei nie verwendet wurde, für
seinen Freund Joseph Beuys, ein Grün-
dungsmitglied der Partei der Grünen.

*Warhol created this election poster
– which was never used by the party –
for his friend Joseph Beuys, a founding
member of the Green Party.*

Joseph Beuys (1921–1986)

Mensch, Du hast die Kraft zu Deiner
Selbstbestimmung / *People, You Have the
Power to Determine Your Own Destiny*
Düsseldorf 1979
Siebdruck / *Silkscreen print*, 86 × 61 cm

Das Wahlplakat für die Grünen zeigt
den Künstler mit seinem Sohn Wenzel.
Es wurde, wie auch das andere Beuys-
Plakat für die Grünen von der Partei
nicht im Wahlkampf eingesetzt.

*This election poster for the German
Green Party (Die Grünen) shows the
artist with his son, Wenzel. Like the
other poster created by Beuys for the
Green Party, it was never used in the
election campaign.*

Joseph Beuys (1921–1986)

Bei dieser Wahl: die Grünen /
At This Election: The Greens
Düsseldorf 1979
Siebdruck / *Silkscreen print*, 88 × 73 cm
(Foto / *Photograph*: Ute Klophaus)

Das Plakat nach einem Entwurf von
Johannes Stüttgen zeigt die Beuys-
Skulptur »Der Unbesiegbare«: Ein
Knetgummi-Hase wird von einem Spiel-
zeugsoldaten aus Plastik bedroht –
in Beuys'scher Terminologie der sinn-
lose Kampf technischer Kälte gegen
natürliche Wärme und Fruchtbarkeit.
Das Plakat wurde von der Partei der
Grünen als Wahlplakat abgelehnt.

*Designed by Johannes Stüttgen, this
poster shows Beuys' sculpture "Der
Unbesiegbare" (The Unconquerable
One). It depicts a hare made from
modeling clay being threatened by a
plastic toy soldier – for Beuys, this
represents the senseless war waged
by cold technology against natural
warmth and fertility. The German
Green Party declined to use this poster
as part of their election campaign.*

bei
dieser Wahl:

Beuys: Der Unbesiegbare

Photo: Klophaus

die GRÜNEN

MANIFEST

ver fehler fängt
schon an,
wenn einer
sich anschickt

Keilrahmen
und
Leinwand
zu Koufen

Joseph Beuys

1. 11. 1985

Edition Staeck · Postfach 10 20 63 · D-6900 Heidelberg

Joseph Beuys (1921–1986)

Manifest / *Manifesto*
Düsseldorf 1985
Offset / *Offset print*, 84 × 59,5 cm

Diese harsche Absage an die traditionelle
Malerei – die bereits 1919 russische
revolutionäre Künstler ausgesprochen
hatten – war ursprünglich mit Kreide
auf eine Schiefertafel geschrieben und
erschien zunächst in einer Postkarten-
edition.

"The mistake begins as soon as some-
one gets the idea of buying stretcher
and canvas": This harsh rejection of
traditional painting – already demanded
by Russian revolutionary artists in
1919 – was originally written in chalk
on slate, and first appeared printed on
postcards.

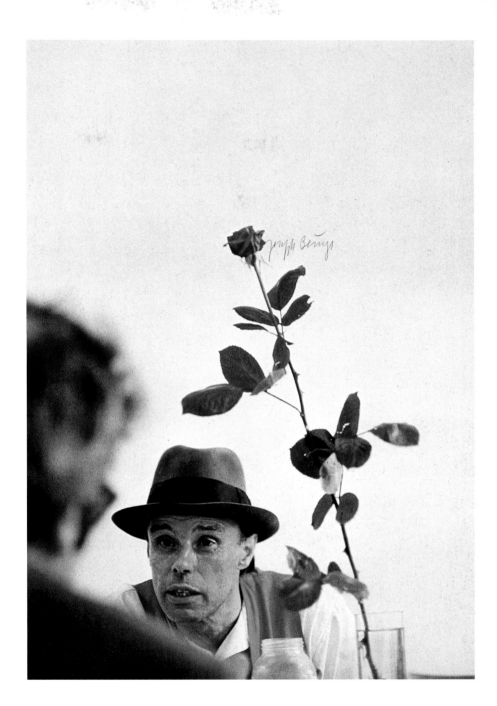

Joseph Beuys (1921–1986)

Ohne die Rose tun wir's nicht /
We Won't Do It Without the Rose
Düsseldorf 1972
Offset / *Offset print*, 80 × 56 cm
(Foto / *Photograph*: Winfried Bauer)

Beuys hatte auf der Documenta 1972
einhundert Tage lang mit Besuchern
diskutiert und dabei stets eine Rose
neben sich stehen gehabt. Er sah die
Rose als Symbol der Revolution, die
dem kalten Messkolben, in dem sie steht,
überlegen ist. Kurz darauf ließ er ein
Multipel mit einem solchen Messkolben
anfertigen (»Rose für direkte Demo-
kratie«), das der Käufer mit einer lang-
stieligen Rose zu vervollständigen hatte.

*At Documenta 1972, Beuys, with a rose
beside him, conducted a discussion with
visitors that lasted one hundred days.
He saw the rose as a symbol of the
revolution, superior to the cold volumet-
ric flask in which it stood. Shortly after-
wards, he brought out a multiple con-
sisting of this same type of volumetric
flask (Rose für Direkte Demokratie:
A Rose for Direct Democracy), which
the buyer would have to complete by
adding a long-stemmed rose.*

Antoni Tàpies (*1923)

No Central Nuclears
Barcelona 1979
Offset/*Offset print*, 75 × 51,5 cm

Der Künstler wandte sich gegen Pläne
für eine nukleare Aufbereitungsanlage
in der Nähe Barcelonas.

The Catalan artist declares his opposi-
tion to plans for a nuclear processing
plant near Barcelona.

Keith Haring (1958–1990)

Plakat für atomare Abrüstung/*Poster*
for Nuclear Disarmament
New York 1982
Lithografie/*Lithograph*, 61,5 × 46 cm

20000 Exemplare dieses ersten und
auf eigene Kosten gedruckten Plakates
des Künstlers wurden kostenlos auf
einer Anti-Atomwaffen-Demonstration
in New York verteilt. Oben wird das vor
Lebenskraft pulsierende Baby von Engeln
beschützt, unten stemmt sich der ver-
strahlte und ausge-x-te Mensch mit
seinen Marionetten-Armen gegen den
Himmel.

This was the artist's first poster, printed
at his own cost. 20,000 were given
away free of charge at an antinuclear
weapons demonstration in New York.
At the top is a baby, radiating life force
and protected by angels; at the bottom
is a contaminated, "x"ed-out human
being whose arms are puppets rising
up against heaven.

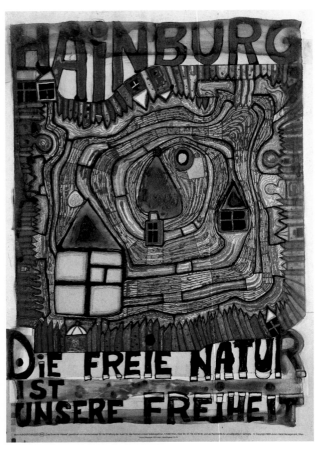

Friedensreich Hundertwasser
(1928–2000)

Hainburg – Die freie Natur ist unsere Freiheit / *Hainburg – Free Nature is Our Freedom* (808B)
ohne Ort / *no place* 1984
Offset / *Offset print*, 84 × 59,5 cm

Bei Hainburg sollte in den Donauauen ein Wasserkraftwerk entstehen, gegen das es jahrelang Proteste von Umweltverbänden gab, die der Künstler unterstützte.

Here, the artist is lending support to the environmental organizations that were protesting against a plan to build a hydropower station in the Danube meadows at Hainburg, in Austria.

Friedensreich Hundertwasser
(1928–2000)

Woche des Umweltschutzes – Neuseeland / *Conservation Week – New Zealand* (726A)
ohne Ort / *no place* 1974
Offset und Prägedruck / *Offset print, embossed*, 84 × 59,5 cm

Das Plaktat entstand für eine Woche des Umweltschutzes in Neuseeland.

This poster was created for a conservation week in New Zealand.

Friedensreich Hundertwasser
(1928–2000)

Rettet den Regen – jeder Regentropfen ist ein Kuss des Himmels / *Save the Rain – Each Raindrop Is a Kiss from Heaven* (690A)
ohne Ort / *no place* 1983
Offset und Prägedruck / *Offset print, embossed*, 84 × 59,5 cm

Das Blatt entstand für einen norwegischen Naturschutzbund.

This print was created for a Norwegian conservation society.

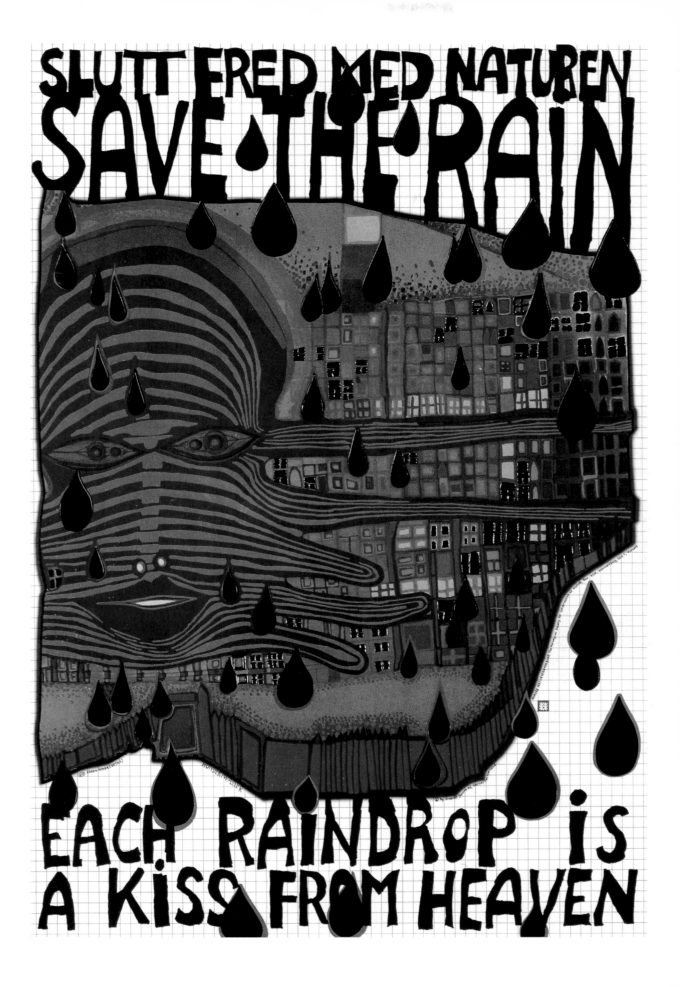

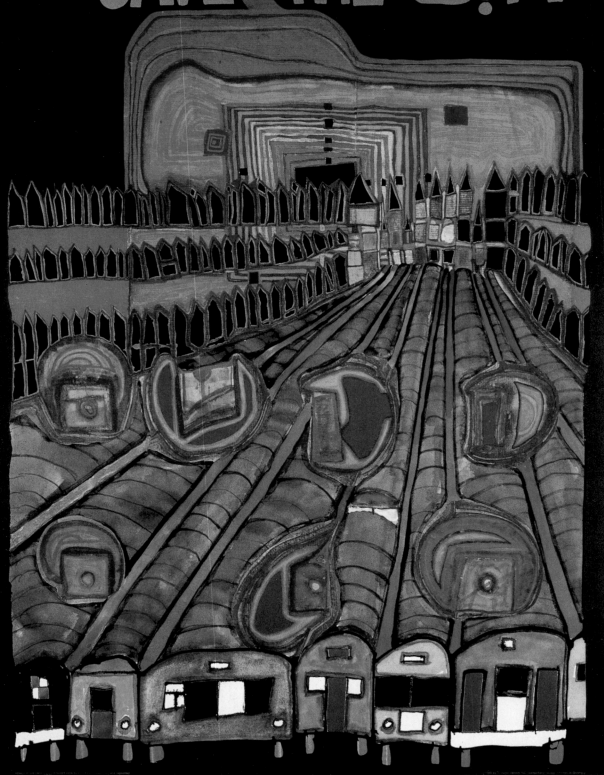

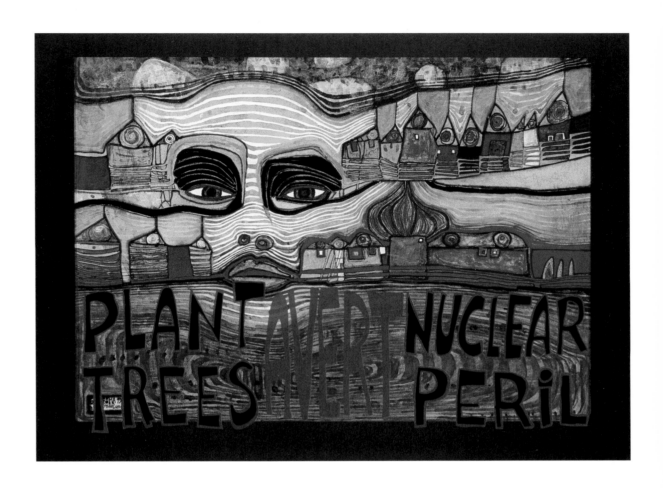

Friedensreich Hundertwasser
(1928–2000)

Benutzt öffentliche Verkehrsmittel –
rettet die Stadt / *Use Public Transport –
Save the City* (553C)
ohne Ort / *no place* 1989
Offset und Prägedruck / *Offset print,
embossed,* 84 × 59 cm

Das Plakat ruft zur Nutzung öffentlicher
Verkehrsmittel auf, um die Umwelt-
verschmutzung in den Städten zu redu-
zieren.

*This poster calls on people to use public
transportation to reduce environmental
pollution in cities.*

Friedensreich Hundertwasser
(1928–2000)

Pflanze Bäume – wende nukleare
Gefahren ab / *Plant Trees – Avert Nuclear
Peril* (691D)
ohne Ort / *no place* 1980
Offset und Prägedruck / *Offset print,
embossed,* 59,5 × 84 cm

Hundertwasser schuf das Plakat zum
Hundertwasser-Tag, der in Washington
D.C. am 18. November 1980 stattfand.
Als Protestaktion wurden dort Bäume
auf dem Judiciary Square eingepflanzt.
Das Plakat entwickelte sich im Laufe
der Jahre zu einem Sinnbild für die Anti-
Atombewegung.

*Hundertwasser created this poster for
Hundertwasser Day, held in Washington
DC on November 18, 1980, when
participants planted trees on Judiciary
Square as a sign of protest. In the years
that followed, this poster came to
symbolize the antinuclear movement.*

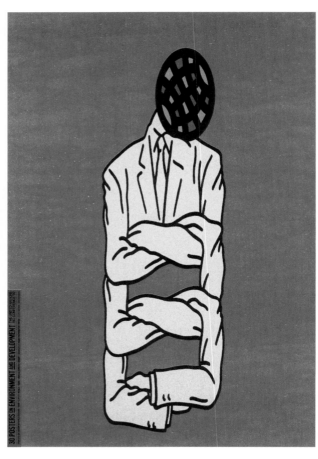

Shigeo Fukuda (1932–2009)

Rio Konferenz '92 / *Rio conference '92*
Tokio / *Tokyo* 1992
Offset / *Offset print*, 64 × 46 cm

Anlässlich der ersten weltweiten UN-Konferenz zu Umwelt und Entwicklung in Rio de Janeiro erschien eine Serie von dreißig Plakaten, entworfen von internationalen Designern, nicht von freien Künstlern. Shigeo Fukuda, bekannt vor allem für seine Plakatentwürfe, war auch als Architekt und Bildhauer erfolgreich.

A series of 30 posters was issued to mark the first global environmental conference, held in Rio de Janeiro in 1992. They were created by international designers, not by artists. Shigeo Fukuda, best known for his poster designs, was also a successful architect and sculptor.

Rafic Farah (*1948)

Rio Konferenz '92 / *Rio conference '92*
Rio de Janeiro 1992
Offset / *Offset print*, 64 × 46 cm

Dieses Blatt stammt ebenfalls aus der Serie zum ersten Weltklimagipfel in Rio de Janeiro 1992. Der Brasilianer Rafic Farah ist sowohl als Designer wie auch als Bildhauer und freier Künstler tätig.

This poster also comes from the series to mark the environmental conference in Rio de Janeiro in 1992. Brazilian-born Rafic Farah works as a designer and as a sculptor and independent artist.

Robert Rauschenberg (1925–2008)

Earth Summit '92
New York / Rio de Janeiro 1992
Offset / *Offset print*, 66,2 × 66,2 cm

Das Plakat für die erste internationale Umwelt-Konferenz in Rio de Janeiro entstand im Auftrag der UNO und nicht wie die dreißigteilige Serie mit Arbeiten von Shigeo Fukuda, Ricah Farah und anderen im Auftrag der örtlichen Veranstalter.

Unlike the three-part series with work by Shigeo Fukuda, Ricah Farah, and others, the poster for the first international environmental conference in Rio de Janeiro was commissioned by the UN and not by the local organizer.

"... *I PLEDGE* to MAKE THE EARTH A SECURE AND HOSPITABLE HOME
FOR PRESENT AND FUTURE GENERATIONS"

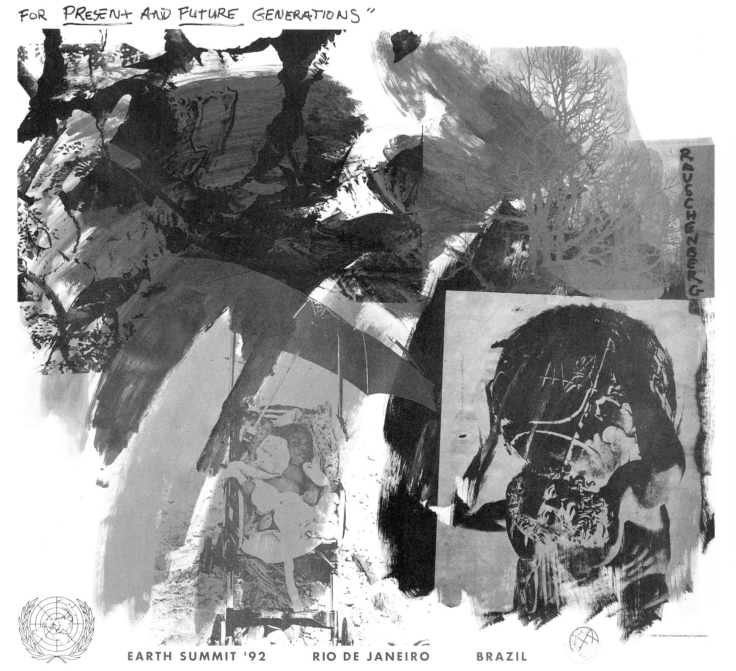

EARTH SUMMIT '92 RIO DE JANEIRO BRAZIL

GLEICHE RECHTE

In den achtziger Jahren kam ein umfassenderes Verständnis von Gerechtigkeit auf. In der westlichen Welt waren die Menschenrechte längst fest in den Verfassungen verankert und in den meisten Gesellschaften auch weitgehend Realität geworden. Nun jedoch galt es, diese verfassungsmäßig garantierten Rechte für alle einzufordern, für ethnische und nationale Minderheiten genauso wie für Behinderte und Kranke oder auch Homosexuelle. Feministinnen, die sich in den sechziger Jahren noch dafür stark machten, eine berufliche Tätigkeit nicht als Makel und als unfeminin anzusehen, kämpften nun um die Gleichberechtigung im Berufsleben oder auch für die Legalisierung von Schwangerschaftsabbrüchen – eine noch wenige Jahre zuvor undenkbare Forderung.

Vor allem die 1981 entdeckte Immunschwächekrankheit Aids schied die Gemüter und bewirkte langfristig einen neuen Umgang mit Minderheiten. Zunächst als Krankheit Homosexueller und damit einer diskriminierten Minderheit angesehen, dauert es Jahre, bis die Krankheit als eine Bedrohung für die ganze Gesellschaft verstanden wurde. Aktivisten begannen vor allem in den USA Mitte der achtziger Jahre auf das Problem aufmerksam zu machen und ein Ende der diskriminierenden Haltung von Gesundheitsbehörden und anderen staatlichen Stellen einzufordern.

Die sich allmählich seit Ende der achtziger Jahre durchsetzende Akzeptanz von Aids als einer Gefahr für alle führte dazu, auch Homosexualität neu zu bewerten. Noch bis in die siebziger Jahre hinein konnte gleichgeschlechtliche Sexualität als psychische Krankheit diagnostiziert werden. Sie war in vielen Staaten illegal und stand als Straftat im Gesetzbuch. Nun begann man von sexueller Präferenz zu sprechen und die Diskriminierung von Homosexuellen war zumindest offiziell verpönt. Der Christopher Street Day, der zur Erinnerung an die heftigen Kämpfe zwischen der New Yorker Polizei und Homosexuellen 1969 in Greenwich Village ausgerufen wurde, hat sich seit den siebziger Jahren international verbreitet und den Charakter eines Volksfestes angenommen.

Vor allem zur Warnung vor Aids entstanden zahllose Plakate rund um den Globus. Künstlerplakate sind nur selten unter ihnen anzutreffen. Eine bemerkenswerte Ausnahme bildet eine Plakatserie von 1993, die von dem Pariser Verlag Artis publiziert wurde. Die Entwürfe entstanden als Siebdruck auf festem Papier und waren nicht zum Plakatieren gedacht, sondern wandten sich an den Sammler. Ihre Bildsprache, selten explizit und häufig eher indifferent, zeugt von einer gewissen Hilflosigkeit vieler Künstler im Umgang mit diesem Thema.

Eine besondere Stellung beansprucht hier das Werk von Keith Haring. Der homosexuelle und aidskranke Künstler war in doppelter Weise betroffen und wollte mit seiner Kunst informieren und aufrütteln. In seinem kurzen öffentlichen Künstlerleben – es umfasste nicht einmal ein volles Jahrzehnt – entwarf er annähernd hundert Plakate, viele davon mit sozialer und politischer Thematik.

EQUAL RIGHTS

During the 1980s, a broader concept of justice began to take root. In the West, human rights had long been enshrined and codified in constitutions, and in most societies they were largely reflected in reality. Now, however, the issue was to make sure that all groups enjoyed these constitutional rights, including ethnic and national minorities, the disabled or sick, and homosexuals. Whereas in the 1960s feminists had campaigned against working women being seen as failures or as unfeminine, they were now fighting for equal rights in the workplace and for the legalization of abortion – a demand that would have been unthinkable only a few years before.

In particular, the discovery of the immune deficiency syndrome AIDS in 1981 polarized opinion and ultimately changed the way minorities were perceived. The condition was initially seen as a disease suffered exclusively by homosexuals and therefore by a minority subjected to discrimination; it took years before AIDS was seen as a threat to the whole of society. In the mid-1980s, activists began to campaign for greater awareness of this problem and for an end to discriminatory practices by health services and other state institutions, primarily in the USA.

The view of AIDS as a universal threat, increasingly accepted since the late 1980s, led to a change in attitudes towards homosexuality. Until the 1970s, homosexuality was still seen as a mental illness. It was also considered illegal in many countries and treated as a crime. Now people began to describe it as a "sexual preference," and discrimination against homosexuals was discouraged (at least officially). Since the 1970s, Christopher Street Day (held to commemorate the pitched battles between the New York police and homosexuals in Greenwich Village in 1969) has been marked internationally and has become a general celebration.

During this period, countless posters were created all over the world, mainly concerned with warning the public about AIDS. Few of these were designed by artists, with the remarkable exception of a series of posters from 1993 published by the Paris-based Artis publishing company. These were silkscreen prints on heavy paper, intended for private collectors rather than for public display. Their imagery is rarely explicit and is often rather indifferent, suggesting that many artists did not really know how to address this theme.

Special mention should be made of the work of the American artist Keith Haring. As a homosexual and AIDS sufferer, he was deeply concerned with both issues, and wanted to use his art to inform and agitate. During his short public life as an artist – less than a decade – he designed more than a hundred posters, many of which were concerned with social and political themes.

A LITTLE KNOWLEDGE CAN GO A LONG WAY

A LOT OF PROFESSIONALS ARE CRACKPOTS

A MAN CAN'T KNOW WHAT IT'S LIKE TO BE A MOTHER

A NAME MEANS A LOT JUST BY ITSELF

A POSITIVE ATTITUDE MAKES ALL THE DIFFERENCE IN THE WORLD

A RELAXED MAN IS NOT NECESSARILY A BETTER MAN

A SENSE OF TIMING IS THE MARK OF GENIUS

A SINGLE EVENT CAN HAVE INFINITELY MANY INTERPRETATIONS

A SOLID HOME BASE BUILDS A SENSE OF SELF

A STRONG SENSE OF DUTY IMPRISONS YOU

ABSOLUTE SUBMISSION CAN BE A FORM OF FREEDOM

ABUSE OF POWER COMES AS NO SURPRISE

ACTION CAUSES MORE TROUBLE THAN THOUGHT

ALIENATION PRODUCES ECCENTRICS OR REVOLUTIONARIES

ALL THINGS ARE DELICATELY INTERCONNECTED

ALWAYS STORE FOOD

AMBITION IS JUST AS DANGEROUS AS COMPLACENCY

AMBIVALENCE CAN RUIN YOUR LIFE

AN ELITE IS INEVITABLE

ANGER OR HATE CAN BE A USEFUL MOTIVATING FORCE

ANIMALISM IS PERFECTLY HEALTHY

ANY SURPLUS IS IMMORAL

ARTIFICIAL DESIRES ARE DESPOILING THE EARTH

AT TIMES INACTIVITY IS PREFERABLE TO MINDLESS FUNCTIONING

AT TIMES YOUR UNCONSCIOUS IS TRUER THAN YOUR CONSCIOUS MIND

AUTOMATION IS DEADLY

AWFUL PUNISHMENT AWAITS REALLY BAD PEOPLE

BAD INTENTIONS CAN YIELD GOOD RESULTS

BEING ALONE WITH YOURSELF IS INCREASINGLY UNPOPULAR

BEING HAPPY IS MORE IMPORTANT THAN ANYTHING ELSE

BEING HONEST IS NOT ALWAYS THE KINDEST WAY

BEING JUDGMENTAL IS A SIGN OF LIFE

BEING SURE OF YOURSELF MEANS YOU'RE A FOOL

BOREDOM MAKES YOU DO CRAZY THINGS

CALM IS MORE CONDUCIVE TO CREATIVITY THAN IS ANXIETY

CATEGORIZING FEAR IS CALMING

CHANGE IS VALUABLE WHEN THE OPPRESSED BECOME TYRANTS

CHASING THE NEW IS DANGEROUS TO SOCIETY

CHILDREN ARE THE CRUELEST OF ALL

CHILDREN ARE THE HOPE OF THE FUTURE

CLASS ACTION IS A NICE IDEA WITH NO SUBSTANCE

CLASS STRUCTURE IS AS ARTIFICIAL AS PLASTIC

CONFUSING YOURSELF IS A WAY TO STAY HONEST

CRIME AGAINST PROPERTY IS RELATIVELY UNIMPORTANT

DECADENCE CAN BE AN END IN ITSELF

DECENCY IS A RELATIVE THING

DEPENDENCE CAN BE A MEAL TICKET

DESCRIPTION IS MORE VALUABLE THAN METAPHOR

DEVIANTS ARE SACRIFICED TO INCREASE GROUP SOLIDARITY

DISGUST IS THE APPROPRIATE RESPONSE TO MOST SITUATIONS

DISORGANIZATION IS A KIND OF ANESTHESIA

DON'T PLACE TOO MUCH TRUST IN EXPERTS

DREAMING WHILE AWAKE IS A FRIGHTENING CONTRADICTION

DYING AND COMING BACK GIVES YOU CONSIDERABLE PERSPECTIVE

DYING SHOULD BE AS EASY AS FALLING OFF A LOG

EATING TOO MUCH IS CRIMINAL

ELABORATION IS A FORM OF POLLUTION

EMOTIONAL RESPONSES ARE AS VALUABLE AS INTELLECTUAL RESPONSES

ENJOY YOURSELF BECAUSE YOU CAN'T CHANGE ANYTHING ANYWAY

EVEN YOUR FAMILY CAN BETRAY YOU

EVERY ACHIEVEMENT REQUIRES A SACRIFICE

EVERYONE'S WORK IS EQUALLY IMPORTANT

EVERYTHING THAT'S INTERESTING IS NEW

EXCEPTIONAL PEOPLE DESERVE SPECIAL CONCESSIONS

EXPIRING FOR LOVE IS BEAUTIFUL BUT STUPID

EXPRESSING ANGER IS NECESSARY

EXTREME BEHAVIOR HAS ITS BASIS IN PATHOLOGICAL PSYCHOLOGY

EXTREME SELF-CONSCIOUSNESS LEADS TO PERVERSION

FAITHFULNESS IS A SOCIAL NOT A BIOLOGICAL LAW

FAKE OR REAL INDIFFERENCE IS A POWERFUL PERSONAL WEAPON

FATHERS OFTEN USE TOO MUCH FORCE

FEAR IS THE GREATEST INCAPACITATOR

FREEDOM IS A LUXURY NOT A NECESSITY

GO ALL OUT IN ROMANCE AND LET THE CHIPS FALL WHERE THEY MAY

GOING WITH THE FLOW IS SOOTHING BUT RISKY

GOOD DEEDS EVENTUALLY ARE REWARDED

GOVERNMENT IS A BURDEN ON THE PEOPLE

GRASS ROOTS AGITATION IS THE ONLY HOPE

GUILT AND SELF-LACERATION ARE INDULGENCES

HABITUAL CONTEMPT DOESN'T REFLECT A FINER SENSIBILITY

HIDING YOUR MOTIVES IS DESPICABLE

HUMANISM IS OBSOLETE

HUMOR IS A RELEASE

IDEALS ARE REPLACED BY CONVENTIONAL GOALS AT A CERTAIN AGE

IF YOU AREN'T POLITICAL YOUR PERSONAL LIFE SHOULD BE EXEMPLARY

IF YOU HAVE MANY DESIRES LIFE WILL BE INTERESTING

IF YOU LIVE SIMPLY THERE IS NOTHING TO WORRY ABOUT

IGNORING ENEMIES IS THE BEST WAY TO FIGHT

ILLNESS IS A STATE OF MIND

IMPOSING ORDER IS MAN'S VOCATION FOR CHAOS IS HELL

Jenny Holzer (*1950)

Truisms
New York 1981
Offset / Offset print, 88 × 58 cm

Die drei Drucke gehören zu einer Serie
von acht Blatt mit einzeiligen Sprüchen
– Binsenweisheiten oder Allgemein-
plätzen –, die in absurder Weise
alphabetisch sortiert sind. Sie zeugen
von Vorurteilen, Hass und Gewalt,
von Frauenfeindlichkeit und Intoleranz.

*These three prints belong to a series
of eight sheets. They list one-line
phrases – platitudes or commonplaces –
sorted alphabetically to create a sense
of absurdity. They tell of prejudices,
hate and violence, misogyny and
intolerance.*

DISASTER DRAWS PEOPLE LIKE FLIES.
SPECTATORS GET CHILLS BY IDENTIFYING
WITH THE VICTIMS, FEELING IMMUNE ALL
THE WHILE! THIS IS A PARTICULARLY
UNATTRACTIVE FORM OF VOYEURISM.
THE DETACHED AND ALIENATED DWELL
ON DISASTER; THEY RECEIVE THEIR
QUOTA OF STIMULATION THIS WAY.
THEY AREN'T SYMPATHETIC, JUST BORED.
THEY ANALYZE THE LATEST MASS MURDER,
THEY'RE MAUDLIN OVER STARVING BABIES,
THEY FIND IMAGES OF TERROR AND
REVOLUTION COMPELLING. THEY ADORE
PATHOS. THEY CONGRATULATE
THEMSELVES ON THEIR AWARENESS AND
THEIR STRONG STOMACHS. A LITTLE
REALITY THERAPY WOULD PUT THESE
DILETTANTES TO FLIGHT. ALL THE
"PITIFUL" AND "ENGAGING" PHENOMENA
ARE NOT SUPPOSED TO COME HOME.

THOU ART THAT KIND OF PRIVILEGED
WOMAN WHO IS REALLY REALLY
SURE THAT NOTHING WILL EVER
HAPPEN TO THEE. THOU IMAGINE
THAT THOU ART SACRED, THAT
THY BODY IS A TEMPLE WHERE
NONE BUT THE ANOINTED MAY
ENTER. SURPRISE! THY TEMPLE
GATES ARE ABOUT TO BE
OPENED. BEFORE THOU CAN SHIVER,
EVERYONE WILL BE EXPLORING THY
SECRET ALTAR. FREE ADMISSION!
THOU WILL BE COMMON PROPERTY,
EVERYONE'S WHORE, BEFORE
THOU ART USED-UP, MESSED-UP
AND THROWN IN A PILE WITH
OTHER JUNK THAT USED TO
LOOK GOOD BUT IS USELESS.
IT IS THINE OWN FAULT. THOU
THOUGHT THOU WERE BETTER THAN US.

Jenny Holzer (*1950)

Aufrüttelnde Worte / *Inflammatory Essays*
New York 1981
Offset auf getöntem Papier / *Offset print
on colored paper*, 43 × 43 cm

Die Serie der »Inflammatory Essays«
entstand zwischen 1979 und 1982.
Sie wurden auf farbig getöntes Papier
gedruckt und können, in Wiederholung
geklebt, auch wie eine Tapete ange-
bracht werden.

*The "Inflammatory Essays" series
was created between 1979 and 1982.
It was printed on colored paper and
could be applied in sequence, like
wallpaper.*

Jenny Holzer (*1950)

Aufrüttelnde Worte / *Inflammatory Essays*
New York 1981
Offset auf getöntem Papier / *Offset print
on colored paper*, 43 × 43 cm

Die teils grausamen, teils aggressiven
Geschichten der »Inflammatory Essays«
bestehen aus genau hundert Worten.
Sie vermögen in ihrer Anhäufung von
Vorurteilen und Irrationalität in der Tat
zu empören.

*The stories in the "Inflammatory
Essays," which are sometimes cruel,
sometimes aggressive, each consist
of exactly 100 words. As a cumulation
of prejudices and irrationality they are
capable of causing outrage.*

Jenny Holzer (*1950) und / and
Keith Haring (1958–1990)

Schütz mich vor dem was ich will /
Protect Me from What I Want
New York 1986
Offset / Offset print, 84 × 59,5 cm

Die Gemeinschaftsarbeit der beiden
amerikanischen Künstler entstand für
die Wiener Festwochen 1986.

*This collaboration by the two American
artists was created for the Vienna
Festival.*

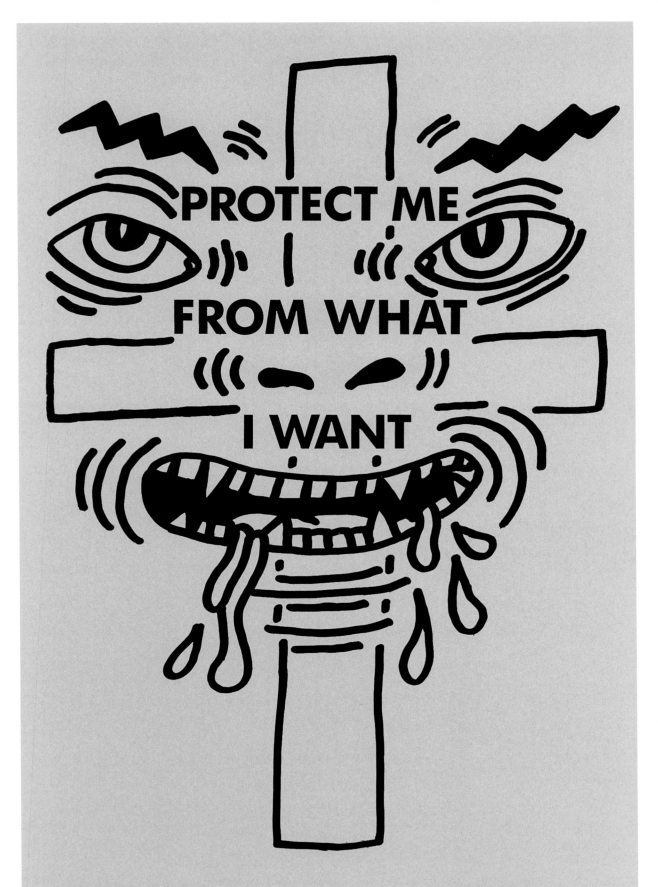

'SCHÜTZ MICH VOR DEM WAS ICH WILL', KEITH HARING — JENNY HOLZER, WIENER FESTWOCHEN 1986, AM HOF

THE ADVANTAGES OF BEING A WOMAN ARTIST:

Working without the pressure of success.

Not having to be in shows with men.

Having an escape from the art world in your 4 free-lance jobs.

Knowing your career might pick up after you're eighty.

Being reassured that whatever kind of art you make it will be labeled feminine.

Not being stuck in a tenured teaching position.

Seeing your ideas live on in the work of others.

Having the opportunity to choose between career and motherhood.

Not having to choke on those big cigars or paint in Italian suits.

Having more time to work after your mate dumps you for someone younger.

Being included in revised versions of art history.

Not having to undergo the embarrassment of being called a genius.

Getting your picture in the art magazines wearing a gorilla suit.

Please send $ and comments to:
Box 1056 Cooper Sta. NY, NY 10276 **GUERRILLA GIRLS** CONSCIENCE OF THE ART WORLD

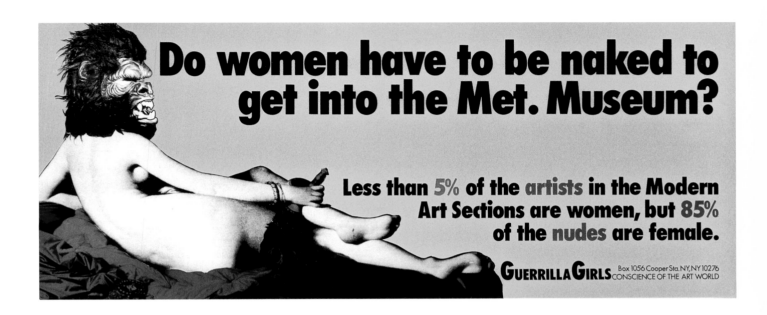

Guerrilla Girls (Künstlergruppe /
Artist group; seit 1985 / *1985 onwards*)

Die Vorteile eine Künstlerin zu sein /
The Advantages of Being a Woman Artist
New York 1988
Offset / *Offset print*, 43 × 56 cm

Eines der typischen, nur mit Sprache
arbeitenden Plakate der Künstlerinnen-
Gruppe. Die satirischen Textzeilen zählen
– fast in der Art von Jenny Holzer –
scheinbare Vorteile von Künstlerinnen
auf: Arbeiten können, ohne unter Druck
zu stehen. Nicht an Ausstellungen mit
Männern teilnehmen zu müssen. Flucht-
möglichkeiten in Neben-Jobs zu haben.
Zu wissen, dass die Karriere mit achtzig
erst richtig losgeht. Sicher zu sein, dass,
egal welche Kunst du machst, sie als
feminin bezeichnet werden wird. Und
so weiter.

*This is a typical text-only poster from
this group of women artists. In satirical
phrases (almost in the style of Jenny
Holzer) it lists the supposed advantages
of being a woman artist: being able to
work without the pressures of success,
not having to take part in exhibitions
with male artists, being able to escape
to a part-time job, knowing that your
career might take off at the age of 80,
the certainty that whatever kind of art
you produce it will be described as
feminine, and so on.*

Guerrilla Girls (Künstlergruppe /
Artist group; seit 1985 / *1985 onwards*)

Müssen Frauen nackt sein, um ins
Metropolitan Museum zu kommen? /
*Do Women Have to be Naked to Get
into the Met. Museum?*
New York 1989
Siebdruck / *Silkscreen print*, 28 × 71 cm

Der Entwurf wurde in verschiedenen
Formaten verbreitet und wiederholt auf-
gelegt. Das Motiv verbindet eine Maske,
die auf den Hollywood-Film »Planet der
Affen« zurückgeht, mit der berühmten
»Odaliske« von Jean-Auguste-Dominique
Ingres im Louvre. Die Affen-Maske
wurde zum Markenzeichen der Guerrilla
Girls.

*This design was distributed in a variety
of formats and was printed several
times. It combines a mask from the
Hollywood film "Planet of the Apes"
with Jean-Auguste-Dominique Ingres'
famous "Odalisque" in the Louvre.
The ape mask was a kind of trademark
for the Guerrilla Girls.*

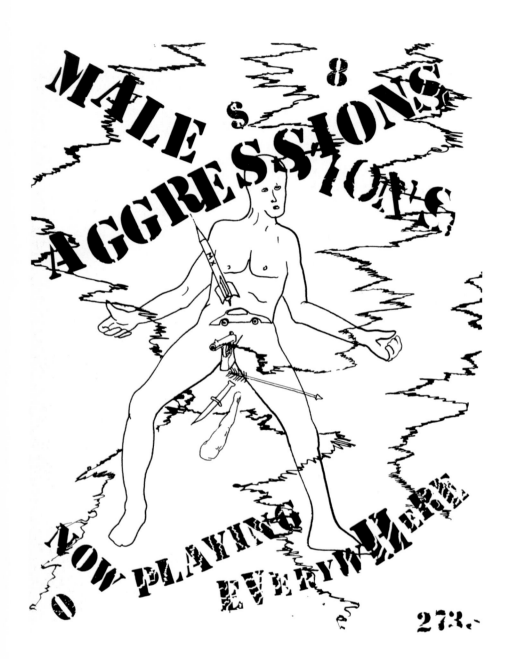

273.-

Jonathan Borofsky (*1942)

Männliche Aggressionen machen sich jetzt überall breit / *Male Aggressions Now Playing Everywhere*
Maine, USA 1985
Offset / *Offset print*, 58,5 × 44,5 cm

Die Zeichnung spielt auf das Wettrüsten der achtziger Jahre an und verknüpft es ironisch mit männlichem Potenzgehabe. Borofsky, vor allem durch seine großen, zu Archetypen erstarrten Skulpturen bekannt, setzt sich in seiner Kunst häufig mit gesellschaftlichen Fragen auseinander.

This drawing references the arms race of the 1980s, ironically connecting it with masculine posing. Borofsky is best known for his large sculptures, which seem like frozen archetypes. His art-works often address social issues.

Barbara Kruger (*1945)

Dein Körper ist ein Schlachtfeld / *Your Body Is a Battleground*
New York 1989
Offset / *Offset print*, 84 × 59,5 cm

Das Motiv wurde in unterschiedlichen Formaten und großer Auflage als Antwort auf Abtreibungsgegner gedruckt. Das Blatt erschien zur Anhörung am 26. April 1989 im Obersten Gerichtshof der USA, mit der die Bush-Administration hoffte, ein älteres Urteil zu kippen, das Abtreibung legalisiert hatte.

This poster – a response to anti-abortion campaigners – was extensively reproduced in a variety of formats. It was published to coincide with the hearing of the April 26, 1989 in the US Supreme Court, at which the Bush Administration hoped to overturn a previous ruling legalizing abortion.

Your body

Support Legal Abortion

is a

Birth Control

battleground

and Women's Rights

We get exploded because they've got

money

and

God

in their pockets

¡AQUI! BARBARA KRUGER ISSUE NO. 4 SET NO. 1 © 1984

SINGLE ISSUE $10.00
5 ISSUE SET $45.00
PUBLISHED BY
¡AQUI! MAGAZINE
457 COURT ST.
BKLYN, N.Y. 11231

Barbara Kruger (*1945)

Die lassen uns explodieren, denn sie
haben Geld und Gott in ihren Taschen /
*We Get Exploded Because They've
Got Money and God in Their Pockets*
New York 1984
Siebdruck / *Silkscreen print*,
175 × 144,5 cm

Das mehrfach gefaltete Blatt erschien
als Ausgabe der Plakat-Zeitschrift
»Aqui«. Die Künstlerin verwendet die
laute Bildsprache der Reklame und ver-
bindet sie mit irrationalen und irritieren-
den Forderungen.

*This poster, folded several times,
appeared as an edition of the poster
magazine "Aqui." The artist couples the
blaring images of an advertisement with
irrational and disturbing assertions.*

Barbara Kruger (*1945)

Franklin Furnace setzt sich für die
garantierten Rechte des ersten Verfas-
sungszusatzes ein / *Franklin Furnace
Fights for First Amendment Rights*
New York 1990
Offset / *Offset print*, 71 × 56 cm

Die New Yorker Organisation Franklin
Furnace unterstützt Performance- und
andere Avantgardekünstler, deren Inhalte
häufig zu Konflikten mit Zensurmaß-
nahmen führen. Das »First Amendment«,
der erste Zusatz zur Verfassung der
USA, garantiert unter anderem die freie
Meinungsäußerung. Auf dem Foto steckt
ein spielendes Kind seine Hand in eine
Brunnenfigur – eine Geste, die hier be-
drohlich wirkt.

*Franklin Furnace is a New York organi-
zation that supports performance artists
and other avant-garde artists whose
subject matter often leads to conflict
with state censorship. The First Amend-
ment to the US Constitution guarantees,
among other things, freedom of speech.
In the photograph, a playing child puts
its hand into a fountain figure in a
seemingly threatening gesture.*

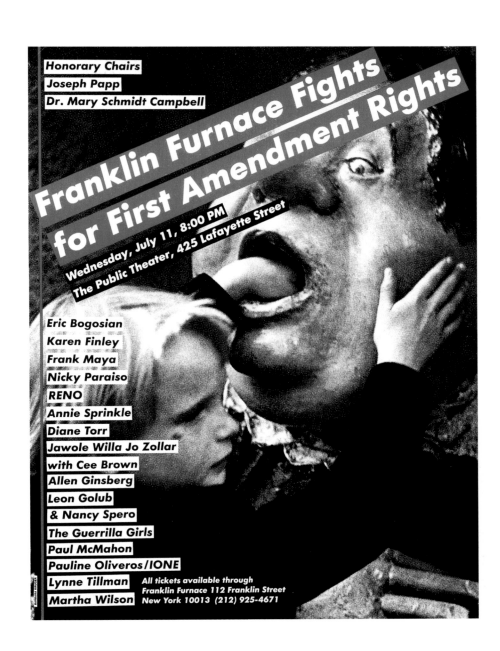

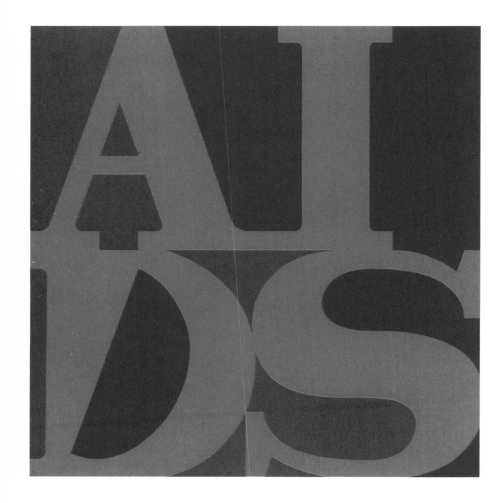

General Idea (Künstlergruppe /
Artist group; 1969–1994)

Aids
New York 1987
Siebdruck / *Silkscreen print*,
68,4 × 68,5 cm

Das Blatt, das wie eine Tapete im Rap-
port geklebt werden kann, zitiert in Typo-
grafie und Farben das berühmte »Love«-
Motiv von Robert Indiana von 1965.
Zwei der drei Mitglieder der kanadischen
Künstlergruppe waren an Aids erkrankt.

*The typography and colors of this
poster, multiple copies of which could
be applied like wallpaper, are reminis-
cent of the famous "Love" motif created
by Robert Indiana in 1965. Two of the
three members of this Canadian artists
group suffered from AIDS.*

General Idea (Künstlergruppe /
Artist group; 1969–1994)

Nazi-Milch / *Nazi Milk*
New York / Neapel / *Naples* 1979
Offset / *Offset print*, 65 × 45 cm

Das Blatt erschien 1979 zur Art Basel
als Ankündigung der Galerie Lucio
Amelio aus Neapel. Das irritierende Bild
weckt Assoziationen an das soldatische
Auftreten von Faschisten, die Homo-
sexuelle inhaftieren ließen, und spielt
zugleich auch auf Fetisch-Vorlieben in
homosexuellen Kreisen an.

*This poster was published in 1979 for
the Art Basel Fair as an announcement
by the Lucio Amelio Gallery in Naples.
The provocative image suggests military
assemblies of fascists (who arrested
homosexuals) whilst referencing
fetishes in homosexual circles.*

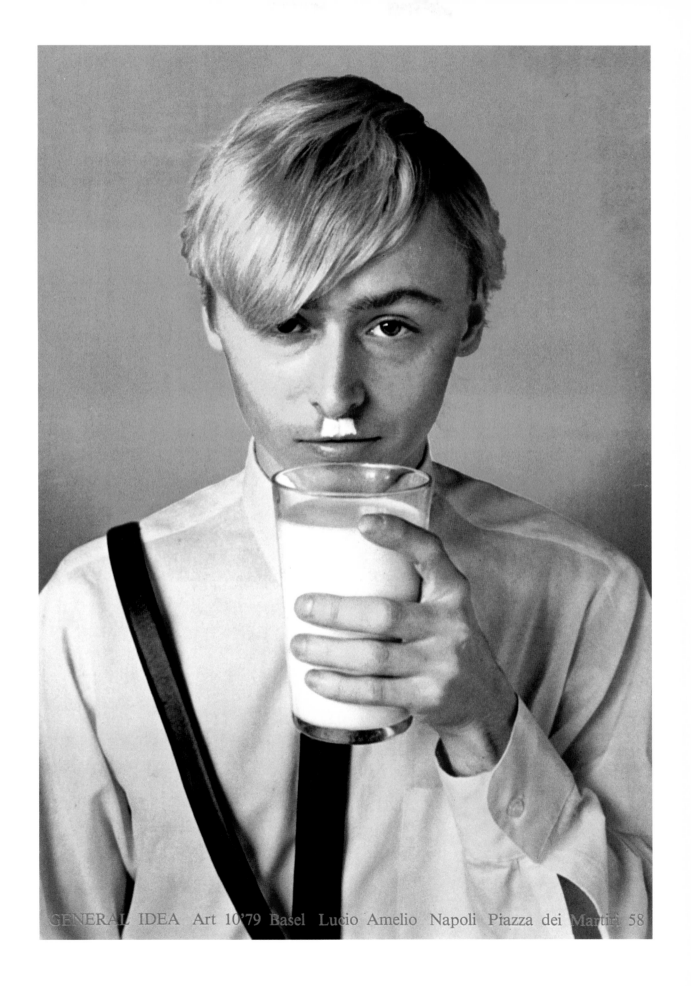

GENERAL IDEA Art 10'79 Basel Lucio Amelio Napoli Piazza dei Martiri 58

STOP AIDS
VEREINIGTE BÜHNEN WIEN
27. JUNI 1989 19.30 UHR
RAIMUNDTHEATER

Keith Haring (1958–1990)

Stoppt Aids / *Stop AIDS*
New York 1989
Offset / *Offset print*, 84,5 × 59 cm

Der Künstler entwarf das Plakat für
eine Aids-Veranstaltung der Vereinigten
Bühnen in Wien.

The artist designed this poster for
an AIDS event held by the Vereinigte
Bühnen in Vienna.

Keith Haring (1958–1990)

Nieder mit der Droge Crack /
Crack Down!
New York 1986
Offset / *Offset print*, 65 × 43,5 cm

Das Plakat entstand für eine Anti-
Drogen-Initiative in New York.

This poster was created for a New York
anti-drug initiative.

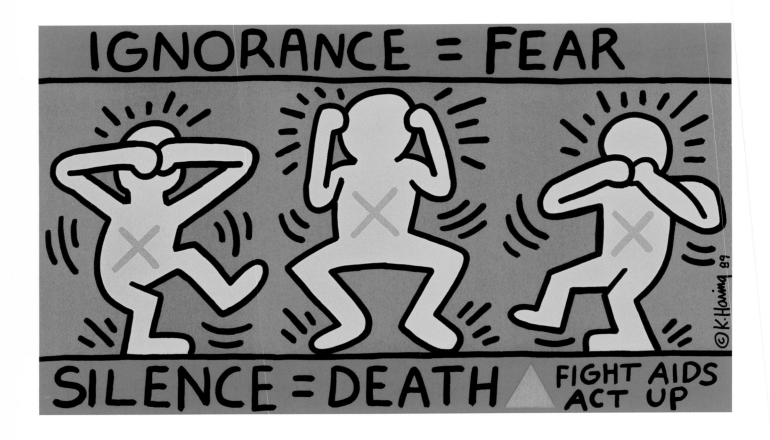

Keith Haring (1958–1990)

Unwissen schafft Furcht, Schweigen
bedeutet Tod / *Ignorance = Fear,
Silence = Death*
New York 1989
Offset / *Offset print*, 61 × 109,5 cm

Das Blatt entstand für die Aids-Aktivisten
der Gruppe Act Up (Aids Coalition to
Unleash Power) und wurde auch in
großem Format auf New Yorker Bussen
plakatiert. Es wehrt sich gegen das viel
zu lange Verschweigen der Krankheit
durch US-Regierungsstellen.

*This poster was created for the AIDS
activist group Act Up (AIDS Coalition
to Unleash Power). A large version
was also displayed on New York buses.
It is a protest against US governmental
agencies continued silence on the
AIDS issue.*

Keith Haring (1958–1990)

National Coming Out Day
New York 1988
Offset / *Offset print*, 66 × 58,5 cm

Das Plakat entstand für die »National
Gay Rights Advocates«. Haring schuf
eine ganze Reihe von Plakaten, die sich
für die Rechte von Homosexuellen ein-
setzen.

*This poster was created for the National
Gay Rights Advocates. Haring produced
a whole series of posters championing
the rights of homosexuals.*

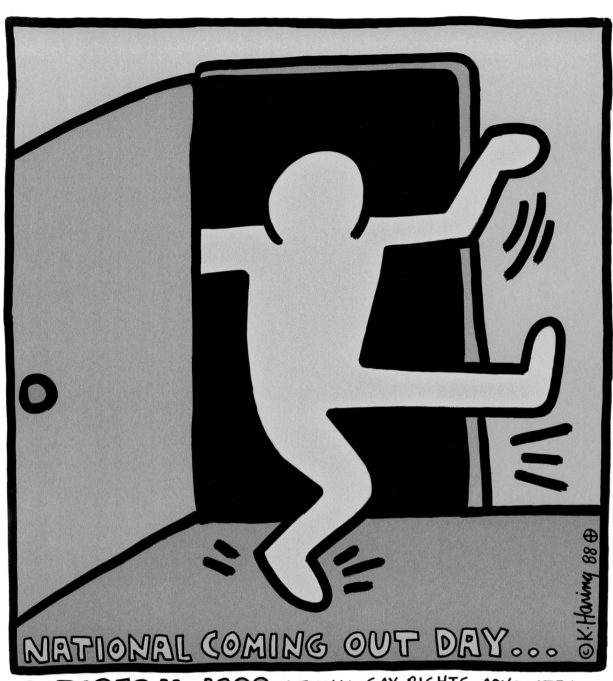

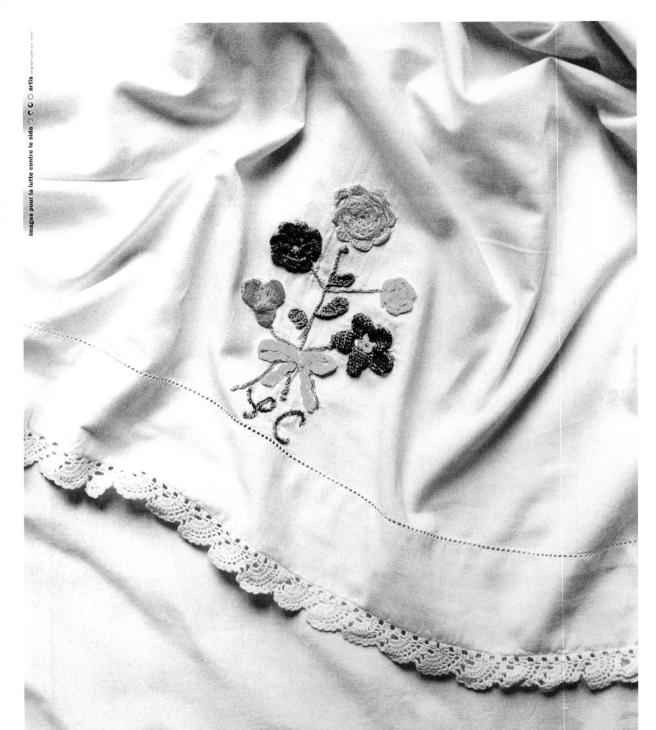

Elle s'appelait Valentine. Elle était née le 4 février 1888. À 96 ans, sa santé déclina. Elle était fatiguée de vivre. Mais elle s'était fixé un but : devenir centenaire. À l'agonie, peu avant ses 100 ans, elle revint à la vie pour demander : «Combien de jours reste-t-il ?» Il restait 6 jours. Elle murmura : «Je tiendrai. Je tiendrai.» Elle est morte le 4 février 1988. Elle avait choisi, pour figurer sur son faire-part de décès, ce verset de la bible : «Elle a fait ce qu'elle a pu.» Avant de mourir elle avait brodé un drap à mes initiales. Je l'offris à Hervé, alors malade, en souvenir de cette nuit, lointaine déjà, où je lui avais proposé de partager mon lit. Il m'avait opposé un refus, ajoutant : «Plus tard, tu sauras que je te sauve la vie.» Je l'invitai ainsi à dormir un peu avec moi. Et puis, j'aurais aimé croire qu'ayant été brodé par une femme devenue centenaire grâce à une volonté farouche, ce drap, auréolé de foi, lui transmettrait sa force. Le 27 décembre 1991, Hervé est mort à l'âge de 36 ans.

Sophie Calle (*1953)

Sie nannte sich Valentine / *Her Name
was Valentine*
Paris 1993
Siebdruck / *Silkscreen print*, 84 × 59,5 cm

Die Künstlerin erhielt das mit ihren
Initialen bestickte Betttuch als Geschenk
von einer Freundin, die genau an ihrem
100. Geburtstag starb. Die magische
Kraft, die das Tuch daraufhin nach An-
sicht der Künstlerin ausstrahlte, sollte
sich auf ihren kranken Freund Hervé
übertragen, dessen frühen Tod es aller-
dings nicht verhindern konnte. Das Blatt
entstand zur Aids-Serie des Pariser
Artis-Verlages.

*The artist was given this coverlet em-
broidered with her initials by a friend
who died on her 100th birthday. The
artist hoped the magical power that she
believed resided in the coverlet would
heal an ailing friend, Hervé, but ulti-
mately nothing could prevent his early
death. This poster was created for the
AIDS series by Artis, Paris.*

Jochen Gerz (*1940)

Eines Tages, wenn alle Krankheiten be-
siegt sein werden – wird man dann noch
zu leben wissen? / *One Day, When
All Illnesses Have Been Conquered –
Will We Finally Know How to Live?*
Paris 1993
Siebdruck / *Silkscreen print*, 84 × 59,5 cm

Gerz, bekannt für seine konzeptuellen
Denkmäler im öffentlichen Raum, bietet
bei seinem Plakat für die Serie »Images
pour la lutte contre le Sida« (»Bilder zum
Kampf gegen Aids«), die vom Pariser
Artis-Verlag zum Internationalen Aids-
Tag 1993 herausgegeben wurde, nur
einen sehr allgemeinen Gedanken.

*Gerz is best known for his conceptual
memorials created for public spaces.
His poster from the AIDS series
produced by Artis, Paris, for Inter-
national AIDS Day 1993 offers a rather
vague and general thought.*

Ben (Benjamin Vautier; *1935)

Wir werden siegen / *We Shall Overcome*
Paris 1993
Siebdruck / *Silkscreen print*, 84 × 59,5 cm

Das Plakat ist Teil der Serie des Artis-
Verlages zum Internationalen Aids-Tag.
Ben bringt mit seiner unverwechselbaren
Schrift seine Zuversicht zum Ausdruck:
Wir werden siegen.

*This poster is for the Artis International
AIDS Day 1993 series. Ben's un-
mistakable style aptly expresses his
confidence: we shall overcome.*

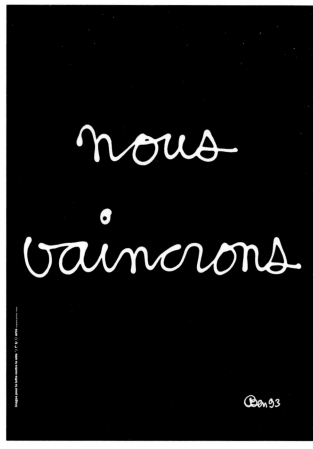

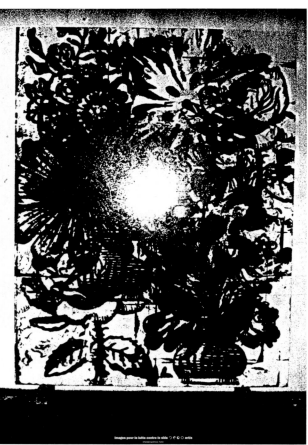

Zush (auch/*also known as* Evru
oder/*or*: Zush Evru; *1946)

Aids – 13 Millionen Infizierte /
AIDS – 13 Million Infected
Spanien / *Spain* 1993
Siebdruck / *Silkscreen print*, 84 × 59,5 cm

Zush zeigt als seinen Beitrag zur Serie
des Pariser Artis-Verlages ein gespensti-
sches Gesicht, das den Hinweis auf
13 Millionen Infizierte trägt.

*In his contribution to the Artis Inter-
national AIDS Day 1993 series, Zush
depicts a ghostly face on which is
written the number of people infected
by AIDS.*

Christopher Wool (*1955)

Ohne Titel / *Untitled*
New York 1993
Siebdruck / *Silkscreen print*, 84 × 59,5 cm

Der Künstler ließ sich nicht auf das
Thema ein, sondern sandte als seinen
Beitrag zur Serie des Artis-Verlages
schlicht ein Motiv aus einer aktuellen
Werkserie.

*Rather than actually address the
subject, the artist simply sent a motif
from his current series of artworks
for the Artis International AIDS Day
1993 series.*

Martin Kippenberger
(1953–1997)

Happy to Be Gay
Davé / Kippenberger / Ohrt
Paris 1993
Siebdruck / *Silkscreen print*, 84 × 59,3 cm

Kippenbergers Beitrag zur Anti-Aids-
Plakatserie des Artis-Verlages scheint
den Ernst des Themas zu negieren.
Seinen frechen Spruch über das frohe
Schwulsein illustriert er absurd mit einer
offensichtlich gestellten Kampfszene
nackter Männer. Es handelt sich dabei
um Kippenberger und seine Künstler-
freunde Davé und Roberto Ohrt, die
1993 in einer Performance auftraten.

*Kippenberger's contribution to the
anti-AIDS poster series by Artis does
not take the subject as seriously as
one might expect. His mischievous
statement about homosexuality and
happiness is absurdly illustrated with a
clearly staged fight between naked men.
The men in the picture are Kippenberger
and two friends of his, artists Davé and
Roberto Ohrt, in an art performance
that took place in 1993.*

GLOBALI-SIERUNG

Die sechste und letzte Themengruppe lässt sich unter dem Schlagwort Globalisierung nur unzureichend zusammenfassen. Der Fall der Berliner Mauer am 9. November 1989 bedeutete das Ende des Kalten Krieges. Der Ostblock brach in sich zusammen, viele Grenzen wurden neu gezogen und noch mehr Grenzen öffneten sich. In Südafrika fand die Apartheid ein Ende. Das Internet und andere digitale Kommunikationsformen spielten eine entscheidende Rolle bei der nicht mehr aufzuhaltenden internationalen »Vernetzung«. Gegner der Globalisierung prangerten das ungerechte Verhalten der Weltbank und anderer Institutionen reicher Staaten an und forderten, einem rücksichtslosen Kapitalismus Grenzen zu setzen. Sie warnten vor dem Verlust nationaler und regionaler Identität angesichts des Vormarsches der Hollywood-Kultur.

Bereits 1985 hatte Robert Rauschenberg als Altmeister des Kunstbetriebes eine Ausstellungstour begonnen, die sich buchstäblich über alle Grenzen hinwegsetzte. Die in wesentlichen Teilen stets vor Ort erarbeitete Ausstellung wurde vor allem in Staaten gezeigt, die von der offiziellen Politik der USA als Gegner betrachtet wurden, so in Kuba und Ostberlin, in Peking oder auch Moskau. 1991, keine zwei Jahre nach dem Fall der Mauer, endete die Tour triumphal in der National Gallery of Art in Washington D.C.

1993 entstand, als Reaktion auf rechtsradikale und ausländerfeindliche Übergriffe in der früheren DDR eine Serie von Künstlerplakaten, die unter dem Motto »I am you« das Miteinander aller Menschen, unabhängig von Nationalität und Religion, demonstrieren sollte. Die zwanzig Großformate wurden international plakatiert und demonstrieren, wie schon frühere Serien, die Vielfalt der zeitgenössischen Kunst und den sehr unterschiedlichen Umgang von Künstlern mit aktueller politischer Thematik. Sie zeugen aber auch von einer oft hermetischen Bildsprache, die in einer größeren Öffentlichkeit auf Unverständnis stößt.

Der Anschlag auf das World Trade Center und mehr noch die Reaktion der US-Politik unter George W. Bush forderten eine ganze Reihe von Künstlern zu Stellungnahmen in Plakatform heraus. Bemerkenswert ist der Einsatz des Bildhauers Richard Serra, mit Plakatentwürfen, die aus dem Internet herunterzuladen waren, gegen die Wiederwahl von George Bush aufzurufen.

Die letzten beiden Bilder in diesem Buch versprechen Hoffnung. Zwar belegt das freche »Fuckin' Politics!« des Japaners Yoshitomo Nara die Unlust, mit der viele jüngere Leute seit dem Aufbruch in den frühen neunziger Jahren die gesellschaftliche und politische Entwicklung betrachten, die Ohnmacht gegenüber internationalen Konzernen oder auch die Enttäuschung angesichts des Wiederauftauchens alter Machtstrukturen. Andererseits gibt es Hoffnung: Der Schriftzug »Hope« ist Robert Indianas Motiv – angelehnt an sein »Love« von 1965 –, um zur Wahl des amerikanischen Präsidenten Barack Obama aufzurufen.

»Hoffnung« scheint darüber hinaus in einem umfassenderen Sinn angebracht. Denn wenn man die Entwicklung der vergangenen Jahrzehnte überschaut, so lässt sich ein steter Gewinn an Freiheit und Gerechtigkeit, im Kleinen wie im Großen, konstatieren, der in der Tat Hoffnung macht. Und Künstlerplakate legen hiervon ein beredtes Zeugnis ab.

GLOBAL- IZATION

Our sixth and final thematic group is rather inadequately headed "Globalization." The fall of the Berlin Wall on the night of November 9, 1989 put an end to the Cold War. As the Eastern Bloc collapsed, many borders were redrawn and still more borders were opened up. Apartheid came to an end in South Africa. The Internet and other forms of digital communication played a crucial role in a new and inexorable international "networking" process. Opponents of globalization complained of the unjust actions of the World Bank and other institutions attached to rich countries, and demanded that restraints be imposed on unbridled capitalism. They warned of the loss of national and regional identities in the face of rampant Hollywood culture.

As early as 1985, Robert Rauschenberg, an established figure in the art world, had embarked on a six-year exhibition tour that literally disregarded all boundaries. This exhibition (the bulk of which was regularly created on location) primarily toured states officially considered political enemies of the USA: it visited, among other places, Havana, East Berlin, Peking, and Moscow. In 1991, less than two years after the fall of the Wall, this tour concluded triumphantly in the National Gallery of Art in Washington DC.

In 1993, in reaction to far right and xenophobic attacks in the former "German Democratic Republic," a series of posters was created by artists under the title "I Am You," with the intention of portraying the fellowship of all humanity independent of nationality and religion. These 20 large-format posters were displayed internationally. Like earlier series, they demonstrate the diversity of the art of the time, and the highly varied way in which different artists address current political issues. However, they also display cryptic imagery unlikely to be understood by the wider public.

The attack on the World Trade Center in New York in 2001, and the reaction of the US political establishment under George W. Bush, led a whole series of artists to express their views in poster form. Particularly noteworthy was the response of sculptor Richard Serra, who took an unusual approach: his poster designs calling for George Bush not to be reelected could be downloaded from the Internet.

Despite everything, the last images in this book offer hope. On the one hand, the mischievous message of "Fuckin' Politics!" by Japanese artist Yoshitomo Nara expresses the lack of enthusiasm with which many younger people have viewed social and political developments since the early 1990s, their feeling of powerlessness when faced with international companies, and their disappointment in the face of re-emerging old power structures. On the other hand, there is hope. In a reference to his famous Love design from 1965, Robert Indiana takes the word "Hope" as his motif, calling for the election of Barack Obama as US president.

"Hope" seems appropriate here in a wider sense. When we look back over the developments of the past decades, we can see a steady increase in large-scale and small-scale freedoms and justice which really does give us a reason to hope – to which posters created by artists during these years bear eloquent witness.

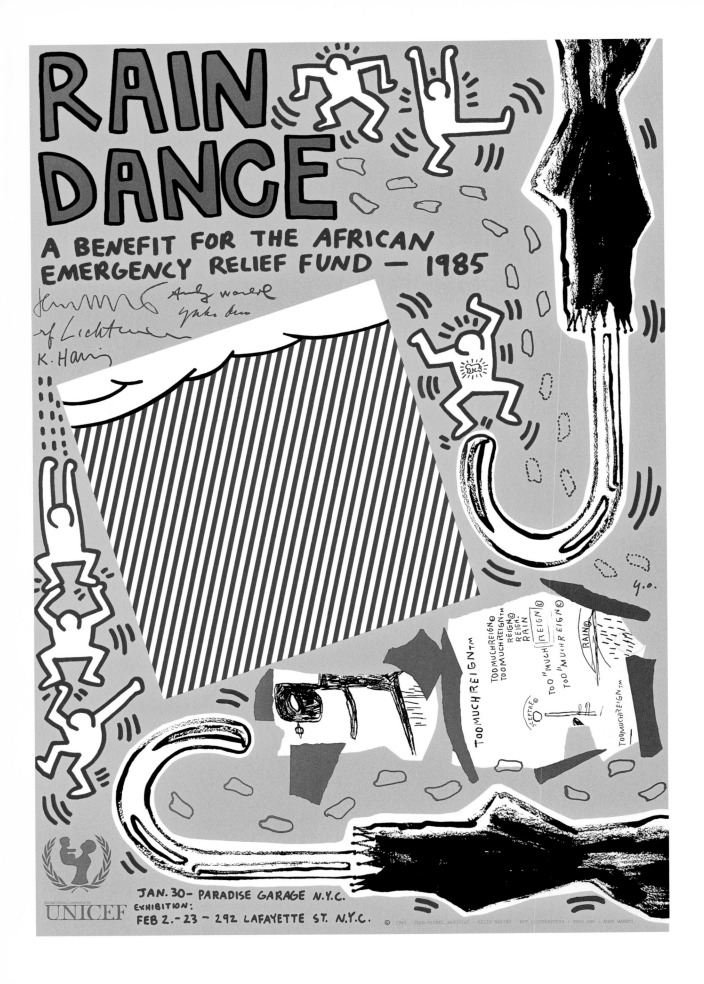

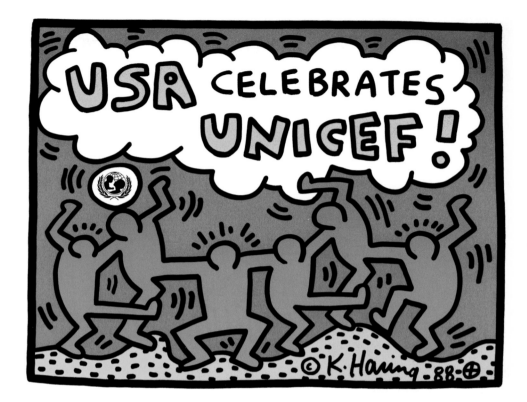

Jean-Michel Basquiat (1960–1988), **Keith Haring** (1958–1990), **Roy Lichtenstein** (1923–1997), **Yoko Ono** (*1933) und / *and* **Andy Warhol** (1928–1987)

Regentanz / *Rain Dance*
New York 1985
Offset / *Offset print*, 79 × 56 cm

Im Sudan, in Äthiopien und Somalia waren nach langen Zeiten der Dürre Mitte der 1980er Jahre schwerste Hungersnöte ausgebrochen. Der Titel spielt auf die Regentänze nordamerikanischer Indianerstämme an. Die Gemeinschaftsarbeit, im Wesentlichen von Keith Haring ausgeführt, entstand für den African Emergency Relief Fund von UNICEF.

By the mid-1980s, lengthy droughts in Sudan, Ethiopia, and Somalia were followed by severe famines. The title of this poster is a reference to the rain dance rituals of certain Native North American tribes. This collaboration, largely the work of Keith Haring, was created for the UNICEF-run African Emergency Relief Fund.

Keith Haring (1958–1990)

Die USA feiern UNICEF! /
USA Celebrates UNICEF!
New York 1988
Offset / *Offset print*, 43,5 × 56 cm

Das Plakat erschien zum 40. Jahrestag der Kinderhilfsorganisation der UNO.

This poster was issued on the 40th anniversary of the UN's International Children's Emergency Fund.

Р.О.К.И. –СССР

Зарубежные Культурные Обмены Раушенберга

2-го Февраля – 5-го Марта 1989

Центральный Дом Художника
Крымский Вал 10

Москва

Выставка организована в сотрудничестве с
Союзом Художников СССР

Robert Rauschenberg
(1925–2008)

Rauschenberg Overseas Culture
Interchange – ROCI
Moskau / *Moscow* 1989
Offset / *Offset print*, 98 × 65 cm

Rauschenbergs Ausstellung in Moskau
im Rahmen seiner Ausstellungstour
durch zehn, zumeist mit den USA ver-
feindeten Staaten war die erste eines
zeitgenössischen westlichen Künstlers
in Russland. Für jede der zehn Stationen
des »Rauschenberg-Übersee-Kultur-
Austauschs« entwarf der Künstler ein
eigenes Plakat.

Rauschenberg's exhibition in Moscow,
part of his exhibition tour of ten coun-
tries (most of which were regarded as
"enemies" of the USA), was the first by
a contemporary Western artist in Russia.
The artist designed an individual poster
for every stop the "Rauschenberg
Overseas Culture Interchange" made.

Robert Rauschenberg
(1925–2008)

Rauschenberg Overseas Culture
Interchange – ROCI
Peking 1990
Offset / *Offset print*, 87,5 × 60,9 cm

Rauschenberg bezog in seine interna-
tionale Ausstellungstournee stets auch
Künstler vor Ort ein. Die Ausstellungs-
reihe hatte 1985 in Mexiko begonnen
und endete 1991 in Washington D.C.

Rauschenberg's international exhibition
tour regularly included local artists.
This series of exhibitions began in
1985 in Mexico and ended in 1991
in Washington DC.

Robert Rauschenberg
(1925–2008)

UN-Konferenz zu menschlichen Sied-
lungen – HABITAT II / *United Nations
Conference on Human Settlement –
HABITAT II*
New York / Istanbul 1996
Offset / *Offset print*, 99,7 × 63,3 cm

Rauschenberg entwarf seit einem Anti-
Apartheid-Plakat von 1983 häufiger
Plakate für die UNO und ihre Organi-
sationen. Das vorliegende Plakat wirbt
für die zweite einer Reihe von UNO-
Konferenzen, die sich unter dem Namen
HABITAT mit der internationalen Ver-
städterung und dem veränderten Leben
in der Großstadt befasst.

*After creating his anti-apartheid poster
in 1983, Rauschenberg often designed
posters for the UN and its associated
organizations. This poster advertises the
second in a series of UN conferences
entitled HABITAT, held to discuss
international urbanization and changes
in lifestyle in the world's major cities.*

Robert Rauschenberg
(1925–2008)

International Trust for Children's
Health Care
Captiva Island, Florida / London 1992
Offset / *Offset print*, 98,8 × 66,3 cm

Die Institution, für die Rauschenberg
hier ein Plakat anfertigte, wurde von
Harold Robles, dem Gründer des Albert
Schweitzer Institutes in Connecticut,
ins Leben gerufen. Sie widmet sich unter
anderem Kindern, die an Leukämie er-
kranken.

*The institution that Rauschenberg
created this poster for was founded by
Harold Robles, founder of the Albert
Schweitzer Institute in Connecticut.
It was set up to address issues such
as child leukemia.*

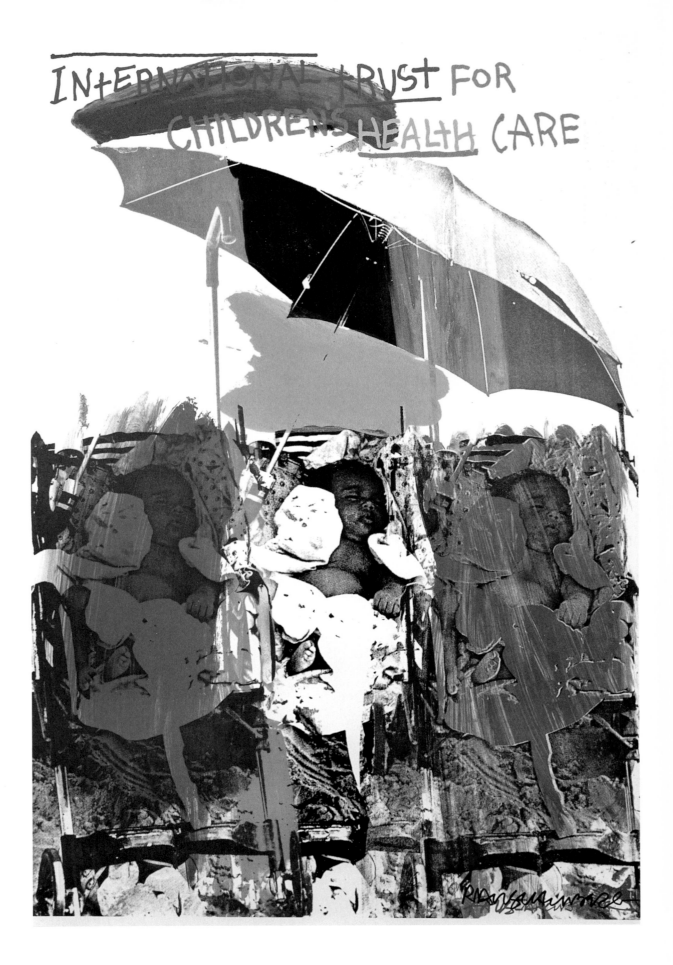

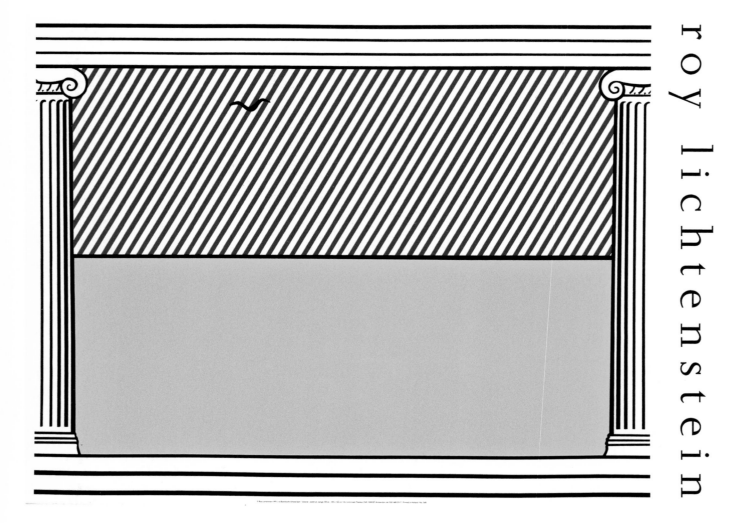

roy lichtenstein

© Roy Lichtenstein *CARE Poster* 1993. Painted & printed paper on board · 39 3/4" x 27 1/8"

Roy Lichtenstein (1923–1997)

Liberté Poster
New York 1991
Offset / *Offset print*, 69 × 98,5 cm

Entworfen für eine Ausstellung zur UN-Erklärung der Menschenrechte im Jahre 1948, die international gezeigt wurde. Lichtenstein verweist mit dem Motiv der ionischen Säulen auf die griechische Tradition der Demokratie und betont mit der überweiten Säulenstellung die grenzenlose Freiheit.

Designed for an international touring exhibition to mark the UN Declaration of Human Rights in 1948, Lichtenstein's poster uses the Ionic column motifs as a symbol of the Greek democratic tradition, while the extremely wide placement of the columns suggests boundless freedom.

Roy Lichtenstein (1923–1997)

Care – Kreuzzug gegen den Hunger /
Care – World Hunger Crusade
New York 1993
Offset / *Offset print*, 75 × 45,5 cm

Die Organisation, die ihren Ursprung im Verschicken der Care-Pakete nach dem Zweiten Weltkrieg hat, ließ bereits dreimal zuvor ihre Plakate von Künstlern gestalten, um den jährlichen »Kreuzzug gegen den Hunger in der Welt« anzukündigen.

This organization, originally formed to send Care parcels after the Second World War, had had posters designed by artists on three previous occasions to announce the annual "crusade against world hunger."

CARE World Hunger Crusade 1993

Katharina Sieverding (*1944)

Deutschland wird deutscher / *Germany Is Becoming More German*
Berlin 1992
Siebdruck in neun Teilen / *Nine-part silkscreen print*, 252 × 356 cm

Im Auftrag der Berliner Kunst-Werke 1993 plakatiert, wandte sich der Entwurf gegen rechtsradikale Tendenzen in Deutschland nach der Wende. Über ein frühes Selbstporträt als Assistentin eines Messerwerfers montierte die Künstlerin den Titel eines Leitartikels der Wochenzeitung »Die Zeit«.

Commissioned for public display by the Berliner Kunst-Werke in 1993, this design is a response to far-right activity in Germany after Reunification. The artist has placed a lead headline from the "Die Zeit" weekly paper above her early self-portrait as a knife-thrower's assistant.

Clean The House !

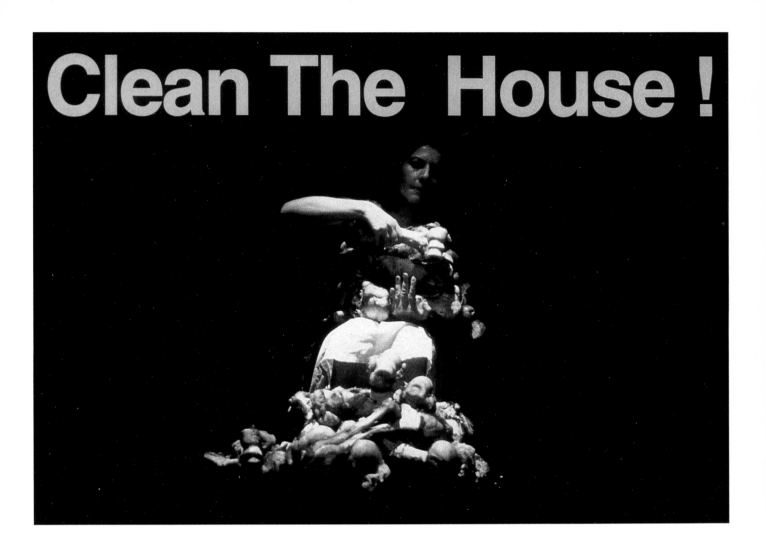

Marina Abramović (*1946)

Clean the House!
Amsterdam / München / *Munich* 1993
Siebdruck in neun Teilen / *Nine-part*
silkscreen print, 252 × 356 cm, kleines
Format / *small format* 57,5 × 80 cm

Abramović' Beitrag zur 1993 entstandenen Serie »I Am You« des Goethe-Institutes verweist auf ihre Aktion Balkan-Barock, in der die serbische Künstlerin, auf einem Berg frischer Schlachthof-Knochen sitzend, bis zur Erschöpfung Knochen schrubbte. Sie verwies damit in drastischer Weise auf die Grausamkeiten des Balkankrieges, in dem oft von ethnischer »Säuberung« gesprochen wurde.

Abramović's contribution to the Goethe-Institut's series references her Balkan Baroque series, with the Serbian artist sitting on a pile of fresh bones from an abattoir and scrubbing the bones until she is exhausted. This is a drastic way of illustrating the atrocities of the Balkan War, often described as "ethnic cleansing."

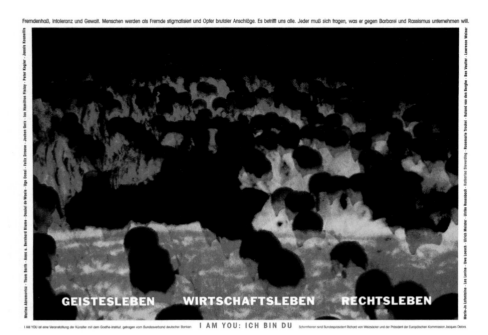

Fremdenhaß, Intoleranz und Gewalt. Menschen werden als Fremde stigmatisiert und Opfer brutaler Anschläge. Es betrifft uns alle. Jeder muß sich fragen, was er gegen Barbarei und Rassismus unternehmen will.

GEISTESLEBEN WIRTSCHAFTSLEBEN RECHTSLEBEN

I AM YOU ist eine Veranstaltung der Künstler mit dem Goethe-Institut, getragen vom Bundesverband deutscher Banken I AM YOU: ICH BIN DU Schirmherren sind Bundespräsident Richard von Weizsäcker und der Präsident der Europäischen Kommission Jacques Delors

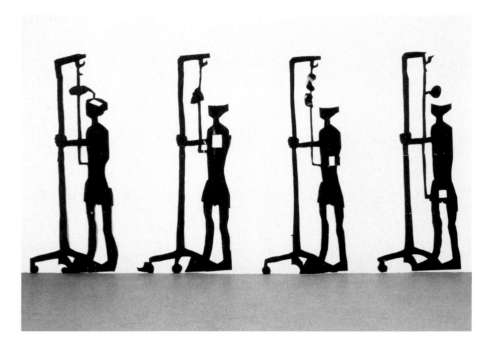

Katharina Sieverding (*1944)

Geistesleben – Wirtschaftsleben –
Rechtsleben / *Spiritual life – Economic
Life – Legal Life*
München / *Munich* 1993
Siebdruck in neun Teilen / *Nine-part
silkscreen print*, 252 × 356 cm

Für die zwanzigteilige Serie des Goethe-
Institutes »I am you«, die sich gegen Ge-
walt und Fremdenhass wendet, entwarf
Sieverding dieses Plakat. Initiiert wurde
die Serie von den beiden süddeutschen
Künstlern Tom Barth und Ugo Dossi
angesichts der rechtsradikalen Aus-
schreitungen in Rostock und andernorts.

*Katharina Sieverding designed this
poster for the 20-part "I Am You" series
by the Goethe-Institut. This series was
instigated by the two southern German
artists Tom Barth and Ugo Dossi as an
indictment of violence and xenophobia
and as a response to far-right violence
in Rostock and elsewhere.*

Felix Droese (*1950)

Ohne Titel / *Untitled*
München / *Munich* 1993
Siebdruck in neun Teilen / *Nine-part
silkscreen print*, 252 × 356 cm

Das Plakat gehört zur zwanzigteiligen
Serie des Goethe-Institutes, für das
Droese seinen aus mehreren Teilen
bestehenden Scherenschnitt »Antiterror-
einheit« verwendete. Er entwickelte
den großformatigen Scherenschnitt als
Medium für seine oft sozialkritischen
Themen.

*Designing this poster for the 20-part
Goethe-Institut series, Droese used
his cut-out "Antiterroreinheit" (counter-
terrorism unit), which has several parts.
He developed the large-size cut-out as
a medium for his themes, which often
included social criticisms.*

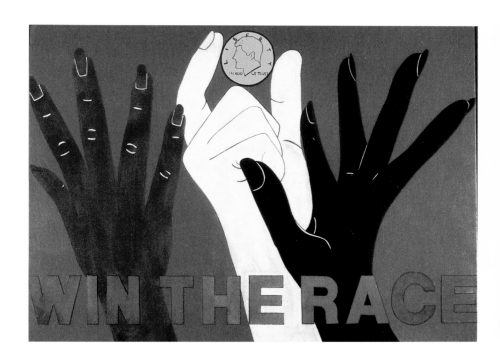

Les Levine (*1935)

Mach das Rennen / *Win the Race*
München / *Munich* 1993
Siebdruck in neun Teilen / *Nine-part
silkscreen print*, 252 × 356 cm

Les Levine, der seit den achtziger Jahren
häufig mit dem Medium Plakat arbeitete,
entwarf das Blatt als Beitrag zu der
zwanzigteiligen Serie des Goethe-Insti-
tutes »I Am You«.

*The American artist Les Levine, who
had worked regularly in the poster
medium since the 1980s, created this
image as his contribution to the Goethe-
Institut's 20-part "I Am You" series.*

Ulrike Rosenbach (*1943)

I Am You
Saarbrücken / München / *Munich* 1993
Siebdruck in neun Teilen / *Nine-part
silkscreen print*, 252 × 356 cm, kleines
Format / *small format* 57,5 × 80 cm

Das Plakat gehört zu der zwanzigteiligen
Serie des Goethe-Institutes »gegen
Fremdenhass, Intoleranz und Gewalt«.
Am Bildschirm vollzieht sich die Begeg-
nung von erster und dritter Welt; im
Hintergrund sind verschleierte Frauen in
einer Wüstenlandschaft zu sehen.

*This poster belongs to the 20-part "I Am
You" series by the Goethe-Institut in-
tended "to combat xenophobia, intoler-
ance, and violence." The images on the
screen portray a meeting of the First
and Third World; in the background are
veiled women in a desert landscape.*

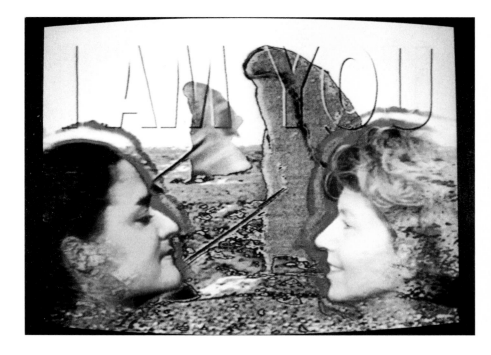

Als das Kind
noch Kind war.

Marie-Jo Lafontaine (*1950)

Als das Kind noch Kind war /
When the Child was Still a Child
München / *Munich* 1993
Siebdruck in neun Teilen / *Nine-part
silkscreen print*, 252 × 356 cm

Das Plakat ist Teil der zwanzigteiligen
Serie des Münchner Goethe-Institutes
»I Am You« »gegen Fremdenhass,
Intoleranz und Gewalt«.

*This poster, by the Belgian artist Marie-
Jo Lafontaine, is part of the 20-part
"I Am You" series by the Goethe-Institut
intended "to combat xenophobia,
intolerance and violence."*

Félix Gonzalez-Torres
(1957–1996)

Blatt aus dem Stapel »Ohne Titel«
(Tod durch Schusswaffen) / *Sheet from
the stack "Untitled" (Death by Gun)*
New York 1990
Offset / *Offset print*, 114 × 84 cm, Höhe
des Stapels / *height of stack* 23 cm

Das Blatt ist Teil eines Stapels, der in
Ausstellungen auf dem Boden liegt.
Jeder Besucher kann sich hieraus ein
Exemplar mitnehmen. Abgebildet sind,
nach einem Bericht aus dem Time
Magazine, Fotos und Kurzberichte von
allen in den USA Erschossenen in einer
Woche im Mai 1989.

*This sheet is part of a stack made up
of the same prints laying on the floor in
exhibitions. The visitors are free to take
a copy with them. Reproduced are, after
a layout in Time Magazine, images and
abridged reports of all the people killed
by hand guns in the United States in
one week in May 1989.*

THE 52ND PRESIDENTIAL INAUGURAL

Tim Rollins (*1955)
und /and **K.O.S.**

Die 52. Präsidentschaftswahl /
The 52nd Presidential Inaugural
New York 1993
Offset /*Offset print*, 66 × 96,5 cm

Das Plakat unterstützt den demokratischen Kandidaten Bill Clinton gegen George Bush sen. bei den Präsidentschaftswahlen 1993. Es reproduziert die Gruppenarbeit »America – A Refuge« von 1992. K.O.S. steht für Kids of Survival, eine Gruppe von sozial schwachen und gefährdeten Schülern, mit denen Rollins seit 1982 in der Bronx zusammenarbeitet.

This poster is in support of democratic candidate Bill Clinton against George Bush Senior. It is a reproduction of group artwork "America – A Refuge" from 1992. K.O.S. stands for Kids of Survival, a group of socially disadvantaged and vulnerable students with whom Rollins had been working in the Bronx since 1982.

Roy Lichtenstein (1923–1997)

Eine neue Generation der Führung /
A New Generation of Leadership
New York 1992
Offset /*Offset print*, 87 × 97 cm

Erschienen in einer Reihe von insgesamt sechs Künstlerplakaten, unterstützt Lichtenstein mit seinem Plakat die Wahl von Bill Clinton. Das Motiv wurde ebenso als Grafikedition gedruckt.

Published as part of a series of six artists' posters, this design by Lichtenstein is in support of Bill Clinton's election campaign. The motif was also printed as a graphic edition for collectors.

Roy Lichtenstein, *The Oval Office*, ©1992. Paid for by the Democratic National Committee.

A NEW GENERATION OF LEADERSHIP

THE ADVANTAGES OF ANOTHER BUSH PRESIDENCY

Trading the tedium of college for the adventure of the battlefield.

Enjoying global warming through the sunroof of your SUV.

Being assured adoption will be easier with contraception unavailable and abortion illegal.

Having more public housing options—behind bars.

Learning to "do-it-yourself" as our alien workforce is deported.

Being titillated by government agents penetrating your intimate data.

Basking in the glow of US world dominance in WMDs.

Not being confused by opposing views in the media.

Leaving something of significance to your children—the deficit.

Knowing your passionate gay sex life will not be dulled by the sanctity of marriage.

Getting a rush as yet another developing country is selected for liberation.

Not having to suffer through Evolutionary Biology—now we know God the Father created the Universe.

Feeling confident that your hard work as a Guerrilla Girl will be needed more than ever.

guerrillagirlsbroadband
Your Virtual Conscience

w w w . g g b b . o r g
P O Box 69 NY NY 10116

Guerrilla Girls Broadband

(Künstlergruppe / Art group; seit 2001 / 2001 onwards)

Die Vorteile einer zweiten Präsident-schaft Bushs / The Advantages of Another Bush Presidency
New York 2004
Offset / Offset print, 46 × 61 cm

Der satirische Kommentar zur Wieder-wahl von George W. Bush zählt in der Art von Jenny Holzer scheinbare Vorteile einer zweiten Amtszeit auf: Die Langeweile der Universität gegen das Schlachtfeld eintauschen. Durch das Sonnendach des Geländewagens die globale Erwärmung genießen. Oder: Den Kindern etwas von Bedeutung hin-terlassen – die Schulden. Und schließ-lich: Zuversichtlich sein, dass die harte Arbeit als Guerrilla Girl mehr denn je gebraucht wird.

In the style of Jenny Holzer, this satiri-cal commentary on the reelection of George W. Bush lists the "advantages" of a second term for Bush: trading the tedium of university for the battlefield, being able to enjoy global warming through the sunroof of your SUV, leav-ing something of significance for your children – a deficit. And, finally: to be sure that the hard work of the Guerrilla Girls will be needed more than ever.

Mike Kelley (*1954)

Die größte Tragödie in Präsident Clintons Amtszeit / The Greatest Tragedy of President Clinton's Administration
Los Angeles 1999
Offset / Offset print, ca. 106 × 67 cm

Das Blatt wurde anlässlich der Aus-stellung »Odd Man Out« in der Patrick Painter Gallery gedruckt. Kelley lastet es Clinton in aufgesetzter Ernsthaftigkeit an, dass dieser nicht das amerikanische Gesundheitssystem reformiert und zur sexuellen Befreiung der Amerikaner beigetragen habe. So müsse er, Kelley, in seiner Ausstellung Ersatzobjekte zur Befriedigung der Besucher zeigen. Das Motiv ist zugleich Teil der Installation »The Secret«.

This poster was produced for the "Odd Man Out" exhibition at the Patrick Painter Gallery in Los Angeles. With false earnestness, Kelley accuses Clinton of not reforming the American health care system, and not contributing to American sexual liberation – thereby forcing Kelley to present objects in his exhibition as a substitute to keep the visitors happy. This motif is also part of his installation "The Secret."

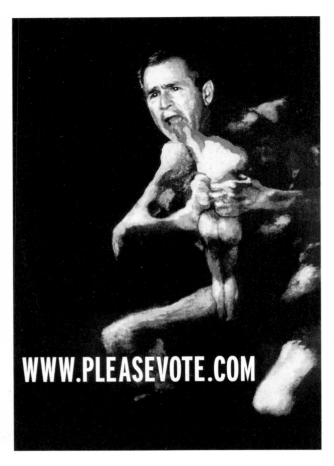

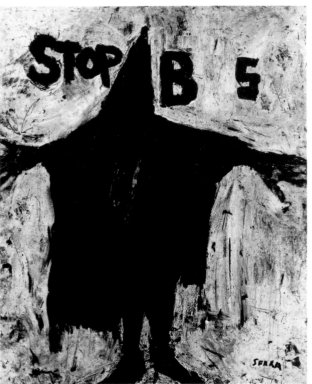

Richard Serra (*1939)

www.pleasevote.com
New York 2004
Tintenstrahldruck / Inkjet print, 75 × 54 cm

Dieser Entwurf Serras gegen die
Wiederwahl von George W. Bush zitiert
Goyas Gemälde »Saturn frisst seine
Kinder«. Er wurde, wie auch das Stoppt-
Bush-Plakat, im Internet zum Download
angeboten.

*This design by Serra urging voters not
to reelect George W. Bush references
Goya's painting "Saturn Devouring
His Children." Like the "Stop Bush"
poster, Serra also made this design
available for download on the Internet.*

Richard Serra (*1939)

Stoppt Bush / Stop Bush
New York 2006
Offset / Offset print, 75 × 61 cm

Von dem Anti-Bush-Blatt Serras ging
nur diese Version anlässlich der Whitney
Biennale of American Art 2006 in Druck.

*Only this version of Serra's anti-Bush
poster was ever printed – on the
occasion of the Whitney Biennale
of American Art 2006.*

Richard Serra (*1939)

Stoppt Bush / Stop Bush
New York 2004
Tintenstrahldruck / Inkjet print, 91 × 71 cm

Den Entwurf mit dem vollständigen
Namen des Präsidenten verbreitete
Serra im Internet. Die Zeichnung zitiert
eines der weltweit verbreiteten Fotos
von Folterszenen in dem US-amerika-
nischen Gefangenenlager Abu Ghraib
im Irak.

*Serra made the version with the
President's full name available on
the internet. The drawing references
photographs showing scenes of torture
from the USA's detention facility at
Abu Ghraib in Iraq, which were seen
around the world.*

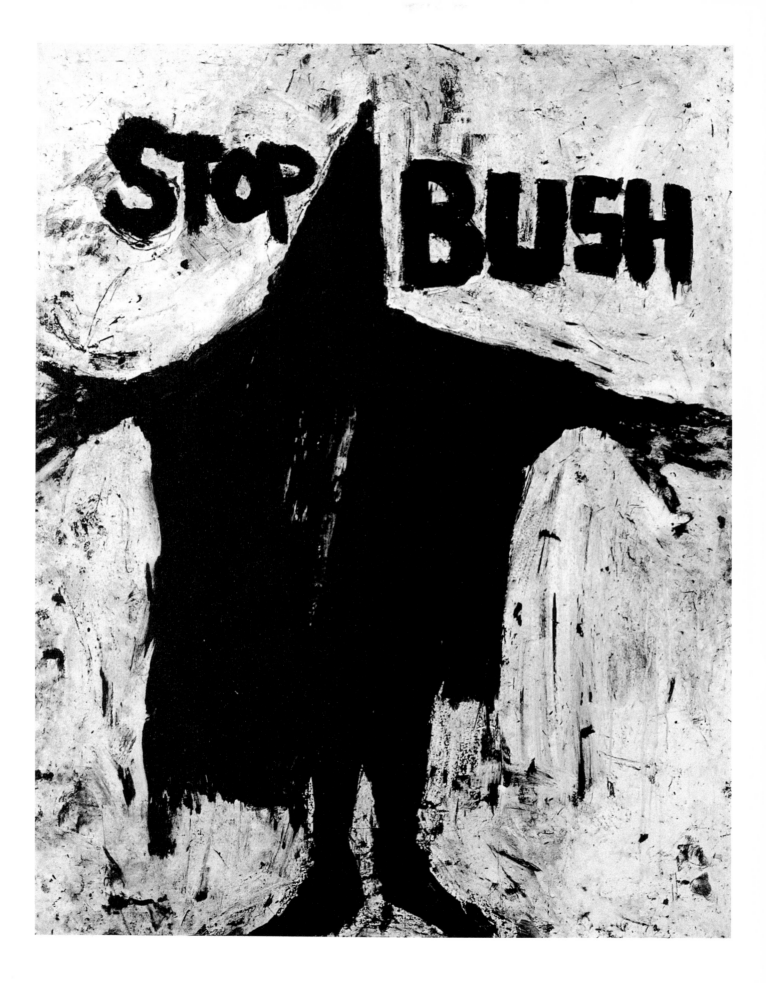

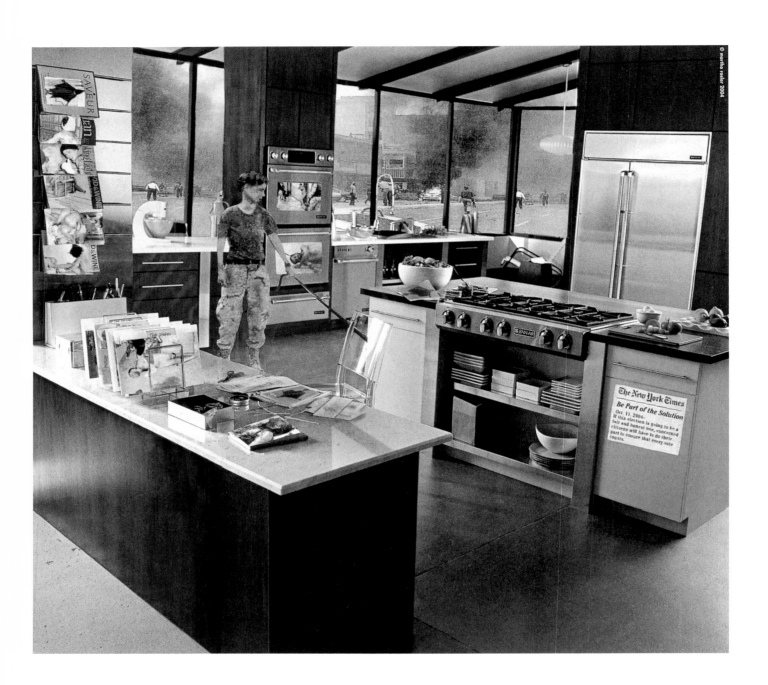

Martha Rosler

Wahl (Lynndie) / *Election (Lynndie)*
New York 2004
Offset / *Offset print*, 59,5 × 68 cm

Rosler versetzt die im Zusammenhang mit den Folterungen im Irak verurteilte Soldatin Lynndie England in eine moderne amerikanische Küche. Überall finden sich Fotos von irakischen Folterszenen. Das Plakat gehört zu der Serie »Bringing the War Home: House Beautiful, new series«. Der Titel bezieht sich auf eine Schlagzeile der New York Times, die den Wähler auffordert, durch die Abwahl von George W. Bush zur Änderung der Missstände beizutragen.

Rosler shows soldier Lynndie England, convicted of involvement in torture in Iraq, in a modern American kitchen. There are photographs of torture scenes in Iraq everywhere. The poster is part of the series "Bringing the War Home: House Beautiful, new series." The title is taken from an article heading in the New York Times, calling on the electorate to help bring human rights violations to an end by removing George W. Bush from power.

Adel Abidin (*1973)

Willkommen in Bagdad / *Welcome to Baghdad*
Bagdad / *Baghdad* / Helsinki 2007
Offset / *Offset print*, 70 × 50 cm

Die sechsteilige Plakatserie zum US-Krieg im Irak wirbt auf sarkastische Weise für eine fiktive Reiseagentur. Die Serie entstand für die Biennale in Venedig. Der irakische Künstler betreibt über das Internet eine fiktive Reiseagentur, die sarkastisch mit den Gefahren des Bürgerkrieges – von Selbstmordattentätern bis zu Landminen – für das Land wirbt. Die Plakate sind in satirischer Weise als Werbeträger konzipiert.

This six-part series of posters on the US war in Iraq sarcastically advertises on behalf of a fictitious travel agency. It was created for the Venice Biennale. The Iraqi artist runs a fictional online travel agency that sardonically presents the hazards of the country's civil war, from suicide bombers to land mines, as selling points. These posters are satirical imitations of advertising media.

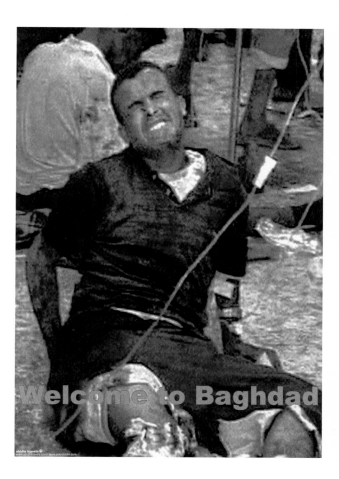

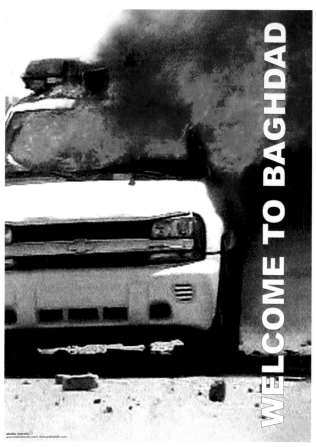

NO TEETH...?
A MUSTACHE...?
SMEL LIKE SHIT...?

BOSNIAN GIRL

Šejla Kamerić (*1976)

Bosnisches Mädchen! / *Bosnian Girl!*
Sarajevo / Frankfurt am Main 2004
Offset / *Offset print*, 84 × 59,4 cm

Das sarkastische Graffiti fand sich in
einer Baracke niederländischer UNO-
Soldaten, die 1993/94 für die Sicherheit
von Srebrenica zuständig waren –
und mit schrecklichen Folgen versagten.
Es wurde von der Künstlerin, selbst
eine Überlebende der Belagerung von
Sarajevo, mit einem Selbstporträt (Foto:
Tarik Samarah) hinterlegt und als Post-
karte, Plakat und auf T-Shirts verbreitet.
Die hier gezeigte Version ist ein Plakat
für den Portikus in Frankfurt.

This sarcastic graffiti text comes from
the barracks of the Dutch UN soldiers
who were responsible for the safety
of Srebrenica in 1993/94 – and failed
disastrously. The artist, a survivor of
the siege of Sarajevo, took this graffiti,
combined it with her own photograph
(taken by Tarik Samarah), and made
it available as a postcard and poster
and on T-shirts. The version shown
here is from a poster for Frankfurt's
Portikus art venue.

Yoshitomo Nara (*1959)

Fuckin' Politics!
Tokio / *Tokyo* 2003
Lithografie / *Lithograph*,
53 × 70,8 cm

Nara ist durch seine scheinbar harm-
losen, netten Kindergestalten weltweit
populär geworden. Auch wenn diese mit-
unter Waffen statt Spielzeug schwenken,
geraten sie selten so in Zorn wie hier.

Nara's seemingly innocuous and sweet
child faces have made him popular all
over the world. Although they are some-
times shown waving weapons instead
of toys, they are rarely as angry as the
example shown here.

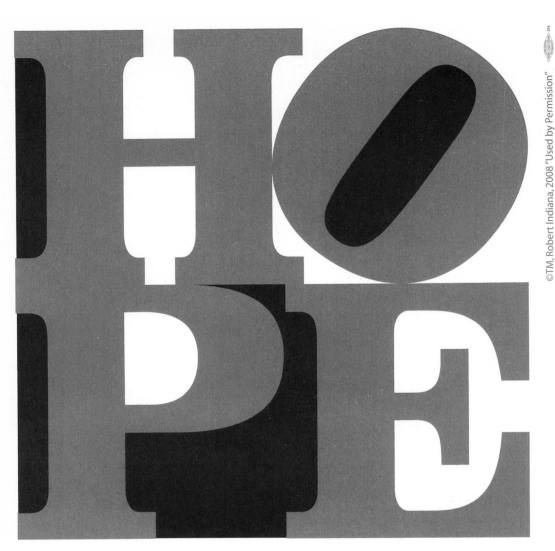

WWW.**BARACKOBAMA**.COM

Robert Indiana (*1928)

Hoffnung / *Hope*
New York 2008
Offset / *Offset print*, 65 × 65 cm

Indiana unterstützte die Wahl Barack
Obamas zum Präsidenten mit diesem
Rückgriff auf seinen »Love«-Entwurf,
der 1965 für eine Weihnachtskarte
des Museum of Modern Art entstanden
war. Es existieren zwei Farbvarianten
des Plakates.

*To support Barack Obama's election
campaign, Indiana designed this poster
based on his famous "Love" design,
which he created in 1965 for a Museum
of Modern Art Christmas card. This
poster exists in two different color
schemes.*

REGISTER
INDEX

Künstlerregister / Index of Artists

Abidin, Adel 163
Abramović, Marina 151
Adams, Edward T. 54
Aléchinsky, Pierre 44
Anuszkiewicz, Richard 71
Appel, Karel 45
Arman 80, 93
Basquiat, Jean-Michel 143
Bazaine, Jean-René 46
Ben 137
Beuys, Joseph 8/12, 96/97, 103–109
Bill, Max 9/13, 83
Blais, Jean-Charles 12
Borofsky, Jonathan 126
Bruggen, Coosje van 91
Calder, Alexander 9/13, 48, 54, 85
Calle, Sophie 137
Cheremnykh, Mikhail 23
Delaunay, Sonja 71
Droese, Felix 152
Erni, Hans 32
Farah, Rafic 116
Flavin, Dan 63
Fukuda, Shigeo 116
General Idea 130
Gerz, Jochen 137
Gianakos, Christos 56
Gonzalez-Torres, Félix 154
Grieshaber, HAP 14/15, 26, 34, 38, 68, 85, 87
Grosz, George 7, 14/15
Guerrilla Girls 125
Haring, Keith 94, 111, 118/119, 122, 133, 134, 143
Haus-Rucker-Co 102
Holzer, Jenny 121, 122
Hundertwasser, Friedensreich 88, 96/97, 112–115
Indiana, Robert 130, 140/141, 166
Jenkins, Paul 101
Johns, Jasper 58
Jorn, Asger 46
Kamerić, Šejla 165
Kelley, Mike 159
Kippenberger, Martin 138
Kokoschka, Oskar 9/13, 26
Kollwitz, Käthe 20
Kruger, Barbara 126–129
Lafontaine, Marie-Jo 154
Lenk, Kaspar-Thomas 65
Levine, Les 153
Liberman, Alexander 80
Lichtenstein, Roy 9/13, 89, 98, 101, 143, 149, 156
Lissitzky, El 6/10, 14/15, 23
Lucebert 93
Machado, Antonio 34
Maciunas, George 57
Matta Echaurren, Roberto 40
Miró, Joan 6/10, 25, 34, 38, 66/67, 72–75, 83
Nara, Yoshitomo 140/141, 165
Oldenburg, Claes 91
Pechstein, Max 19

Picasso, Pablo 2, 6/10, 14/15, 25, 28–31
Pistoletto, Michelangelo 84
Rauschenberg, Robert 10/11, 11, 60, 98, 101, 116, 140/141, 145, 146
Rebeyrolle, Paul 48
Rivers, Larry 60
Rollins, Tim 156
Rosenbach, Ulrike 153
Rosenquist, James 53
Rosler, Martha 163
Roth, Dieter 87
Saint-Phalle, Niki de 7/10, 51
Saura, Antonio 91
Self, Colin 40
Serra, Richard 9/13, 140/141, 160
Shahn, Ben 14/15, 25, 32
Sieverding, Katharina 150, 152
Siqueiros, David Alfaro 34
Sonderborg, K.R.H. 87
Staeck, Klaus 64, 65, 68
Steinlen, Théophile A. 6/10, 16, 17
Stella, Frank 58
Tàpies, Antoni 66/67, 76–79, 93, 111
Trova, Ernest 100
Vedova, Emilio 42
Vostell, Wolf 54, 94
Warhol, Andy 53, 63, 96/97, 106, 143
Wool, Christopher 138
Youngerman, Jack 83, 84
Zush 138

Sachregister

Aids 12, 118, 130, 132–134, 137, 138
Amnesty International 9, 66, 80, 83–85
Apartheid 7, 66, 91, 93, 140, 146
Arbeiter 16, 17, 20, 36, 65, 87
Atomkraft, Atomkrieg 32, 110, 111, 115
Demonstration 36, 53, 88, 98, 111
Deutschland 7, 9, 14, 19, 20, 21, 25, 36, 65, 68, 87, 150
Fahne 6, 56–58, 66, 91
Faschismus 6, 14, 25, 87, 130, 131
Faust 24, 25, 91, 128, 129
Feminismus 7, 51, 71, 118, 121, 124, 125
Fesseln 6, 10, 84, 93
Folter 7, 68, 160, 161, 163
Freiheit 6, 8, 17, 31, 34, 46, 66, 76, 88, 89, 94, 112, 129, 140, 149, 159
Frieden 6, 14, 26, 28, 31, 32, 38, 50, 51, 84, 88
Gefangener 31, 53, 58, 66, 80, 83–85, 160, 161
Gewalt 121, 152–154
Globalisierung 7, 116, 140–166
Hinrichtung 40, 53–55
Homosexualität 118, 130, 134, 135, 138, 139
Hunger 6, 9, 14, 26, 27, 143, 149
Katalonien 7, 38, 66, 72, 75–77, 79, 111
Kind 8, 9, 26, 27, 96, 129, 143, 146, 147, 154, 159, 160, 165
Kreuzigung 26, 27, 54, 68
Mai 1968 7, 36, 38, 45, 66
Mai, der 1. 16, 38, 87, 154
Menschenrechte 6, 7, 72, 73, 118, 149, 163
Protest 32, 36–66, 79, 93, 112, 115
Rassismus 38, 93, 153
Revolution 6–8, 15, 19, 23, 36, 45, 46,

96, 105, 108, 109
Tod 38, 42, 75–77, 79, 91, 134, 137, 154, 155
Umwelt 6, 7, 66, 96–117
UNO, UNESCO 7, 66, 71–73, 85, 93, 94, 96, 98, 116, 143, 144, 146, 165
USA 7, 14, 32, 36, 42, 56–58, 60, 61, 65, 66, 68, 69, 71, 80, 88, 91, 96, 98, 101, 102, 118, 126, 127, 129, 140, 144, 145, 154, 155, 159–163
Waffe 36, 54, 55, 106, 107, 111, 154, 155, 165
Wahl 7–9, 14, 19, 36, 60–63, 65, 71, 87, 106, 107, 140, 156–160, 163, 166

Subject Index

AIDS 12, 119, 130, 132–134, 137, 138
Amnesty International 13, 67, 80, 83–85
Apartheid 11, 67, 91, 93, 141, 146
Catalania 11, 25, 38, 67, 72, 75–77, 79, 111
Child(ren) 12, 13, 26, 27, 97, 129, 143, 146, 147, 154, 159, 165
Crucifixion 26, 27, 54, 68
Death 38, 42, 75, 76, 77, 79, 91, 134, 137, 154, 155
Demonatration 15, 53, 88, 98, 111
Elections 8, 11–13, 15, 19, 37, 60–63, 65, 71, 87, 106, 107, 141, 156–159, 160, 166
Environment 10, 11, 67, 97–117
Execution 40, 53–55
Fascism 10, 15, 25, 87, 130, 131
Feminism 10, 71, 119, 124, 125
Fetters 10, 84, 93
Fist 24, 25, 91, 128, 129
Flag 10, 56–58, 67, 91
Freedom 10, 12, 17, 31, 46, 50, 51, 67–95, 112, 129, 141, 149
Germany 11, 12, 15, 19, 20, 23, 25, 34, 37, 57, 65, 68, 87, 94, 97, 106, 141, 150
Globalization 11, 116, 140–166
Homosexuality 119, 130, 134, 135, 138, 139
Human rights 10, 11, 72, 73, 119, 149, 163
Hunger 10, 15, 26, 27, 143, 149
May 1968 7, 37, 38, 45, 48, 66
May 1 16, 38, 87, 154
Nuclear power/war 32, 110, 111, 115
Peace 10, 15, 26, 28, 31, 32, 38, 51, 84
Prisoners 31, 53, 58, 67, 80, 83–85, 160, 161
Protest 11–13, 32, 37–65, 67, 79, 93, 112, 115, 134
Racism 38, 93, 153
Revolution 14, 15, 19, 23, 37, 45, 46, 97, 105, 108, 109
Torture 11, 68, 160, 161, 163
UN/UNESCO 7, 11, 67, 71–73, 85, 93, 94, 97, 98, 116, 143, 144, 146, 165
USA 11, 15, 32, 37, 42, 56–58, 60, 61, 65, 67–69, 71, 80, 91, 97, 98, 101, 102, 119, 126, 127, 129, 141, 144, 145, 154, 160
Violence 121, 126, 152, 153, 154
Weapons 32, 54, 55, 106, 107, 111, 126, 154, 155, 165
Workers 16, 19, 20, 37, 65